The Arbor House
BOOK OF
CARTOONING
by
MORT GERBERG

ARBOR HOUSE
New York

This book is
dedicated to the memory
of Bob Abel—who
opened doors.

Library of Congress Catalogue Card Number: 81-71666

ISBN: 0-87795-399-6
Hardcover edition: 0-87795-372-4

Designed by Barbara Huntley
Manufactured in the United States of America
10 9 8 7 6 5 4 3 2 1

Acknowledgments

I wish to thank the following artists, publications, syndicates and companies for permission to print cartoons, illustrations and sketches:

Charles Addams © The New Yorker 1979. ☐ Niculae Asciu © the New York *Times* 1980, 1981. ☐ Tony Auth and Philadelphia *Inquirer*. ☐ R. O. Blechman © the New York *Times*, March 11, 1981. Animation cel reproduced with permission. ☐ Herblock © 1981 by Herblock in the Washington *Post*. ☐ George Booth © The New Yorker 1977. Sketches reproduced with his permission. ☐ Roz Chast © 1982. ☐ Dick Cavalli from The Saturday Evening Post. ☐ Whitney Darrow, Jr. © The New Yorker 1975. Illustration by Whitney Darrow, Jr. from *Unidentified Flying Elephant* © 1968, published by Windmill Books, Inc./Simon & Schuster. ☐ Liza Donnelly © the New York *Times* 1982. Drawing excerpted with permission of Chemical Engineering, July 27, 1981 © 1981 McGraw-Hill, Inc. Sketch reproduced with artist's permission. ☐ Doyle Dane Bernbach, sketch for a Chivas Regal advertisement. ☐ Boris Drucker illustrations © 1980, DeSoto, Inc. and © Sylvania. ☐ Jules Feiffer © 1981. Reprinted with permission of Universal Press Syndicate. All rights reserved. ☐ Field Newspaper Syndicate for Moma by Mell Lazarus. Courtesy of Mell Lazarus and Field Newspaper Syndicate. ☐ Ed Fisher © The New Yorker 1979. Sketches reproduced with permission. ☐ Dana Fradon © The New Yorker 1981. ☐ Edward Frascino © The New Yorker 1981. ☐ Illustration from *It'll All Come Out in the Wash* by Nigel Gray. Illustrated by Edward Frascino. Illustrations © 1979 by Edward Frascino. Sketches reproduced with permission. ☐ John Gallagher, from The Saturday Evening Post. ☐ Mort Gerberg © The New Yorker 1965, 1975, 1977, 1979. ☐ Reproduced by special permission of Playboy magazine; © 1974, 1978, 1980, 1981 by Playboy. ☐ Illustrations reprinted by permission of Scholastic Inc. from *Favorite Riddles, Knock-Knocks, and Nonsense* by Rita Gelman. Text © 1980 by Scholastic Inc. Illustrations © 1980 by Mort Gerberg. ☐ Illustration reprinted by permission of Scholastic Inc. from *The Biggest Sandwich Ever* by Rita Golden Gelman. Text © 1980 by Scholastic Inc. Illustration © 1980 by Mort

Contents

Preface

As far as I can remember, I was always attracted to cartoons. When I was seven years old, I made a drawing of Mickey Mouse (which I still have because my mother saved it for me) that won wide acclaim and predictions that I would grow up to be a professional cartoonist.

And so I did, but only after sampling more "conventional" careers like journalism and advertising. Through them all though, I continued to doodle, as a life of cartooning beckoned, irresistibly, like the Lorelei.

When I finally surrendered and began cartooning full-time, I did so on my own, except for attending one three-month cartooning class and glancing into a do-it-yourself book.

The first time I consciously considered how a cartoon is created was in 1973 (after I had already been a professional for ten years), when Ed Fisher and I wrote the foreword to a cartoon collection, *The Art in Cartooning*. Two years later, I introduced a course at the Parsons School of Design in New York called "Cartooning For Communication," which incorporated some of the ideas from that foreword. This book is based on that course. Like the course, *The Arbor House Book of Cartooning* devotes two-thirds of its contents to the magazine gag cartoon; the other third presents overviews of other related areas in which gag cartoonists work.

Much of the information and examples come from my own long experience with magazine cartoons, children's books, syndicated comic strips,

spot illustrations, television cartoons, humor books, advertising and animation. Also, just as fellow cartoonists visit my classes as guest speakers, this book includes many first-hand accounts of their personal approaches to cartooning, as well as samples of their work. The aim is to share professional experiences, so that the instruction is by example, rather than step-by-step rules; cartooning, one of the liveliest, most spontaneous arts, defies being described and taught according to a strict procedure. The book, though, is not meant to be an all-inclusive historical review or collection of "best" work; it's more an appreciative "show and tell."

Over the years there have been two audiences in my class: people who have a deep admiration for cartoons and wish to heighten it by understanding the behind-the-lines process, and those who want to become professional cartoonists and are willing to invest time and energy to test themselves. This book addresses the same audiences.

I am grateful to all my fellow cartoonists for their support; for talking with me about their work and allowing me to show it; as well as to editors, publishers and syndicates for their interviews and assistance in granting permissions. Those who made visible contributions are credited throughout the book and in the index. I'm sorry I couldn't include even more examples. I also want to thank Sam Magdoff, Associate Dean at Parsons, for establishing and supporting my classes, and all my students, who gave me the opportunity not only to develop this material but to study it myself. Teaching the class and writing this book has truly been an education for me. I feel particularly gratified by those students who "graduated" into becoming professionals and now share their experiences with me as colleagues.

A special word of thanks goes to Anne Hall and Meg Siesfeld, who helped locate and research material, and to Jillian Blum, who helped me assemble, type and keep track of it all; to Henry Morrison, who encouraged me throughout; to Arnold Ehrlich and Don Fine, for their patience; and to my daughter, Lilia Gerberg, who loves cartoons and is an inspiration, and my wife, Judith Levine Gerberg, for her understanding, support and positive energy up and down the freelance trail.

Part One
THE
MAGAZINE
GAG CARTOON

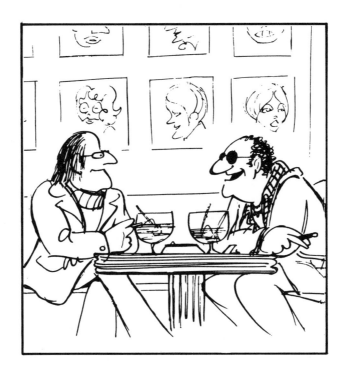

1

Always on Wednesday

I remember feeling like the new kid on the block. I had slipped unobtrusively through the doorway, hoping nobody would notice me, and quickly sat in a corner in a green leather chair with a torn seat.

There might have been thirty-five people, almost all male, milling around a large room that appeared to be a temporary storage space for desks, filing cabinets, folders, tables and other office equipment. Everyone was drinking coffee from white Styrofoam cups and chattering animatedly, laughing in short, explosive bursts, particularly when they showed each other drawings pulled from briefcases or large manila envelopes tucked under their arms. The scene was fascinating, although I wasn't sure it exactly fit my fantasies about what Wednesday at the Saturday Evening Post would really look like. I sat there, drinking it all in, an outsider. But not for long.

A stocky man wearing horn-rimmed glasses and a plaid sports jacket approached me.

"Have you signed in?" he said.

I looked at him dumbly.

"First time at the Post?" he asked.

I nodded hopefully.

"You sign in," he said, pointing to a sheet of paper taped to a pillar at one end of the room. "Write your name at the bottom of the list; that's the order we follow."

I mumbled my thanks and went to look at the list. The name at the bottom was Barney Tobey. Wow! I thought. Barney Tobey! I see the cartoon

editor of the Saturday Evening Post after Barney *Tobey*? Just like *that*? I scanned the other names. The ones on top had been scratched through but all were legible. Richter, Wolfe, Monahan, Markow, Porges, Ross, Kaufman, Cramer, Habbick, Savage, Shirvanian, Tippit, Busino, Marcus, Michaud, Harris, Tobey . . . these were names that I *knew;* their cartoons came immediately to mind. And *me?*

I picked up a pencil, took a breath and signed my name under Tobey's, suddenly aware that I was being watched by some of the others. How about that? I thought. I just walked right in here. *Anybody* who wants to can be a cartoonist.

The man in horn-rimmed glasses was looking over my shoulder. "Mort Gerberg? Hi. My name is Al Kaufman," he said. "I don't think I've met you." Of course not. I was only a beginner.

That was in 1963. The first of hundreds of Wednesday "rounds" I would make before the magazine market underwent a drastic transformation. Wednesday was—and still is—the traditional "look" day at all the magazines in New York. No appointments necessary. The door was open. Through the sixties my impression is that perhaps fifty cartoonists would weave their way up and down the streets, scurrying in and out of offices, seeing editors, showing new drawings, picking up previous weeks' holds, like a swarm of bees buzzing around a field of flowers, all following some personal order based on geography (where the magazine was located) and money (how much it paid).

It was exciting, rushing from one place to the next, so that you could cover all your markets by late afternoon. There was often a backup at one place or another; you never knew which editor would be in a meeting or late getting in. The Saturday Evening Post was always like a Sargasso Sea. You *expected* to get stuck there, sometimes for two hours. The Post was the top "open" general market and *everybody* went there. I'd try it first thing in the morning, then late in the morning, then early afternoon and late afternoon, but it made no difference. There would always be a cluster of cartoonists pacing, bellyaching about anybody who stayed for more than five minutes with the editor— David Lyle, Mike Mooney or Leila Hadley—trading quips, showing drawings, carrying on with the magazine's employees. Cartoonists waiting their turn at the Post always reminded me of a cattle drive in a Western movie. One particularly slow-

moving morning I started mooing; my moos were instantly echoed by other cartoonists. It was the first hint of consciousness-raising for cartoonists.

After the Post my other regular stops included Look, the Saturday Review, Harper's, Esquire and, less frequently, the Ladies' Home Journal, McCall's, TV Guide, Signature, New York Times Book Review, Skiing, True, 1000 Jokes, and the "girlies" like Cavalier, Swank, Nugget, Dude and Gent, and finally Paul Krassner's The Realist, where my first cartoons appeared. Late in 1963 I started mailing roughs to Playboy, and a couple of years later, dropping my work off at The New Yorker.

Each office offered something different in the way of welcome or hospitality. The Post had free coffee and, for the early birds, pastry or rolls, which disappeared quickly. Few of the waiting areas had enough chairs for everyone. There was a lot of leaning against walls. I remember once sitting on rolled up carpets in a hallway at True. Magazines always seemed to be renovating or relocating.

But despite the discomforts that cartoonists generally met with, Wednesday was the day we all pointed toward. Besides being selling time, Wednesday provided the cartoonist with an emotional release. After working in solitude all week, it was an opportunity to meet colleagues, be with kindred souls who really understood, share gags, news of okays, holds and rejections, "secret" markets and general all-round good fellowship heightened by the fact that everyone was in head-to-head competition with his buddy for a small rectangle of white space in a magazine.

Wednesday's highlight was lunch, a large, happy, boisterous affair at some "regular" restaurant like the Pen and Pencil, Costello's, the Press Box, the Blue Ribbon or the Lobster, depending on the year and group you were with.

There are several explanations of why Wednesday was the day of choice for editors' open door policy. Jack Markow, the veteran cartoonist, writer and editor whose career dates back to the early days of The New Yorker, says: "The best consensus I have, culled from both cartoon editors and cartoonists is: In nineteen thirty-seven, the old Cartoonists Guild of America held its meeting on Wednesday nights at the Hotel Knickerbocker in New York as a convenience to out-of-town members who wanted to attend these meetings and also see editors on the same day, the Guild urged the few major markets who were 'looking' on various

days to use Wednesday as the 'look' day. As other major markets came into being, they fell into line and Wednesday has been the day ever since."

Markow recalls in Cartoonist Profiles that the forties and fifties were the times of a cartoonist's dream—"a real seller's market." Besides the magazines which I mentioned visiting myself, there were Collier's, Liberty, Woman's Home Companion, cartoon-minded newspaper supplements like This Week, Parade, American Weekly, Family Weekly and Suburbia Today. In addition, recalls Markow, there were many magazines that were "low paying but with the redeeming feature of quantity buying. These all-cartoon publications gave instant okays—sometimes six to eight to a cartoonist. Many were started during the war and aimed at servicemen. Included were Army Laughs, Broadway Laughs, Laff Time, 1000 Jokes and Gags, which used one hundred cartoons per issue."

Wednesday in the fifties, says Markow, "could start at dawn and end at midnight . . . covering maybe twenty to thirty markets in all. The early riser would sign in between eight and eight-thirty at the Saturday Evening Post on East Forty-second Street. Since the cartoon editor would not arrive from Philadelphia until about ten, this gave the cartoonist a chance to cover a few other markets before rushing back to the Post in time for his turn. By lunch time, sixty comic men and women would have visited this magazine. The publisher's belt extended from Forty-second Street to Fifty-ninth Street, and fine planning and agility were necessities in covering sufficient markets before lunch."

Bill Yates, a longtime magazine and strip cartoonist, and now the comics editor at King Features Syndicate, was the editor at 1000 Jokes at that time. He remembers that he would even look through and buy, on the spot, the remaining cartoons from cartoonists riding with him in the bar car on the train back home to Connecticut on Wednesday night.

Of course, not *everybody* prospered then. Such luminaries of today, like Bob Weber and George Booth, undoubtedly ahead of their time, found it rough going. Weber admits that in 1953 he "started taking stuff around . . . and my first sale was to the Saturday Evening Post, which was terrific—but in the whole year I only sold eight cartoons." Booth reports: "Wednesday in the 'good old days'? I *died* in the 'good old days'. In nineteen fifty-six, I think it was, I rounded out a full two thousand dollars. I

reported everything truthfully to IRS—worked with SEP, Look, and so forth. The IRS sent a representative in an olive drab auto to my hovel to investigate. The poor devil was all choked up with emotion by the time he left. Finally things got so bad I took employment."

Jerome Beatty, Jr. was the cartoon editor at Collier's from 1954 to 1956, taking over from Gurney Williams. He remembers that "there were more cartoonists walking around Fifth Avenue than you could count. You were always bumping into them; they'd be rushing from one office to the next, with their bags and envelopes full of drawings. They'd come in, pick up their rejects from a file drawer, then they sat and waited their turn. Of course, they saw each other at every office."

The reviewing process was pretty standard, says Beatty, although "Gurney didn't see anybody in person who hadn't sold in the past, and if you went without selling anything for maybe a month, you couldn't come in and sit down while he went through your stuff—you had to leave it. But I didn't do that. I saw everybody. I'd always hold out a few; I mean, you couldn't give a guy his whole batch without holding *some*. Then I'd take about twenty or thirty that I liked into William Chessman [the art director] and he'd buy what he wanted and they'd go into inventory."

After Collier's folded in 1956, Beatty went to Esquire where he was a part-time cartoon editor, appearing every other Wednesday to collect and screen material. He remained there for about ten years, and although the magazine started out with a big page size and featured a lot of color cartoons, notably the Petty and Vargas girls, "they kept buying fewer and fewer cartoons and I had less and less to do."

By 1963, then, when I first started my Wednesday rounds, the general magazine market for cartoons had already begun to shrink, although I wasn't aware of it. Television was regarded only as an exciting new communications medium, certainly not a threat to mass-circulation general interest magazines like the Post, Look and Life.

The doodles were on the wall, though, and an article about cartoonists in Newsweek of December 23, 1968, noted that "Wednesdays have become more and more melancholy. The Post rarely buys more than ten cartoons a week," compared to the time, one cartoonist noted, when they used to buy thirty or forty and remind you to come back next

week. Look, reported the article, usually ran less than a dozen cartoons in any issue.

I remember getting a sweet shock of success on the last Wednesday of December 1968, when Jack Flagler, Look's humor editor, congratulated me when I came in.

"For what?" I wanted to know.

"You—and two others," said Flagler, "were the top-selling cartoonists at Look in nineteen sixty-eight."

My mouth hung open. I couldn't believe it.

"You're kidding, Jack," I protested. "I sold you only nine cartoons all year."

"That's right," smiled Flagler, "more than anybody else."

That meant about $2,000 for the year for being top seller at Look. A message was seeping through to me. In cartooning, at least moneywise, there was less to success than met the eye.

According to that 1968 Newsweek article, the number of cartoonists had shrunk over the years to about two hundred professional magazine cartoonists, some working for trade journals and specialized markets, while others sold to the major markets and supplemented their incomes with cartoon-related work.

Things soon got even tighter. Early in 1969 the Saturday Evening Post bit the dust, to be followed late that year by the supposedly unsinkable Life, which a few months earlier had run a six-page groundbreaking (I thought) combination photograph-and-cartoon satire of mine on the New York Mets. A few years later, Look joined the magazine graveyard.

On July 19, 1972, the *Wall Street Journal* ran a front-page article entitled "A Dying Art: Cartoonists Dwindle As Big Magazines Fold," which focused on the work of Lee Lorenz, the popular New Yorker cartoonist who would shortly succeed Jim Geraghty as the magazine's art editor.

"Magazine cartooning is a precarious field these days," the article stated, pointing out that there were fewer and fewer magazines to sell to, citing the demise of the big generals and the drop in usage in others. In addition, as Jack Flagler noted, a "new breed of magazine art director looks with disdain on cartoons because they think they spoil the so-called look of the magazine . . . a triumph of form over substance."

Even the traditional Wednesday lunch was af-fected. The Washington Post, on January 23, 1972, glorified "Cartoonists' Elite clubby lunches," in a selectively affectionate article about The New Yorker being the "just one stop" remaining on Wednesday rounds. While there were very few places to go, it said, "there were still cartoonists' lunches in New York every week, one on Wednesday and one on Tuesday, starting from the outer office of New Yorker art editor James Geraghty." The Tuesday lunch was called the A-lunch, usually attended by cartoonists who had been with the magazine at least twenty-five years, and was held at the Lobster restaurant; the Wednesday lunch, mostly for the younger set, was the B-lunch at the Blue Ribbon. Geraghty presided over both lunches, and only occasionally did cartoonists from one group eat with the other group.

My own fantasies about the cartoonists' lunches were that they would be something like the famous Algonquin affairs of the early New Yorker days, attended by Dorothy Parker, George S. Kaufman, Robert Benchley, Marc Connelly, et al., where the conversation was always incredibly bright and funny. As usual, reality was different. Although they were certainly not without a superabundance of witty remarks, I found the table talk at the B-lunches more serious than I expected, concerned with worldwide political issues, the question of whether cartoons were, or should be, as foolishly funny as they were in the "old days," or should have some anger and social message to them, and what this meant to selling them—as well as unbelievably unglamorous topics such as the chores of everyday life. I remember listening in amazement to a heated discussion, led by Dana Fradon, about how to handle an infestation of gypsy moths. Somehow, I couldn't imagine Dorothy Parker even *knowing* what a gypsy moth was. The lunch conversation continued to stress practical notes, and a few years later cartoonists' concerns with dwindling markets were joined by the more fundamental question of where to have lunch, as first the Lobster, then the Blue Ribbon, then, most recently, the Teheran went out of business. It seemed that the gods were trying to tell us something.

But cartoonists are like phoenixes—they always seem to rise again, demonstrating adaptability and resourcefulness, a certain survivability; indeed, perhaps part of the excitement of cartooning is that you never know what is coming next. So today there are still somewhat regular Tuesday and

Wednesday cartoonists' lunches, only we're not sure where.

Considering the buffeting and the difficulties cartoonists constantly deal with in the marketplace, to say nothing of the rigorous demands of the craft itself, I sometimes wonder what kind of person a cartoonist is.

Joe Kubert, a cartoonist who runs a school of cartoon and graphic art in New Jersey, says that what's most important in a potential student is commitment. Cartoonists, he says, cartoon because "they're compelled to do it." Several other cartoonists agree that if they weren't doing it for a living, they'd do it anyway. "Generally," says Kubert, "a person who wants to be a cartoonist is a loner, somebody who wants to be in a world by himself," and has the abilities to create that world, or other worlds.

Opinions from other cartoonists support this theme and even stretch it a bit. Dana Fradon says that Jim Geraghty once observed that "all cartoonists had difficult births." Fradon himself thinks that cartoonists are "basically antisocial, rather liberal or left of center, with a skeptical but not cynical point of view about most things."

Sam Gross finds "the most common characteristic in cartoonists is their sense of independence and distaste of rules and regulations. I assume most of them were thrown off school projects just as I was, and that's why I get along with them so well."

Bud Handelsman has "noticed that many cartoonists are left-handed Scorpios. However, I happen to be a right-handed Aquarian. They have no common personality traits, apart from a healthy paranoia, but most of them are brilliant and charming."

Chuck Saxon thinks that "they're all misanthropes; they didn't do that well with baseball or girls, and so they became observers. They also all work very well alone; some people can't stand being alone at all." In Lee Lorenz's words, cartoonists are mostly "private people, who generally lead rather reclusive lives, and who see themselves as outsiders." But they can't be overly shy, he adds. "If you're too paranoid, you can't succeed."

Picking up that note, Bob Weber feels that cartoonists are "depressive—prone to depression and gloominess," a form of reaction to the world around them. Perhaps it's true that "Wednesday's child is full of woe." Ed Koren says that he became a cartoonist "because I'm so angry, in a pervasive way; so cartooning is a vehicle for my anger. All cartoonists should have a degree of anger within them—after all, they hold human behavior up to ridicule."

Jack Ziegler, on the other hand, states that "all cartoonists are diametrically opposed to one another and the only thing they have in common is that four or five of them have sense enough to wear sensible shoes."

Personally I find that cartoonists are people who like to be in charge of things, to have a sense of being in control not only of their own lives, but of other people's too, and who feel it's important to do things in their own way.

Commenting from an editor's viewpoint, Jerome Beatty, Jr. says that he "never envied a cartoonist. They'd have to sit up all Tuesday night to get a batch for Wednesday morning; force themselves to sit there and think of something amusing." If they had a common trait, he says, "it would be a terrific combination of humor with perseverance; they don't really go together. Cartoonists are always being rejected. You're in a business where people are telling you *no*—what you did is no good; it's a terrible blow. They need a kind of toughness that goes with a soft and happy attitude. . . . They all had good senses of humor and were *fun* to be with . . . much better than writers or actors."

The paths to becoming a professional cartoonist are varied. Some were cartoonists almost from birth. George Booth: "I became a cartoonist because I cannot remember wanting to do anything other than to *be* a cartoonist." Chuck Saxon: "Every cartoonist I know has *always* been a cartoonist, with the exception of Whitney Darrow, who didn't start drawing until he went to college." Bud Handelsman: "I became a cartoonist because of an inner compulsion to do so; and the frustrations are such that anyone who lacks this compulsion had better try something else." Charles Addams: "Cartooning is all I know, I suppose. This is what I'm suited for. I'm like a cow giving milk."

Others arrived through a kind of gravitational pull. In 1939 Mischa Richter was a painter who "felt the art gallery was too slow" and thought he could make a living drawing funny pictures, like Bill Steig. (Steig says he became a cartoonist "by accident," when he began drawing to support his family in 1930.) Sam Gross knew, "even when I was

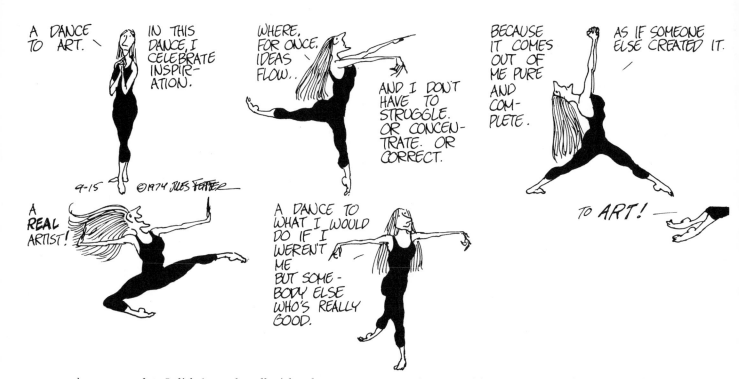

A DANCE TO ART.

IN THIS DANCE, I CELEBRATE INSPIRATION.

WHERE, FOR ONCE, IDEAS FLOW...

AND I DON'T HAVE TO STRUGGLE. OR CONCENTRATE. OR CORRECT.

BECAUSE IT COMES OUT OF ME PURE AND COMPLETE.

AS IF SOMEONE ELSE CREATED IT.

9-15 ©1974 JULES FEIFFER

A REAL ARTIST!

A DANCE TO WHAT I WOULD DO IF I WEREN'T ME BUT SOMEBODY ELSE WHO'S REALLY GOOD.

TO ART! —

quite young, that I didn't work well with other people. I realized that in order to survive in this world and make a living I'd better find something to do where I could work alone and clown around at the same time." Bob Weber was a fashion illustrator for about five years, "and I did a lot of freelance work . . . and I really got to hate it. So I was diddling around, trying to find something I would like to do and I started cartooning and I knew right away that was for me." Joe Mirachi, while studying painting, "became acquainted with several cartoonists, and started drawing cartoons to make some extra money."

Frank Modell remembers the time when, as a kid sick in bed, he was given crayons and some hotel stationery to amuse himself, so he started to draw. To his surprise, he says, everybody thought his work was wonderful. In his cartoon book, *Stop Trying to Cheer Me Up*, he writes: "My Abraham Lincoln copied from a penny drew raves. In school there were certain subjects I could never seem to master, such as arithmetic, English, science, geography, music and history, and on the playing field I was always the last one chosen for softball or touch; so I decided to hang on to drawing pictures. Only years later did I discover that I was a cartoonist."

"I'd been working at jobs for other people for ten years," says Jack Ziegler," and decided to try my hand at writing. It was slow going so I figured

maybe I could support myself and my family by doing cartoons at night . . . It turned out, much to my surprise, that I enjoyed cartooning more than writing."

Lee Lorenz planned to be a painter and art teacher after graduating from Pratt Institute in New York, but ran out of money and needed to generate some income. A comic strip artist named Jack Morley, who drew "Barnaby," had seen his drawings and "suggested that I might want to give cartooning a try. I didn't have anything else better going, so I did. So I sort of backed into it."

In my own case, I had worked in words and pictures in one way or another for about eight years. I was a publicity writer, a newspaper reporter and a magazine advertising promotion director. In sales promotion, while I enjoyed creating ideas for all varieties of selling aids and doodling them for the art department, I couldn't have cared less whether or not the ad lineage went up. I also was increasingly unhappy taking orders from bosses and following a nine-to-five routine.

I had done cartoons for my college newspaper, just for kicks, and now I thought about doing it professionally. I'll give freelancing a good shot, I thought, and if the editors tell me my stuff is no good and throw me out, I'll go back to sales promotion content, with cartooning out of my system. So I left my job and went to live in Mexico, because it

was the cheapest place I could think of and I spoke a bit of Spanish. I stayed a year, practicing drawing and writing on my own, and finally submitting work through the mail. When I made a couple of sales, I decided it was time to return home to New York and try making it in the "real" world.

To assure myself of some kind of income, I found a freelance job at Dude and Gent magazines, reading "slush," or unsolicited manuscripts, for the editor, Nat Lehrman (now the associate publisher of Playboy). I thought the magazine's cartoons were awful and told Lehrman so. His response was to appoint me the cartoon editor, charging me with acquiring better material.

So I wrote and phoned cartoonists whom I admired and invited them to submit their work. To my surprise (the magazines were "girlies" and paid only twenty-five dollars a drawing), they showed up. And that's how I met and became friends with such cartoonists as Ed Fisher, Brian Savage, Donald Reilly, Bud Handelsman (who was just leaving his advertising agency art job to live in England), Ed Koren, Dick Guindon, Bill Murphy, Sid Harris, Lenny Herman and writer-editor Bob Abel, just beginning his lifelong friendship with cartooning through his magazine, Ad-Lib.

It was Herman who informed me of the Wednesday ritual and assured me that it would be perfectly all right if I, a beginner, took a batch of roughs up to the Saturday Evening Post. Which is what led me to that doorway.

The editors didn't throw me out, and while I've lived a high-risk freelance life since, and have worked in practically every form of cartooning, I haven't been back to sales promotion or had any other regular job for twenty years. For me, that's success.

As you no doubt realize, Wednesdays in the eighties are unlike those of the fifties. Sam Gross says that before the upheavals that occurred in the magazine field, cartoonists were typed according to their work. "There were magazine cartoonists, syndicated strip cartoonists, animators, advertising cartoonists, and so on." But after the big changes, "those magazine cartoonists who survived were able, in addition to doing magazine cartooning, to do almost any other cartooning also. At this time, I don't know anybody who is exclusively a magazine cartoonist. In nineteen sixty-four there were a lot of them."

Gross remembers visiting about fourteen magazines on a Wednesday in the sixties. "Now, on a busy Wednesday, I might go to five magazines, and sometimes I just go to The New Yorker and go out to lunch with the other cartoonists I meet there. However, because of the habit of going around on Wednesdays, I have usually lined up other appointments on that day. It might be a book publisher, or an art director at an advertising agency, or I might be trying to sell a poster or other merchandise items."

Wednesdays for Gross and most professional cartoonists now mean much more besides magazine gags. And this is the way it will be for cartoonists just entering the field.

My intention in this book, then, is to tell you what's it's like *in* the box—the magazine gag—and *out* of the box—the other cartoon-related fields, sharing with you my own personal experiences and those of my friends and colleagues. My main focus will be on the magazine gag; I think that if you master the one-panel form you can work in any other cartoon form. This discussion comprises the first section of the book; the second covers the half dozen or so most popular "other" fields which my colleagues and I have worked in.

And so, paraphrasing the title of a television sit-com of a few years ago, based loosely on the life of the inimitable cartoonist James Thurber, this is our world . . . and welcome to it.

2

"What Kind of a Pen Do You Draw With?" Some Words About Materials

Among the attractions of cartooning as a profession are low overhead and absence of technology. The cartoonist needs no complicated tools nor engineering degrees. Some paper, pens, a brush and ink will do it. You can be outfitted for your career in an hour, for twenty dollars. Still, choices must be made.

The question, "What do you use to draw with?" is asked by students of cartooning more than any other, with the possible exception of "Where do you get your ideas from?" Beginners believe that if they use the same tools as the professional does they'll achieve the same results. Wishful thinking. I've sketched with the same Hunt Globe Bowl pen point that Ed Sorel uses, but I'll never produce a drawing that looks like his.

The quality that distinguishes a Sorel drawing from all others is *not* a Globe Bowl pen point; it's Sorel. The only tool a cartoonist should really be concerned with is his own mind, a special way of viewing the world that is peculiar to him alone. That unique sensibility will dictate what you will draw with. Tools should merely be a conduit that eases a smooth flow of ideas between you and your audience.

Today's cartoonists use anything that works for them. "Very often, an idea or a job will suggest a particular medium," says Mischa Richter. "For example, carbon pencil suggests the humanistic, while pen and ink is for allegoric or more kooky stuff. It also depends on the size the drawing will

be reproduced; I'll use Wolff pencils for larger drawings like ads, and mostly pen and ink for The New Yorker." Frank Modell is another who draws in pen and ink, brush, wash, pencil, felt tips, whatever is at hand. Frank claims it's comforting to know he can get stuck just as easily doing a drawing in pencil as in ink.

There are actually so many tools and materials available today that it's hard to keep up with them all. Drawing papers, for starters, differ in being either rough or smooth, heavy or light. For pen and ink work, the usual paper is one with a hard, smooth surface that permits your point to slide fluidly, without grabbing and stuttering, on which the line doesn't spread. Try ledger paper, bond, vellum and bristol, in both kid finishes, which are slightly textured, and plate finishes, which have a slick, sometimes slippery surface.

I used a two-ply Strathmore plate for drawing my comic strip, "Koky," since I needed a sharp, crisp pen line for newspaper reproduction. Mischa Richter prefers a paper that has some "tooth" to it, that will cause little interesting "accidents" in the line and also prevent his pen from skidding during his high-speed drawing. Ed Koren likes a French paper called Rives. "I like the wooliness of its texture," he says. "You can scrub with a pen and get a quality I like." Joe Mirachi, who combines washes with his pen and inks, likes a rough watercolor pa-

"This should be rated 'R.' Some people can lip read, you know."

per. The bumpy surface invites interesting "dry brush" effects and different pen strokes.

If you're working in pencil—lead, charcoal, carbon, grease—the conventional choice is rougher-surfaced paper that will bring out the tones of the pencil line. Try charcoal papers made with pebbled surfaces that range from fine to coarse. Visualization and layout paper, kid finish bristol, newsprint, bond and rough sketching paper also are recommended for pencil.

Chuck Saxon says he used a Strathmore for his richly textured carbon pencil drawings but now he works on an inexpensive lightweight (Bientag) visualization paper through which he can see easily without using a light box. Laying new sheets over the old, he redraws the original rough in successive versions until it's refined to his satisfaction. The final drawing is then dry mounted (a process requiring a special machine) on an illustration board. The drawing must be mounted first; otherwise the paper will curl when it is sprayed with fixative.

Curling often occurs in wash drawings, too, which is why heavier paper is recommended for this medium. Try your first wash drawings on watercolor paper of varying weights and roughness of surface, then on two- or three-ply kid finish bristols, rough sketching bond with a high rag content and on illustration board. All of them should resist curling or crinkling and should absorb water, allowing your wash mixture to flow smoothly and spread evenly. The result will be soft, subtle changes in tone. (But that will happen only after years and years of practice.) For example, study these beautiful wash drawings of Lee Lorenz (page 22), Charles Addams (page 23) and Barney Tobey (page 24). Notice how they differ as a result of using slightly varying techniques and paper.

Lorenz creates his lush washes on a medium weight inexpensive (Aquabee) all-purpose sketching paper that has a slight tooth to it. He works rapidly with the paper very wet. The trick in his technique is to lay a wash tone down in a single stroke and then have the courage to leave it alone. You also have to *know* how dark or light that tone will look when it dries, and how it will reproduce. Not simple.

Addams works on a very heavy (more expensive) Wattman illustration board, which permits him to wet the same areas again and again without having the board curl. Addams's technique is much slower and more deliberate, requiring a different kind of

"Evolution's been good to you, Sid."

control. Barney Tobey's art may be somewhere between those of Lorenz and Addams. His washes are done on two-ply kid finish Strathmore, a paper with a texture that is heavy enough to accept several tones layered over each other without curling, and smooth enough for a loose pen and ink drawing underneath. Other cartoonists prefer to do wash drawings on smoother bonds and bristols because they like the hard edges they get.

For practice sketches and even for doing roughs for submission to markets, an ordinary 8½-by-11 inch twenty-pound bond typing paper is fine. The surface will take any technique well enough, even light washes, and the size is the easiest to handle for both editors and postal people, who need things to be made as simple for them as possible.

I have been using just one kind of paper for almost every medium, for both roughs and finishes. It's a Morilla bond paper that comes in a convenient spiral binding, and is described on the cover as being suitable "for pencil, ink, Conte crayons or Wolff carbon pencils, etc." It's also inexpensive which, I've discovered, is a quality which many cartoonists find attractive. There's a tendency to tighten up when facing an expensive piece of

blank paper because you're apprehensive about making a mistake and ruining it. With cheaper paper you're loose and the drawing flows, because if the drawing does *not* work, you don't worry about tearing up the paper and starting all over. So beginners should know that it's really all right to use inexpensive paper, particularly if your approach is to do thirty spontaneous drawings in order to get exactly the one you want. By the same token, it's also okay for you to use expensive sheets, if you work deliberately and go over the same areas. Like Ed Koren, who scrubs at a drawing and then uses a razor blade to scrape away his inked mistakes because he doesn't like white paint. Richter does the same thing.

Ultimately, the only way to choose drawing paper—and any other material—is to try it out. To keep the comparisons valid, make the same drawings with the same implement on each sheet. And switch around until you find a combination that flows easiest and produces the most pleasing effect. And stay with that for a while. But don't lock yourself into one combination. You must be flexible, not only in the spirit of experimenting with new media, but because manufacturers sometimes do strange

"There's no cause for panic, Mrs. Munson, but, frankly, there are certain indicators that cannot be ignored."

"WHAT KIND OF A PEN DO YOU DRAW WITH?" SOME WORDS ABOUT MATERIALS

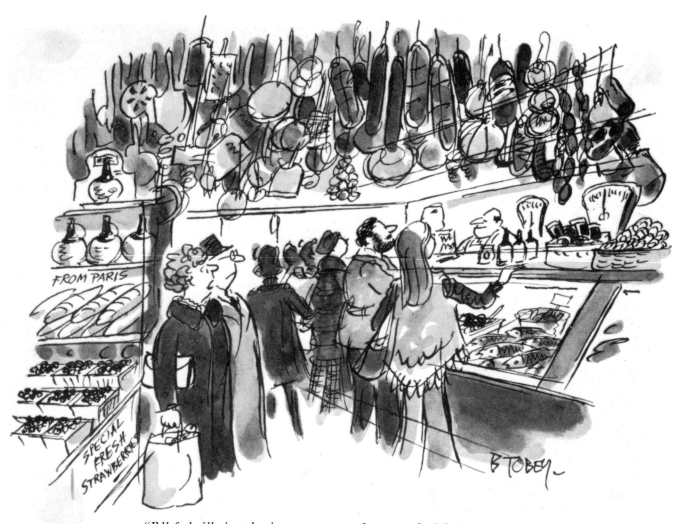

"I'll feel silly just buying a quarter of a pound of Swiss cheese."

things with their products. Ask Donald Reilly about how his favorite carbon pencils suddenly started crumbling in his fingers as he used them, prompting him to switch to charcoal. Or ask Dana Fradon about how his favorite brand of felt tip markers mysteriously disappeared from the stores one day.

This leads from the paper to draw *on* to the implements to draw *with*. The most common drawing instrument is a pencil, in all its incarnations. Pencil is spontaneous, bold and has texture. It is also non-threateningly familiar. Beginners might start sketching with a soft (2B–6B) lead, because it elicits a looser line and encourages a free flow of feeling. I've done finished drawings with an Eberhard Faber Ebony, jet black extra smooth, #6325. A

graphite lead, it gives a good black line and you can produce halftones by rubbing and not get too messy in the process. The harder leads (2H–6H) give lighter, more precise lines, suited for tracings and more exact drawing. Experiment with a number of different pencils, doing the same kind of drawing with each until you find one that feels just right for what you're doing.

You might use a medium soft HB or B for foundation sketches that you'll ink or paint over. If you don't want it to show in your final drawing, this pencil line is easy to erase. For foundation sketches you might also use a blue pencil. Blue doesn't photograph in black-and-white reproduction, so you won't have to bother erasing the sketch lines. I found that a great timesaver when I drew my comic strip. I used a blue Col-erase #1276 to draw every-

thing, including the lettering. It's soft enough to keep the drawing loose and yet not so soft that the line is fuzzy and hard to follow when you're inking over it.

Carbon and charcoal pencils offer a wide range of blacks, tones and textures. As always, there are variations, depending on who's using it and on what. Study the drawings on pages 26, 27 and 28 by Chuck Saxon, Bob Weber, Ed Fisher and Whitney Darrow, Jr., and notice the similarities and differences of artists using the same tools.

Saxon works with Wolff carbon pencils of varying softness. They give him a clean black line, soft gray lines and a complete range of light and dark tones, which he builds up in stages. Weber draws with soft Swiss charcoal sticks which are extremely responsive to his lightest touch. He usually uses a smooth Hammermill ledger paper (sometimes you can spot the watermark in relief) that smudges easily for flat grays and produces a fuzzy-soft stroke.

Ed Fisher, having worked for years with pen and then with brush, is now drawing with Wolff pencils, because "there are so many more things you can do with them." Darrow uses everything at once—Wolff pencil, charcoal sticks, Nupastels, smudges, scribbles and even a loose watercolor wash over the whole drawing. Donald Reilly gets his forceful effects with a Blaisdell charcoal pencil on a 32-pound ledger paper.

Besides carbon and charcoal, beginners should acquaint themselves with other pencils, like Conte crayons, Blaisdell China markers, Stabile pencils and litho pencils. Each has a slightly different feel, which may prompt you to use them in combinations, such as a soft charcoal for a rubbed background and then a carbon pencil drawing over it. Try them on different papers, too. You'll notice that the charcoal line on the slick plate finish gives a totally different effect than the same line on rougher kid finish.

Incidentally, don't forget the fixative for your charcoal drawings. Get a can of the workable type (Krylon is popular) and spray as you work, to prevent smearing. And make sure the window is open when you do; the stuff is as friendly to your lungs as cigarette smoke. Weber used to wear a mask; now he takes his drawings outdoors to spray them.

Pens vary primarily in their flexibility—how much thickness and thinness in their line. Your

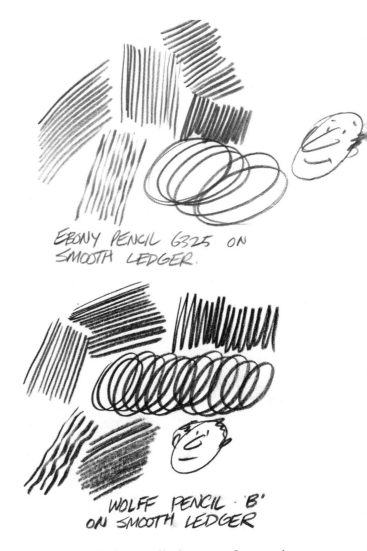

EBONY PENCIL G325 ON SMOOTH LEDGER.

WOLFF PENCIL 'B' ON SMOOTH LEDGER

local art store will have a display case of pen points. Pick up a few and test their stiffness against a counter top. Try a Gillot, a Hunt #99, #22, #56, a Globe Bowl Pointed and Extra Fine Bowl Point, #512 and #513. The stiffer the point, the less variable the line will be. A crow quill point will give you a hairline with light pressure and a thick line when you lean on it. The Globe Bowl Point seems to be popular. If you draw rapidly, it doesn't catch and

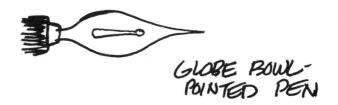

GLOBE BOWL-POINTED PEN

"It all boils down to this: You can forgive but you can't forget, and I can forget but I can't forgive."

splatter as easily as other points. Ed Sorel draws with one "when I want a more delicate line." Barney Tobey uses one. Ed Frascino picks an Extra Fine #512. I used it to draw "Koky," and for waterproof ink cartoons that will have wash and watercolor over them.

Bob Weber (left) does his finishes with a very soft Swiss charcoal stick on smooth ledger paper. Ed Fisher (below) works with Wolff pencils of varying degrees of softness.

"You can start on Monday, Miss Creel. No bluejeans."

Bud Handelsman's choice is "a Hunt #107 nib, which is stiffer than a crow quill and gives me the control I want. Normally, I have two or three on hand with varying degrees of newness. The newest one produces the thinnest line."

Then there are Speedball pen points, designed for lettering, but also used for drawing by many professionals. The pen holds more ink than ordinary pens, so you have to dip fewer times between strokes. The points come in four different shapes: A is square; B is round; C is oblong; and D is oval. Each group has points ranging in size from number 6, which is the smallest, to 0, the largest. The points are fairly stiff and always produce the same kind of line. The C point automatically creates thick and thin lines with your natural hand strokes, while the round B gives a uniform width. Sorel uses a B-6 "for most jobs." Bill Hoest alternates a B-6 with a crow quill. Ed Koren draws his hairy creatures with an A-5 Speedball point, which is *not* broken and bent out of shape, contrary to a fiction

"Honestly! Some days you can't say <u>anything</u> to <u>anybody</u> that isn't construed as interference in the internal affairs of sovereign nations!"

"WHAT KIND OF A PEN DO YOU DRAW WITH?" SOME WORDS ABOUT MATERIALS

"We're all out of van Gogh Yellow. How about Veronese Green?"

invented by Calvin Trillin, the writer and Koren's sometime collaborator.

Mechanical pens like the Rapidographs produce unvarying lines. There are different thicknesses, from 0, the finest, to 6, the heaviest. The pen has an ink reservoir and so requires no dipping. It does need occasional tapping and shaking, though, since the ink flows through a tiny cylindrical point and tends to clog, particularly if you don't use the fountain pen ink made for it, and if you don't clean it regularly. I used Rapidographs when I first began sketching and found that they worked very well in contour drawings when the pen was kept in continuous contact with the paper and moved slowly.

When I sketched faster, though, the pen didn't perform as well, since it didn't produce a line in-stantly on contact. It also tended to skip because of the uneven pressure I put on it, and perhaps because of the paper I used. (Notice the broken-looking lines in the doodle.)

Many cartoonists and illustrators use the mechanical pens with great success, like Shel Silverstein, who combines points of different thickness in his drawings. Jack Ziegler uses "a Rapidograph with a #2½ point and Pelikan ink. I used to have a smaller point but lost it one day when it disappeared down the Disposall as I was cleaning it (although I complained loudly, I was actually glad to see it go—you have to clean the smaller ones *all* the time)."

Fountain pens are favorites of other cartoonists. The fountain pen enables you to work rapidly, without interruptions for either dipping or shak-

ing. It also has a flexible point for a thick and thin line and, after years of being leaned on, actually modifies itself to your personal touch. Cartoonists who rely on them *never* let anyone else use them, for fear of upsetting a balanced line. I drew my first few thousand cartoons first with an Ultraflex, a German import whose point screwed up and out, then an Osmiroid, and liked them both. They were also wonderful for on-the-spot sketching. Among the fountain pen cartoonists are Jules Feiffer and Joe Mirachi, who both use a Pelikan; Arnie Levin, who draws with an Esterbrook or a Rapidograph; and Ed Koren, who sketches with a Mont Blanc.

One more note on pens: George Booth draws his cats and dogs and other people with an ordinary, everyday medium black ballpoint Bic pen. And Bob Blechman, he of the precise, spidery, quavering line, often uses, in addition to the classic crow quill, a felt tip called a Penstix Number 3013 EEF (extra-extra fine).

Recently, for practical reasons, the fiber or felt tip markers have been adopted by a number of professional cartoonists as their primary drawing instruments. For one thing, felt tips are much faster to work with. I found them the best for on-the-spot reportage assignments, when I had to sketch people in action. Felt tips have the comfortable feel of a pencil. There's no need to dip them or fill them. Just draw and when they dry up, fling them away. They can be timesavers, too, if you tend to drip or spill ink on your drawings. The felt tips also come in a range of sizes, shapes and stiffness,

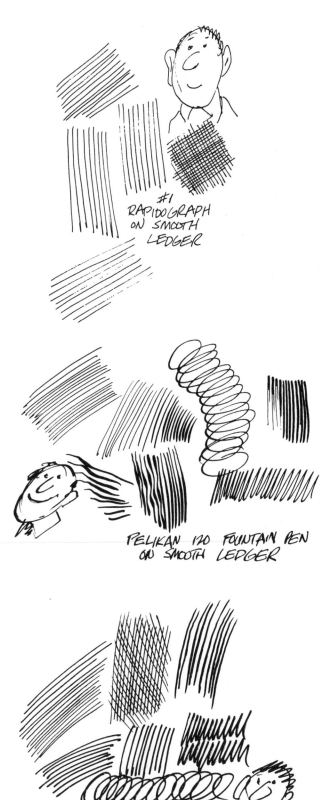

#1 RAPIDOGRAPH ON SMOOTH LEDGER

PELIKAN 120 FOUNTAIN PEN ON SMOOTH LEDGER

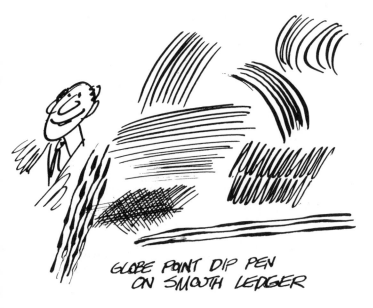

GLOBE POINT DIP PEN ON SMOOTH LEDGER

#EF PENSTIX ON SMOOTH LEDGER.

allowing you to produce effects comparable to any traditional pen line.

Many strip cartoonists use them for these reasons. Jerry Dumas, after working with standard pens for years, now draws "Sam and Silo" with a Sanford Expresso Fine Point and does lettering with a Pilot Razor Point. Mell Lazarus uses a Pilot Razor Point for "Miss Peach" and "Momma." I put in blacks and did all strip borders with an Eberhard Design Marker, 229-LF.

Be aware that some smear; so you can't sweat or cry over your drawings. There are also some that bleed and can't be covered over by white paint, so you can't make any mistakes with them. Dana Fradon draws all his cartoons with felt tips, and adds the halftone washes with gray Design markers. Henry Martin also uses gray Design markers for halftones, having switched from conventional watercolor washes. Frank Modell and Jim Stevenson have drawn with felt tips, not only in cartoons, but in children's book illustrations as well.

"You look like a million! What's the occasion?"

Sometimes a particular job demands nothing but felt tips. Several years ago I drew cartoons on a television news show, NBC's NewsCenter 4. The drawings had to be big and bold enough so that they would "read" on a TV screen in a two-second glance; they had to be finished in color and often had to be completed in thirty minutes. After many experiments I wound up drawing with a big, fat, black marker on treated acetate. Nothing else could have worked as well.

Now what about brushes? A #2 red sable brush is the old favorite for deliberate, detailed inking over pencil lines and energetic dashy effects. Brian Savage uses a small #1 for his cartoons. Jerry Robinson uses a small brush in combination with a dip pen for his "Life With Robinson." Lee Lorenz draws with a #6 brush, a fine, fat instrument that can be loaded up for broad areas and washes and also tapered down to a sharp point for fine lines. Drawing with a brush takes some daring; you should try it, just for the exercise—freehand, with no pencil underneath.

Although there are now many nylon and other artificial material brushes on the market, the sable brush, at about twice the price, is still the better buy. It will perform better, keep a point better, have fewer loose hairs and ultimately last longer. If you use a brush for ink drawings (instead of black watercolor) make sure you wash the brush carefully when you're finished, particularly where the hairs are attached to the metal neck. Dried india ink can ruin a brush quickly by loosening the hairs. You can scrape dried ink off pen points with a razor blade but you can't do that with a brush. If you draw with a watercolor wash, you'll have less trouble keeping it clean.

Drawing inks are of two general varieties, waterproof and nonwaterproof, and are compared as to their blackness, how much they clog and how quickly they dry. (The faster ink dries, the less chance you have of smearing it.) If you're using a fountain or a technical pen, make sure you buy ink that is labeled for that purpose. Periodically flush the pen out with water and some cleanser, like Rapido-eze. You'll need waterproof ink for drawings underneath watercolors, paints and wash drawings. Waterproof ink is also supposed to be blacker and better for reproduction. Supposedly it should never run when you put water on it, but better check it carefully first: you may ruin a drawing. Nonwaterproof ink is the easiest on fountain pens and is faster flowing and better for quick sketching. Inks for all purposes are made by many companies, among them Higgins, Koh-i-noor, Pelikan, Artone, Dr. Martin and Steig. But ink quality can be uneven these days. Handelsman has "the impression that manufacturers are watering it increasingly." I'm now using an FW Non-Clogging India Ink for Technical Fountain Pens for my dip pens and Pelikan Fount for the fountain pens. With the nonwaterproof ink I can brush the lines with water, making them run, and create simple,

"There's a gentleman on the line who insists on speaking with you. He wishes to vow vengeance."

light gray wash drawings that reproduce quite well. My "vow vengeance" cartoon is a good example of this technique, as is my clothing store drawing in the next chapter. Ziegler also uses an ink wash, but he applies it with oil brushes.

Most cartoonists use lampblack watercolor for their wash drawings. The grays are more subtle and the blacks are richer than the ink wash. The Lorenz, Addams, Frascino, Savage and Mirachi cartoons are all done with lampblack washes. Winsor-Newton is a recommended brand.

Full-color work is done in all media. Watercolors used to be standard technique, but now artists are also using acrylic paints, drawing inks, concentrated dyes, colored pencils, crayons, oil paints, colored felt markers—again, anything that feels comfortable. Some are opaque and some are transparent and, of course, the effects differ according to the technique and the paper you're using. The concentrated colors (Dr. Martin or Luma, for example) are quite popular since they're

easy to use, are very vivid and reproduce well. However, some art directors claim they give printers problems because some colors are fluorescent, so get approval before using.

Finally, in addition to your drawing tools, there are some basic miscellaneous supplies. Things like masking tape; push pins; a magnifying glass; a matte knife; a kneaded and a Pink Pearl eraser (but use these only when you're *finishing* a drawing, not when you're beginning it); a ruler (to measure with, *not* to draw with); a pencil sharpener; a sandpaper pad for getting really fine points on charcoal; cardboard stumps, and some cotton for rubbing charcoal; a jar of bleedproof opaque white watercolor paint; a tube of lampblack; a metal palette; and, of course, that universal cure-all, rubber cement, for making corrective patches, pasting together smoothly and for playing with when nothing is going right.

Rubber cement is great for patching, which is

often the simplest way to correct a small mistake on a drawing. Let's say you need a different expression on a character's face. Instead of whiting it out and working over paint (not easy), just draw a new face on a separate piece of paper, cut it to size and cement it down over the old one, redrawing connecting lines where necessary. To make sure the outlines of the patch aren't picked up by the engraver's camera, paint the edges with opaque white. Most cartoonists employ this technique and you'd have to look at their original drawings to believe it.

Another way of using rubber cement in wash and color drawings it to coat areas you don't want painted before you start. When the cement is dry, you can ply your brush with easy, spontaneous strokes, without worrying about coloring the protected sections. When the drawing dries, rub away the rubber cement and the color is only where you want it, without that tight, painted-in look. My favorite use of rubber cement, though, is just handling it, maybe under the pretense of making a "pickup," a ball which is used to pick up other rubber cement, and for general erasing. Pour some out on a hard surface, savoring the aroma, let it dry and roll it up. Then peel the excess dried rubber cement off your fingers. According to some people, it's better than analysis.

As far as larger equipment/furniture is concerned, there is nothing that's really going to make the difference between your success or failure as a cartoonist. If you feel like spending hundreds of dollars for a drawing table that moves simultaneously in many directions, great. If not, be assured that many cartoonists don't work on those official Olympic drawing tables you see in the advertising agencies. A smooth wooden board of manageable size, tilted against a table top, works very well. Eugene Zimmerman, a cartoonist from the 1920s who signed his work "Zim," drew while sitting in a rocking chair with a drawing board resting on his crossed knees. Lee Lorenz works on a drawing pad that lies directly on his lap. And Al Ross once told me that he used to draw his roughs on the subway train while riding down to The New Yorker from the Bronx every Wednesday. The only point to make about what you draw on is that your arm should be relaxed and able to swing easily for long periods of time. A tight arm produces a tight drawing.

Of course you can always use a filing cabinet, but you can get by without a light box, a translucent plastic surface with a light underneath it, used for tracing. Light is obviously essential, though, so get a good lamp that adjusts in all positions, has a reflecting shade and uses regular tungsten bulbs; fluorescents are *not* recommended. Light should come from a source opposite your drawing hand so that no shadows fall on your work. I remember being told that light should come over the *left* shoulder, which I now realize was discriminating against left-handers (whose ranks, some of you will be heartened to learn, are large and include Donald Reilly, Ed Fisher, Brian Savage and Chuck Saxon).

So much for the materials. Try them all, and remember that it doesn't matter *what* you draw with as long as you feel comfortable and you're successful at communicating your idea.

Considering materials to be used for cartooning is somewhat one-dimensional. Considering cartooning itself is another matter.

3

What Is
A Cartoon?

Cartoons? They're the first thing you read when you open a new issue of The New Yorker. Or Playboy. They pull your eye to print ads and television commercials. You find them Scotch-taped to refrigerators, pinned up on office bulletin boards and sometimes in a letter from a friend, covered with the scrawl, "Oh, Harry, this is so *you!*" Cartoons are the most powerful, the pithiest form of human communication, used everywhere and in many forms. They are an integral part of the American culture and you want to learn to "do" them.

A cartoon is totally familiar to you, but do you really know what it is? Webster defines a cartoon as "a drawing, as in a newspaper or magazine, caricaturing or symbolizing, often satirically, some action, situation or person of topical interest." Accurate enough, but if you're looking for guidelines in creating one, ask a cartoonist.

Mischa Richter defines a cartoon as "a visual humorous comment about something that's familiar to all of us." Ed Koren sees a cartoon as "a combination of visual and verbal jokes—Buster Keaton and Henny Youngman—a convention of life turned on end, done quickly and succinctly. If you don't get a cartoon right away, you don't hang around to find out why." Arnie Levin thinks of a cartoon as "basically a story—a moment that's been singled out as different from the next one." For Jules Feiffer, "a cartoon is a form of therapy."

Henry Martin calls a cartoon a "marriage of a

funny idea with a funny drawing." According to Chuck Saxon, "I don't think it's a joke-telling thing . . . a cartoon is primarily a comment or a revelation . . . that shows some of the foibles and ridiculousness about normal life." Dana Fradon says it's "something that is first and foremost funny . . . that illustrates a skeptical attitude . . . a laugh at the truth, contrasted to the sham that people live by." And in Jack Ziegler's view, "my definition of a cartoon is a drawing that tickles me."

As you see, the definitions say the same thing, but differently, varying with the approach of each cartoonist. For the "how-to" purposes of this book, I'll define a cartoon as *instant communication of a funny idea*. It is designed so that a reader will get its message in a glance, in the flip of a magazine page. It's about a six-second experience for the average reader, but if it's a great cartoon, the experience may echo through a lifetime. (Like Shel Silverstein's classic, here.)

A cartoon is a split second in time—the one precise moment in some continuous action that not only perfectly describes that action, but also tells us what immediately preceded it, and perhaps implies what will happen next. Look at Frank Modell's cartoon on the next page. At a glance you know that the witness has been testifying and has said something to annoy both the lawyer and judge. The judge speaks, and then we understand why. We experience a mini-drama, represented by a single picture. The drawing does not move, but it surely is not a still life.

It's simple looking, but difficult doing. To be successful, the cartoon must be the *right* freeze frame from the movie. If Modell had drawn a preceding frame when, perhaps, the lawyer was objecting to the judge, it might not have worked. The humor here, as always, depends greatly on timing and tension.

In creating a cartoon, the challenge is not only to envision the correct moment, but to reproduce it so readers can see it, too. It's helpful to recognize that within the single-panel cartoon are found familiar elements commonly associated with art and drama. I offer them here only as aids to defining a cartoon and as guidelines for what can go into its creation. The practical approaches will follow.

To begin with, there's the *cast*, the people who perform in the cartoon; the actors. Cartoon

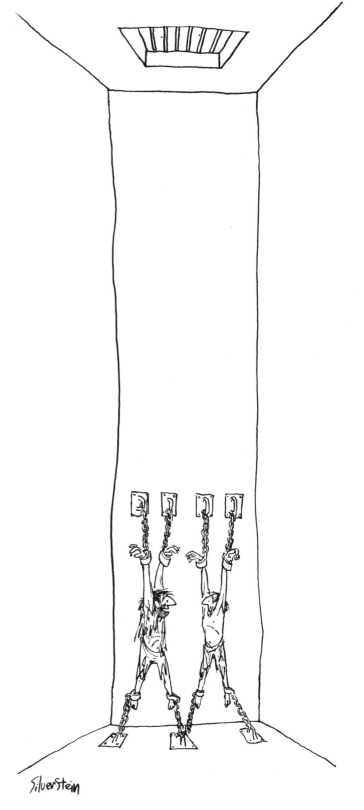

"NOW HERE'S MY PLAN . . ."

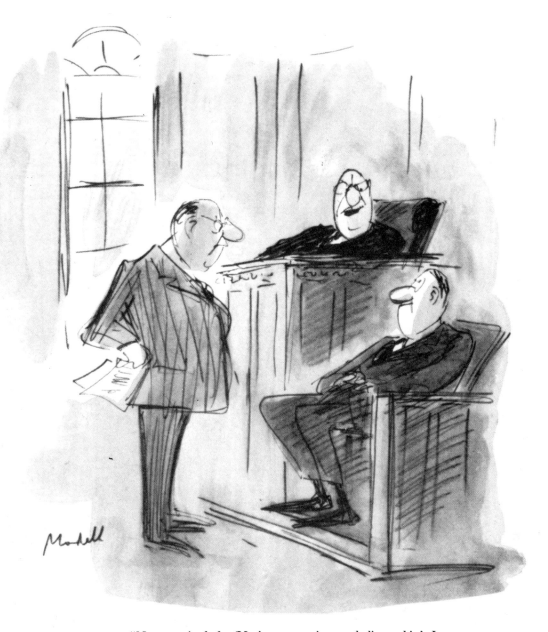

"Never mind the 'You're not going to believe this.' Just answer the question, yes or no."

characters must be of a very specific type. They are people we immediately recognize from life, people we *know*, like Saxon's surburbanites. Cartoon people must *look* the part. Gangsters, professors, salesmen, tycoons must be unmistakably identifiable. To cast the right actor, the cartoonist functions as a casting director and holds "auditions," sketching perhaps thirty faces before he finds the right one. (Sometimes the first is the one that works best, which is why magazines occasionally publish the rough sketch instead of a finished version.) Ed

Frascino "auditioned" at least two dozen ladies—several shown on the next page—before he found the two he liked. Want to guess who got the part? (The cartoon is on page 61.)

Cartoon actors are more than pretty faces, though; they speak *dialogue*, in the form of captions. Here the cartoonist is a dramatist, putting a well-turned phrase into his character's mouth. A cartoon caption is super-disciplined writing—about twelve words painstakingly chosen for their meaning, imagery and sound, then polished and

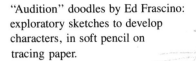

"Audition" doodles by Ed Frascino: exploratory sketches to develop characters, in soft pencil on tracing paper.

strung together in a rhythm that puts the beat on the funny part. Carl Rose's classic little girl frowning at her plate: "I say it's spinach, and I say the hell with it!" Lee Lorenz's departing churchgoer to the minister: "Just between us, Doctor, how much of that stuff is cast in cement?" Or Donald Reilly's fourteenth-century nobleman looking critically at his portrait and telling the artist, "Give me more angels and make them gladder to see me."

Cartoon actors not only look and speak the part, they move in character. This is the element of *gesture*, the facial expressions and body language, the physical acting which helps convey the sense and mood of the cartoon, even before you "get" the situation. A mere glance at Modell's lawyer and judge convinces you they're annoyed. Look at the postures of Saxon's couple, with arms and legs crossed, chins in hand. You *know* they've been having a quarrel. Their gestures provide a solid frame for the caption.

The action of a cartoon is always located in some specific place—the consideration of *setting*. The cartoonist chooses the stage which is most appropriate to his situation, where the idea works funniest and most naturally—a bar, an airport, an office, anyplace in time or space. He not only decides *where* his scene is to be played, he draws only the most characteristic features that make it instantly recognizable to readers. Convincing settings play a major role in Saxon's cartoons. Drawing environ-

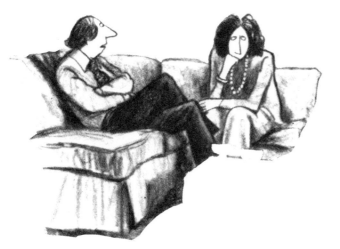

ments is "my pleasure," he says. And, "certainly, environment tells as much about the people as facial expressions." The same holds true for the chaotic clutter of George Price's rooms, the selected litter on George Booth's lawns or the surreal landscapes of Ziegler and Kliban. Settings may also be minimal, as in my clothing store cartoon here.

The element of setting includes a consideration of costumes and props. The manner in which characters are dressed and what they carry are visual tipoffs to their profession, their net worth and any number of pertinent things about their personality. In a cartoon, says Saxon, "the reader has to see what you're doing immediately, and you can do that far more with the way people dress . . ." Clothing distinguishes the panhandler from the passerby. A cartoon doctor has a stethoscope hung around his neck. Professors wear glasses and smoke pipes. Tycoons chew big cigars. Gangsters wear dark shirts and white ties. Stereotypes, of course, but they work.

Now in order for a cartoon to communicate instantly, its components must be artfully arranged within the frame so the reader sees them in a particular sequence. The cartoon's *composition* presents elements in proper order and holds them together. It is the cartoonist functioning importantly as director. Imagine that you're telling a joke at a party. You begin, "There was an old man who couldn't sleep . . ." And you go on to tell what the son said and how the doctor replied, and so on until finally the last thing you utter is the punch line. And everybody laughs. You hope.

Composition in a cartoon is the means by which you tell your story to your audience without personally standing in front of them. Composition is remote control.

Sometimes you don't get a laugh. You may have told the joke wrong. Like delivering the punch line before you fully set up the situation. Humor springs from an unexpected twist. But your audience can't appreciate a twist unless they first know what's straight. Through composition, you use certain optical devices and techniques, like solid blacks and perspective, to direct the reader's eye through the frame so that first he sees the basic information and then the little difference that makes it funny. We'll discuss and practice these techniques fully in Chapter 6; for now, think of the element of composition as telling the joke right.

There are other elements in a cartoon drawing which, while more subtle, are also important, for they add special seasoning ingredients that differentiate and distinguish cartoonists' work. They are *atmosphere, calligraphy* and *texture*—the pure, aesthetic aspects of a drawing. I mean the dark, brooding wash tones of an Addams drawing, the playful line of Levin, the aggressive pen stabs of Richter, Saxon's carbon pencil, Weber's charcoal smudges, Blechman's precise squiggles.

Through atmosphere, calligraphy and texture,

"*Notice how the lapels reflect Wall Street's bold expectations for an economic upswing in the latter part of the year.*"

the mood of the drawing is created, which establishes a certain expectation in the reader. At the sight of an Addams cartoon you anticipate—you look for—some macabre twist; you expect whimsy from a Levin look, zaniness from Ziegler. The mind-set serves to quicken communication of the idea. What the drawing looks like should be consistent with the humor it portrays. A light, fanciful idea should not be given heavy-handed treatment. Different strokes for different folks.

The last element in a cartoon is simple enough to understand but difficult to practice. It's really self-control but I'll call it *selectivity*—what to leave in and what to leave out. Since a cartoon is designed to be read at a glance, it should contain no unnecessary material that might confuse or distract the eye. Every line and word in a cartoon should help to achieve the goal of delivering the message quickly and effectively. It's easy, however, to add embellishments, or emphasize the wrong elements, or put props in the wrong places, without even being aware of it. When I first began making the rounds Jim Geraghty was the cartoon editor at The New Yorker. Once he paused over one of my roughs and shook his head. The drawing was of two female models looking in a department store window. The situation depended on seeing that they were long-legged and chic.

"Look what you did," Geraghty said, pointing to a large portfolio I'd drawn in front of the girls' legs, hiding them and the idea. "It's tough enough to sell cartoons without making it harder for yourself. Don't get in your own way."

The truth is that I still do it, like many other professional cartoonists, but now I'm more likely to notice and correct it before the editor sees it. The last stage of my drawing is done with a brush and white paint, removing lines. Ed Frascino draws freely, knowing that he'll take things out later, calling the white paint process "working in negative space." A good general rule is: *If in doubt, leave it out.* Less is often more.

Cast, dialogue, gesture, setting, composition, atmosphere, calligraphy, texture and *selectivity*. Nine elements of a cartoon. Every professional cartoonist uses them in different combinations, emphasis and varying degrees of awareness. And the way he chooses and blends them results in a tenth consideration, something called *style*. Beginning cartoonists are obsessed with it. "Where do I get a style?" they ask, as if they could find some art supply store that stocked different varieties along with the Strathmore.

A cartoon style, like any other, is simply the creator's personal touch. It is his own particular vision, his voice, his point of view made up of all his opinions, deepest loves and hates. It manifests itself in the subjects he chooses and the way he renders them. It is his preference for satirizing businessmen, black humor, or the way he draws shoes. Style is the sum total of thousands of personal prejudices, and it is achieved by tuning in to oneself and doing what comes most naturally.

Your own attitude of mind is the most valuable ingredient you can put into your cartoons; it is the only truly original thing you have to offer. A new, original voice is always of interest to an editor.

I've defined the basic magazine gag cartoon as instant communication of a funny idea, presented in a single panel that can be likened to a freeze frame from a film of some dramatic sequence. I've also identified ten elements often found in that frame which work together in varying degrees to transmit the message as swiftly and accurately as possible.

And underneath all of this, one simple principle is operating: *A cartoon violates some cliché in life.* A cliché is anything which is so familiar to us that we automatically accept it, almost without notice. "Patterns of life . . . natural rhythms," says Arnie Levin.

Visual clichés are stop signs, escalators, bicycles, telephones. Clichés are also phrases like "How are you," "Have a nice day," "Glad to meet you," "Thanks for coming." Or situations like people watching television, sitting in a bar, driving a car, dining in a restaurant. Cartoon clichés are all the clichés of real life, plus those from memory, like well-known fairy tales, history, mythology, literature—and the imagination, which we can thank for the well-worn desert-island situation.

The cliché is the vehicle of instant communication. The cartoonist uses it to send his message. And the message is in twisting it, turning the cliché around. Adding a new association. Violating the cliché. Like Sam Gross's amusement park scooter ride, which you recognize, but then a blink later you notice that instead of scooters there are tanks cruising around. Or Bud Handelsman's highway scene, with traffic inching past a group of road workers standing around a "Men Working" sign.

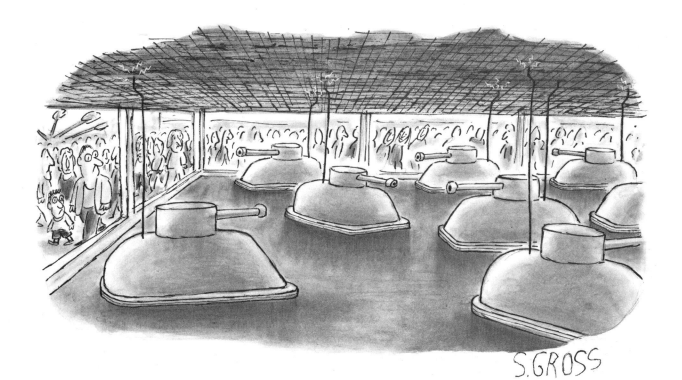

Except that the sign reads, "Men Chatting." Here is my own contemporary variation of a caught-in-the-act cliché.

The cliché is the cartoonist's trap. He attracts the reader's interest with the familiar and then fools him by changing it just enough to make it a surprise—and funny. In words as well as pictures. Like my own galley slave in chains at the oars, replying to a slave driver holding a clipboard, "My vacation? How about the first two hours in August?"

The cliché is also operative in all the elements of the cartoon. The cartoonist casts the actors who most look as though they belong in a particular situation. In captions the cartoonist uses colloquialisms and catchphrases currently fashionable. He directs his actors in gestures and facial expressions that exactly typify the action. And for his settings he uses backgrounds and props that are immediately identified with the scene. The cliché, in effect, is the cartoonist's shorthand.

So much for defining what a cartoon is. Obviously, all cartoons can't be described in these terms, just as cartooning can't be learned easily by following any set of rules; it's too elusive an art form. So don't consider these definitions as chiseled in stone; they're merely points of departure and reference for further study and practice.

And now, let's get to the drawing board.

"My God! My wife! My clone!"

WHAT IS A CARTOON?

39

4
Cartoon Drawing

Before putting pencil to paper let's clearly distinguish cartoon drawing from realistic illustration, and identify its aim.

Basically, a cartoon drawing *suggests* rather than reproduces. It gives an impression, a feeling of its subject instead of exactly mirroring it. Cartoon drawing should be lightly whimsical, not seriously anatomical.

The purpose of cartoon drawing is to help achieve "instant communication of a funny idea." To do this, the drawing favors visual clichés, and distorts and exaggerates them to make them immediately recognizable. Cartoon drawing is therefore unfair.

Cartoon drawing aims to be simple, selecting only the essence of the form, leaving out the unnecessary, allowing space for the reader's imagination, inviting his personal involvement. (Click: "That house reminds me of the one we rented at the beach last summer.")

Compare these cartoon drawings with the realistic advertising illustration. Chances are that your eye was pulled to the cartoons first. No wonder. They're easier to look at. No expertise necessary to participate. They project a relaxed, undemanding feeling that makes them comfortable to be with. Cartoon drawing says FUN.

The illustration of the man wearing a suit concentrates on authoritative rendering of lapels, buttons, and pockets; the drawing is helping to sell suits. The man's face is anatomically accurate, un-

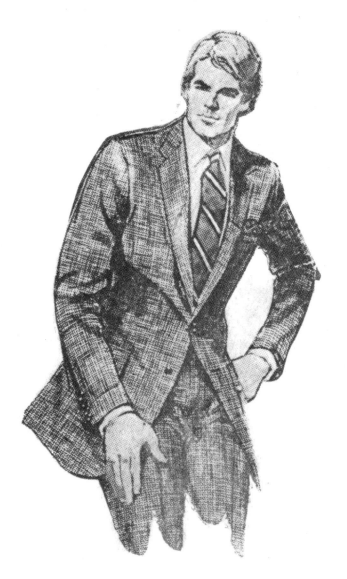

interesting and unimportant. He is a bland model posing; something just to hang a suit on.

In Fisher's and Lorenz's cartoons, though, we get only simple suggestions of "suit" without details, but appropriate-looking for the characters wearing them. Their faces, anatomically *in*correct, are interesting and animated, conveying a personality and emotion. These are actors portraying roles.

The same comparisons hold true between cartoon and realistic drawings of automobiles, bicycles, houses, animals, computers, landscapes.

Cartoon drawing begins where realistic illustration ends. Cartoonists select images from life, then change them in slight twists or in large wrenches, in the service of communicating an idea. Since it is an interpretation rather than a reproduction, cartoon drawing is an opinion, a quiet, subtle comment on all its subjects, a point of view that differs with each cartoonist. Take a moment right now to flip through this book and notice the individual ways that cartoon shoes are drawn. Or ears. The repeated way that a cartoonist draws helps form his style.

Cartoon drawing today is practiced in numerous styles, ranging from the elegant, deep-toned washes of Addams to the dancing light lines of Levin. The first cartoon drawings, though, as seen mostly on the pages of Punch, Judge and Life in the 1890s, were almost all elaborate pen-and-inks. Look at the examples on the following pages from the hands of A. B. Frost, T. S. Sullivant, Charles Dana Gibson and Heinrich Kley.

Hardly simple, they're all involved, intricate, rich in detail. But, of course, that's what life *looked* like in Victorian times, so the artists' styles were merely

A LITTLE INCIDENT.
SHOWING THAT EVEN INANIMATE OBJECTS CAN ENTER INTO THE SPIRIT OF THE GAME.

Upper left: One of A. B. Frost's "Imaginative Animals," a series of ten animal cartoons, in pen and ink from Life, 1921. Excellence in line drawing was a given among artists of the period. Frost's work was characterized by exaggeration of shape and size. The goat's head here is realistically too large for the body, one of the distinctive features of the drawing.

Left: Pen and ink cartoon by T. S. Sullivant on smooth bristol, from Life, around 1900. Sullivant was particularly adept at creating birds and animals with recognizably human attitudes and personalities. Notice the monkey's hat and umbrella hanging in mid-air, to emphasize its shocked response to the tiger.

THE MAGAZINE GAG CARTOON

Above: Pen and ink cartoon by Charles Dana Gibson from Life, 1900. Gibson's drawings were infused with an elegance which perfectly characterized the times. In fact, the idealized look of his women, such as this one, became a standard, popularly known as "The Gibson Girl." Cartoon captions would often be labels, or "inside" explanations of the scene. Others would be conversations or long monologues.

Right: Two panels from a twelve-panel pantomime narrative cartoon sequence entitled "The Fatal Mistake. A Tale of a Cat," by A. B. Frost. The subtle variety of pen line produced a wide range of coloring in the drawings. The great energy and action is created through the facial expressions of the cat and the people, their body language and the way objects flutter, billow and simply hang in mid-air. Long, multi-panel narrative stories without captions, a popular form of the period, perfectly captured the precise moments in time that described the action.

CARTOON DRAWING

reflecting the era. Also, by making such comprehensive drawings, they were producing a form of home entertainment befitting the times—interesting pictures that the whole family could sit and look at leisurely. Remember, these were the days long before television—*or* radio *or* movies.

The humor in these cartoons was less evolved. Captions were two- and three-line jokes, puns, soliloquies and long-winded, ponderous explanations of the situations, For example, a T. S. Sullivant drawing from Punch shows a clothed hippopotamus couple sitting at the dinner table with this caption:

MR. HO: "I lost my balance as the street car started today and sat right on the monkey's lap."

MRS. HO: "Oh, I hope you apologized."

MR. HO: "No, it was too late, but I'm going to send a wreath."

Or, a little later, a John Held, Jr., cartoon from the old Life, of a scantily clad flapper with her slick-haired beau, and this exchange:

——"The trouble with you boys today is you have no imagination."

——"Well, girlie, nowadays we don't need imagination."

As you see, the early cartoons were really illustrations of simple jokes.

By about 1910, though, cartoon drawings had begun to loosen up. This may have been due, in part, to the advent of photography. For one thing, it permitted drawings, through photoengraving, to be reproduced *exactly* as the artist created them, instead of having them copied, through the woodcut process, in which *another* artist hand-cut the original onto a piece of wood, losing much of its individuality and spontaneity.

Also, with photography available to capture pure reality, artists were freed to interpret what they saw and felt, rather than record it realistically. So cartoon artists began using exaggeration and distortion to help get their ideas across; drawings become funnier in themselves, and relied less on jokes and puns.

Bucolic Intermezzo
Schäferstündchen

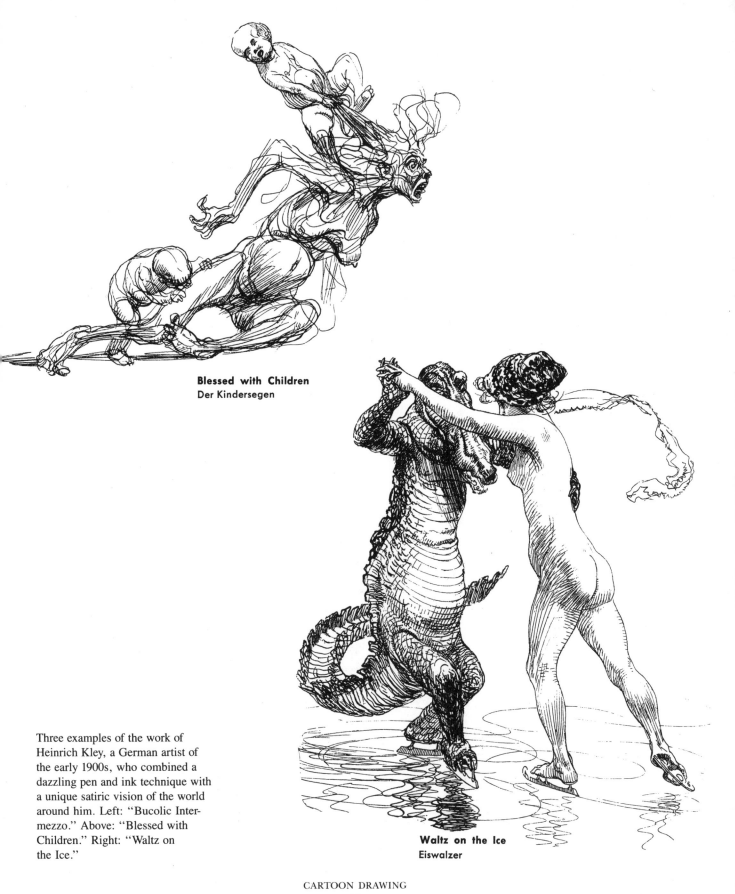

Blessed with Children
Der Kindersegen

Three examples of the work of
Heinrich Kley, a German artist of
the early 1900s, who combined a
dazzling pen and ink technique with
a unique satiric vision of the world
around him. Left: "Bucolic Inter-
mezzo." Above: "Blessed with
Children." Right: "Waltz on
the Ice."

Waltz on the Ice
Eiswalzer

In the 1920s the communications pace picked up, influencing cartoons to become even simpler. There was jazz, with its up-tempos and new forms, and radio and talking movies, all of which taught people to listen to a message and get its meaning *immediately at that moment* before it disappeared. So, following the new, faster national tempos, captions in cartoons were shortened to one line and strived to make their points crisply. And in 1925, The New Yorker was born and became the most forceful influence of all on the cartoon.

At the direction of its editor, Harold Ross, writes Robert Coates in *Contemporary American Humorous Art*, the two-line cartoon joke was ruled out. "In doing so," says Coates, Ross was "striking out at one of the tiredest effects of the then-contemporary humor. He was ruling out vaudeville—rather, one of the things that were even then killing vaudeville." In the printed jokes, "the participants were always pictured facing each other, with the joke printed baldly underneath—like the straight man and the comic in the 'patter' acts in the theater.

"In a broader sense, still, he was ruling out illustration; for what he . . . began insisting on instead was a drawing that conveyed its point so clearly that only a few words on the part of one speaker—or, for that matter, no text at all—were sufficient to round out its meaning; and the result was to make the drawing stand much more solidly on its own feet, pictorially *expressing* the idea instead of merely illustrating it . . ."

And so the one-line "gag" cartoon came into its own. "Instant communication" was at hand.

With it, particularly in the pages of The New Yorker, came even more freedom and individual expression in cartoon drawing. Go to the library and look through the first New Yorker cartoon album (1925–1950) and you'll see a dazzling array of styles and techniques, from James Thurber's crawling, minimal line to powerful crayon drawings by Reginald Marsh.

Trends in cartoon drawing continued towards the simpler and speedier, and in cartooning's golden days of the fifties, a simple, so-called "bigfoot" style of drawing became very popular. Most of the cartoons which appeared in magazines such as the Saturday Evening Post, Collier's and American Legion had this look. Cartoonists like Bill Yates, Tom Henderson, Irwin Caplan, Dick Cavalli and John Gallagher were among the major practi-

THE SATURDAY EVENING POST

"I may have a lot of faults but being wrong isn't one of them!"

THE MAGAZINE GAG CARTOON

tioners. Characteristically, the drawings were simple, stylized and highly exaggerated, perfectly matched to the broad brand of humor they portrayed. And they all looked pretty much the same, as you can see. "You *had* to work that way then," recalls Gallagher. "If you didn't use a number two red sable brush at the Post, they wouldn't let you in the door."

"It's upside-down pineapple-rum cake, thash what it is."

Left: Cartoon by Bill Yates.
Above: Cartoon by Dick Cavalli.
Right: Cartoon by John Gallagher.
All from the Saturday Evening Post in the 1950s.

"I'm sending you in there, Bogwell, because you're the one man on this team whose father is dean of the university!"

In the Caviar Fields

These days cartoon drawings come in *any* form. Major magazines like the National Lampoon, Playboy and The New Yorker are publishing more and more "original voices," pushing the boundaries of cartoon art ever outward. Notice the work of people like B. Kliban, Bob Mankoff, Roz Chast, John Caldwell, Jack Ziegler, Peter Vey, Mick Stevens, Liza Donnelly, Sarah Downs, Chris Browne, Peter Steiner, Dick Cline.

It's interesting to note, too, that just as the historical development of cartoon drawing moved from complex to simple so, too, does an individual artist's work simplify over the years, as he perfects the art of depicting the essence of forms. Often the cartoonist changes his tools and technique along the way. Ed Fisher's early, sketchy pen-and-ink gave way to a brush-and-ink, which was in turn replaced by a carbon pencil. Lorenz switched from a pen to a bold brush.

While there have been trends in cartoon draw-

ing, then, there is no one "right" method of doing it. Anyone who successfully draws cartoons ultimately does so his own way, in his own style and voice. (Of course when you're just beginning, it's sometimes helpful to study and even copy the work of a favorite artist or two, to get the feel of doing it "professionally" and gain some confidence in your ability.) So I'm not going to propose any step-by-step, this-is-the-way-you-should-do-it drawing methods here. Instead, I'll share some approaches that have been helpful to me, my colleagues and my students. And then, within that framework, you do it *your* way.

Learning to make cartoon drawings begins with constant doodling—quick little sketches of anything you see or imagine, in sketchbooks, on napkins, newspapers, packages, envelopes; at a drawing board, restaurant, business meeting, on a bus or in bed. Cartoonists doodle the way athletes work out, musicians play, singers sing.

Robert Mankoff has developed a distinctive "dot" technique of drawing that helps establish his cartoon voice. Roz Chast's cartoons are in a form all their own, reflecting her personal style. Far Left: Cartoon by Jack Ziegler.

"Hey, it's such a nice day I think I'll escape on foot."

Doodling is an activity that exercises and stimulates you on two levels. From the pure drawing viewpoint, it's technical practice and learning. If you make enough sketches of telephones, your hand will eventually get the right *feel* of it—your hand will automatically "know" how to draw a telephone, without your thinking much about it. Or shoes or horses or TV sets. And after thousands of drawings, your hand will have its own memory bank of familiar images; you'll find yourself drawing more easily, more confidently and convincingly, without needing to research everything. You'll also be depicting things according to your personal tastes and biases, the result of which will be your own style. (Nobody, but *nobody*, draws shoes the way Jack Davis does.)

Study this collection of doodles, scribbles and sketches by Modell, Fisher and Woodman. The subjects are both from life and imagination. Spontaneous sketches, like these, are usually done with no specific idea in mind; the act of drawing itself is the important part.

Quick on-the-spot sketches by Frank Modell. Notice how only a few lines are used to capture a gesture.

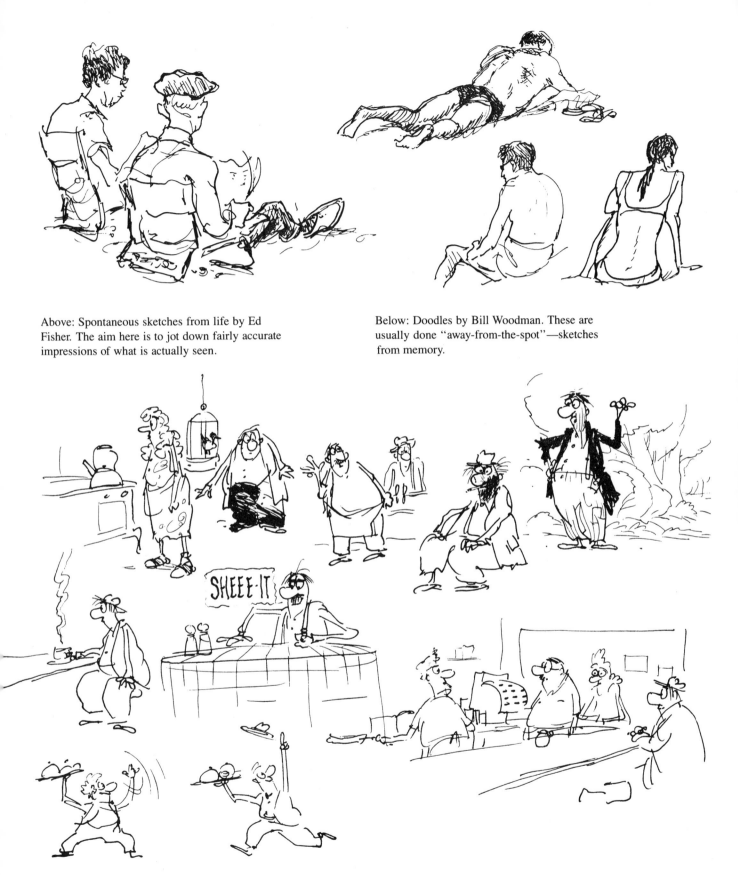

Above: Spontaneous sketches from life by Ed Fisher. The aim here is to jot down fairly accurate impressions of what is actually seen.

Below: Doodles by Bill Woodman. These are usually done "away-from-the-spot"—sketches from memory.

SHEEE-IT

On a second level, doodling stimulates the free-association process which is the core of cartoon thinking. Doodling a dog and then "for no reason" sketching a flower in its mouth might trigger some other association which results in an idea for a cartoon. Many cartoonists consciously do this to create ideas, as we'll see in the next chapter.

Right now, though, we're focusing on drawing. Let's go on, with the same "warm-up" exercise I use in the classes I teach, designed to limber up the fingers and mind simultaneously. This is the way it works.

Without props, a student poses some familiar action and announces what it is. Like shaving, swinging a baseball bat, typing, trying on a coat, anything that's a broad gesture and can be held for three minutes. The model aims to "act out" the pose as realistically as possible; to curl the fingers exactly as they would fit around a bat, to feel the weight of the

crate he pretends to lift, then communicate the frozen action to the rest of the class as faithfully as possible.

The other students begin sketching the announced pose, but must use it only as a departure point for drawing a totally different imagined action. For example, the pose of "hailing a taxicab" may become "holding a subway strap." Or "conducting an orchestra" could turn into "hanging up the wash." The basic physical gesture remains the same, but the interpretation changes. The principle is fundamental to cartooning; you take something from life, then change it into something different, preferably funny.

With a three-minute time limit you focus only on the crucial elements of the gesture and doodle them boldly. The goal is not a good-looking finished drawing, but to perceive and jot down the essence of an action while, at the same time, to free-associate and imagine different "scenes" that "fit" what you see. Don't think, though—react spontaneously, and let your imagination fly as far as it can. The wilder your "rewrites," the better.

It sounds tricky and difficult, but after one or two poses, you'll get the hang of it and I guarantee the results will surprise you. It's your first tipoff to what your own imagination can do if you completely unleash it.

Here are several idea sketches, made in three minutes in class by former students, Michael Quint, Anne Gibbons, Liza Donnelly and Jim Murphy. I've noted the announced pose, which inspired what you see.

Obviously, you'll need assistance from a friend to pose your first idea-sketches. But once you've learned the technique, you can apply it to regular life drawing. Take a sketchbook out to a bus stop or restaurant or park and look for models. Remember, instead of sketching what you *see, change it.* Don't draw the newspaper in that old man's hands; put in something crazier. It doesn't matter what, as long as it's *not* what's there and it fits the pose. Allow only a couple of minutes per pose. The key word is spontaneity.

Practice idea-sketches regularly and you'll soon be doodling without any posed models. And once you're doodling, you're on your way.

Practice *posing* too. Do that in front of a mirror. Acting out gestures helps teach you to draw your characters. Think of a cartoon as a mini-drama, with you directing yourself as all the actors. If you

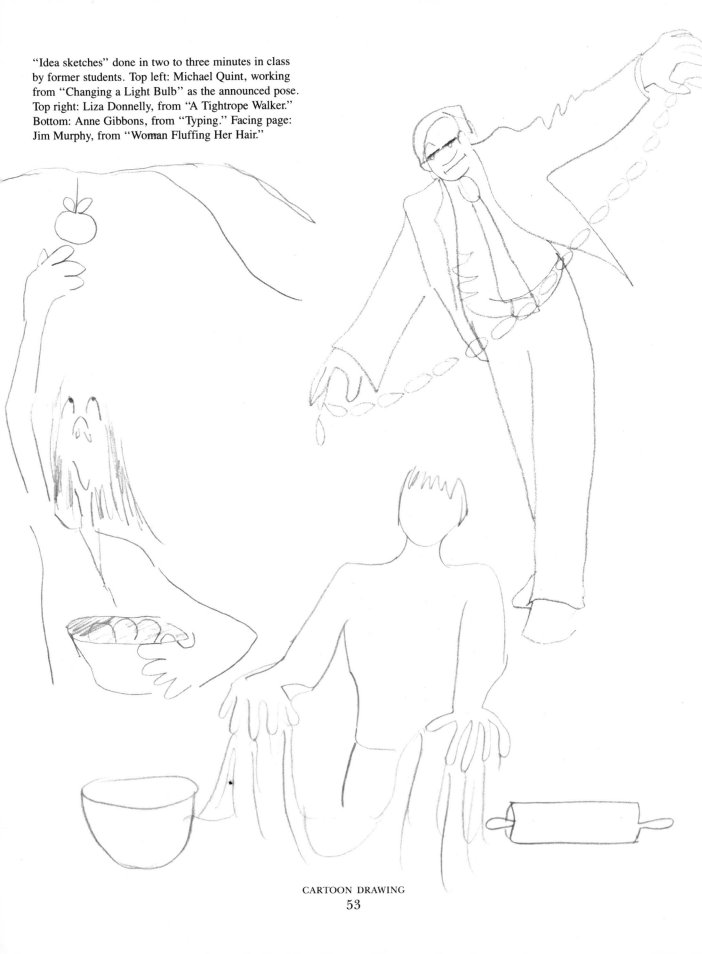

"Idea sketches" done in two to three minutes in class by former students. Top left: Michael Quint, working from "Changing a Light Bulb" as the announced pose. Top right: Liza Donnelly, from "A Tightrope Walker." Bottom: Anne Gibbons, from "Typing." Facing page: Jim Murphy, from "Woman Fluffing Her Hair."

can feel your characters' emotions, you'll be better able to draw them so your readers will feel them, too. Frank Modell is a master at capturing people who are angry. One reason he's so good at it is that when he was a boy, he vividly remembered his father's anger and studied it. "I watched the way anger worked on the topography of his face, just inches away from mine: the narrowed eyes, the vertical furrow between the brows, the inflated nostrils," recalls Modell.

"When I draw somebody," says Bob Weber, "I feel the smile, but I also feel what his collar is like; how tight his tie is, and I try to feel what the guy is like. Is he a little introverted, embarrassed, or is he self-important? I feel those things; if I'm lucky, I feel them clearly."

Lorenz speaks of drawing in the same way. In creating his characters, "I feel them more than I see them," he says. While he's drawing, "People say they see me making all these faces . . . but I'm not aware of that. What I'm doing is acting out what I'm drawing. I *feel* the character—this guy's a pain

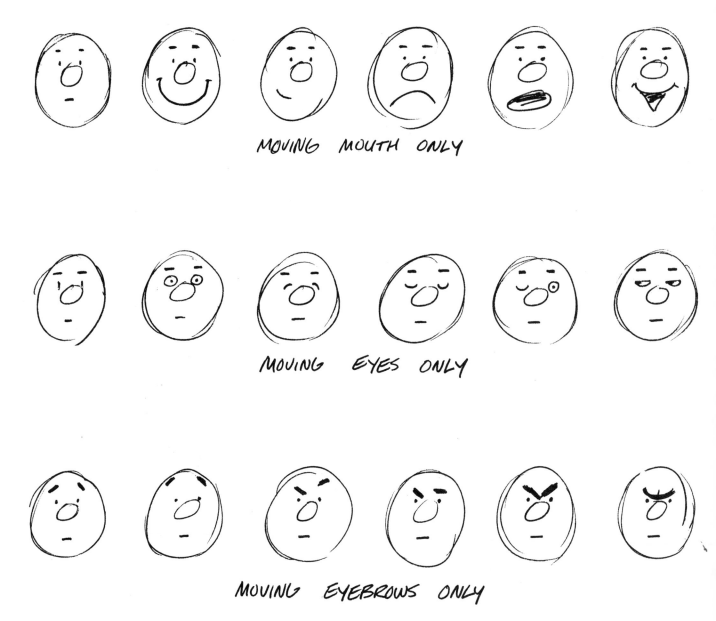

MOVING MOUTH ONLY

MOVING EYES ONLY

MOVING EYEBROWS ONLY

in the neck, or a doormat, or whatever—but I don't have pictures in my head of what these people look like; it's more visceral than anything else."

Cartoon characters, like real people, communicate feelings primarily through facial expressions, so learn them well. Make some faces at yourself in the mirror and see how you can convey a vast range of emotions by moving eyes, eyebrows and mouth in various combinations. Practice doodling them spontaneously, and also by choosing some emotion at random and sketching a dozen variations of it. Like anger, for instance. Try six "shots." Now, how many are actually annoyance, or disgust, or impatience, or frustration, or mild frustration, and not true anger?

As you can see from these examples, the difference is only in the subtle change of angle in an eyebrow or the downturn in a mouth. The variations are infinite and you should strive to put down on paper the one that exactly mirrors the emotion you feel.

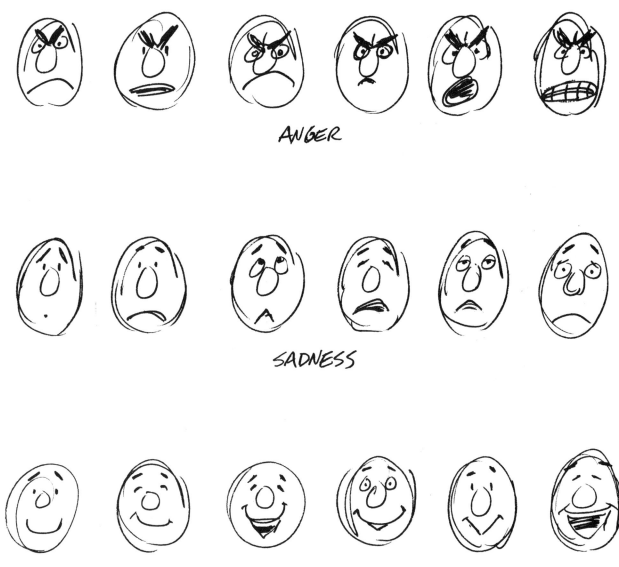

ANGER

SADNESS

HAPPINESS

As an experiment, copy or even trace a few expressions shown here, but make some slight alteration of your own and observe the difference in degree of the emotion. Also, try redrawing the faces from some of the cartoons in this book.

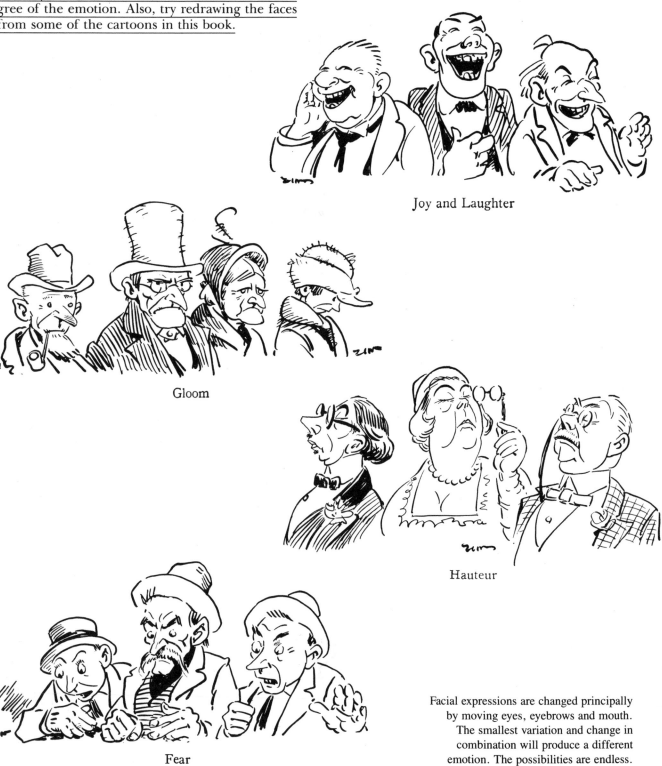

Joy and Laughter

Gloom

Hauteur

Fear

Facial expressions are changed principally by moving eyes, eyebrows and mouth. The smallest variation and change in combination will produce a different emotion. The possibilities are endless.

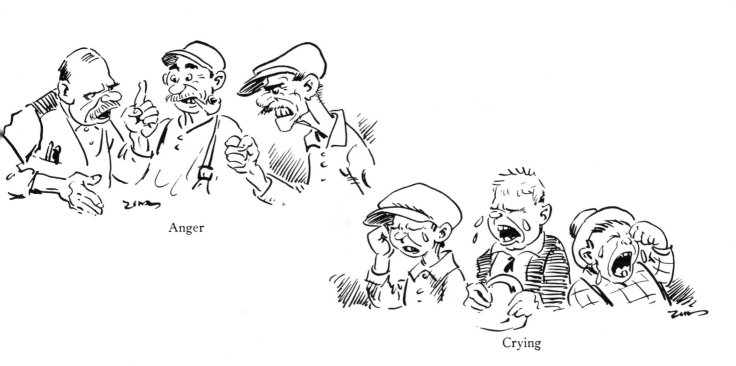

Anger

Crying

Cartoon characters also communicate through body language. Remember, a cartoonist has a license for exaggeration and your intention is not to render anatomically correct straining tendons but to suggest, convincingly, the *feeling* of the action.

Action drawing looks funnier and more interesting if the figures are distorted and stretched out of normal proportions. Keep figures in action off-balance, too, teetering as if they were about to fall over. These Zim drawings, for instance.

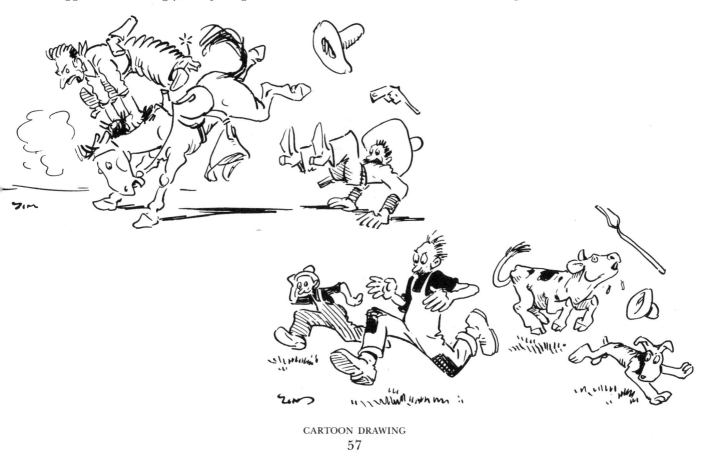

CARTOON DRAWING

Look at Booth's man-and-dog sequence. Notice the figures in midair, the shadows beneath them, the double and triple lines, all of which suggest urgency and motion. Brian Savage's gorilla is in midact of utterly destroying the door.

The faster the action, the fewer the details. When a skier races downhill, you don't *see* his buckles and buttons. A ballplayer swings a bat in a blurred arc. A repeated action is rendered in multiple images, like Booth's man and dog. Don't just add "whizz" lines; concentrate on drawing frozen action.

"Who is it?!"

Stationary people, sitting in chairs and standing against walls, are also speaking body language, so those gestures must be studied as well. Notice how heads tilt, shoulders slouch, arms fold, legs cross, backs bend, and practice sketching them. (The way Richard Nixon hunched his shoulders was expressive of his personality and became a popular focus for political caricaturists.)

BOOTH.

THE MAGAZINE GAG CARTOON

Look at Modell's courtroom scene again (page 35). Notice the way the lawyer stands, hands on hips, head forward, chin jutting out. His posture alone tells us he's very annoyed. The witness lounges in his chair. Saxon's seated couple (page 26) sinks solidly into the couch, and the woman's pose is perfectly pensive. Weber's secretary slumps.

As you did with expressions, doodle all kinds of body language, trying to capture a sense of the action in a few seconds. Do a bunch of them in quick succession and you're sure to get a few that really "say" it. If you can, practice the action yourself. It's just like making faces in the mirror.

Cartoon characters must *act* with their bodies and faces so that readers know at a glance what's going on even before they read the caption. In captionless and multi-panel cartoons it's the whole story. Here's Richter's general coming upon a movie line and shaping it up, without a word, with movements that clearly signal authority. Sam Gross's man in the bathtub (next page) doesn't just sit there; he is reacting, which is another kind of gesture: the "take." "Takes" range from a casual stare to a look of disbelief at some unexpected sight or statement. Like Addams's lady looking out the broker's window. Koren's partygoers, Fisher's diplomat. Darrow's tennis players. Silverstein's prisoner.

The reacting characters are important because they function as a surrogate audience; their response to the situation clues the reader on how to respond and also aids in communicating the idea quickly. Take a few minutes to look at all the cartoons in this book, focusing only on the characters who are listening or looking, and imagine how the cartoon would look without their performance.

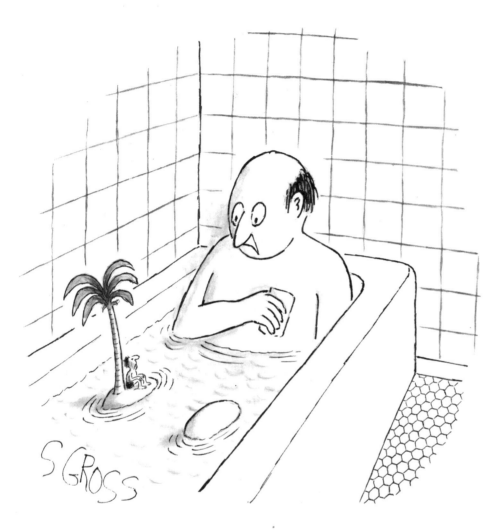

Examples of the "take." The way characters look when they are reacting to a situation or caption is as important as the acting by the principals. Above: Sam Gross. Upper right: Charles Addams. Far right: Whitney Darrow, Jr.

They are supporting actors and they must be told by you, the cartoonist-director, how they should behave to enhance the scene.

As another exercise, act their parts yourself. Imagine yourself in these cartoon situations and draw how you would react.

While there are no absolutes, cartoon characters should *not* laugh at the situations they participate in. It's like laughing at your own joke as you deliver the punch line. Frascino's cartoon would not work so well if the listening lady were laughing. It is for the reader, coming upon the scene, to *discover* the humor.

In his cartoons Chuck Saxon "prefers ideas in which the person speaking is seen to be absolutely serious and the people around him are taking it on his terms . . . and the reader sees the situation as being ridiculous, so the reader is participating."

Besides facial expressions and body language, people communicate nonverbally with their hands.

Among the more obvious examples are angry fists, accusing fingers, beckoning fingers, hitchhiking thumbs, palms out for money, hands clasped in pleading, held up in protest and spread in horror. People use their hands to emphasize their words. Everyone does it, usually unconsciously. Look around you and notice how expressive hands can be. The way Jack Benny used them was an art form.

Drawing hands can be difficult for beginners who get too involved in their anatomy. Remember that cartoon drawing *suggests*, it does not reproduce. What you're aiming for is the *feeling* of a hand wrapped around a glass, or a finger pointing; cartoonists achieve this in different ways. Compare Fisher's cartoon hands with Fradon's, or Handelsman's, for example.

You'll become more comfortable drawing hands by doodling them hundreds of times. Start off by examining your own hand. Notice how the thumb works, where the fingers and wrist bend, that the

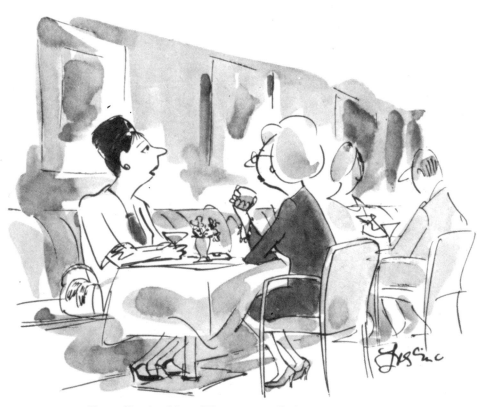

"I shall miss him. His name rolled so trippingly off the tongue—Valéry Giscard d'Estaing."

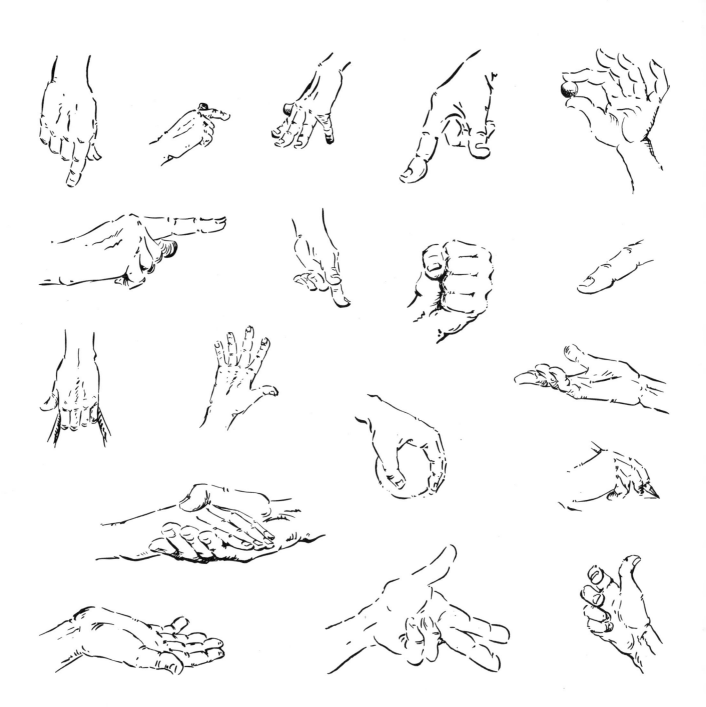

palm is a little longer than the fingers. Practice copying this group of cartoon hands to get the feel of the form, then sketch your own. Use a mirror to get both left and right. Then try groups of six-second doodles of hands communicating various emotions, the way you did facial expressions.

Even if they turn out looking misshapen, keep drawing them. Avoiding hands in your cartoons merely calls more attention to them. Invariably, student cartoons feature hands in pockets, behind the back, under tables, anyplace where they can't be seen. Any poorly drawn hand is better than one blatantly tucked out of sight. Hands are highly expressive and versatile tools of cartoon communication, so learn to use them well.

So much for drawing people. Let's talk about

Hands may be drawn semi-realistically or impressionistically, but they should be visible to help convey the attitude of the characters.

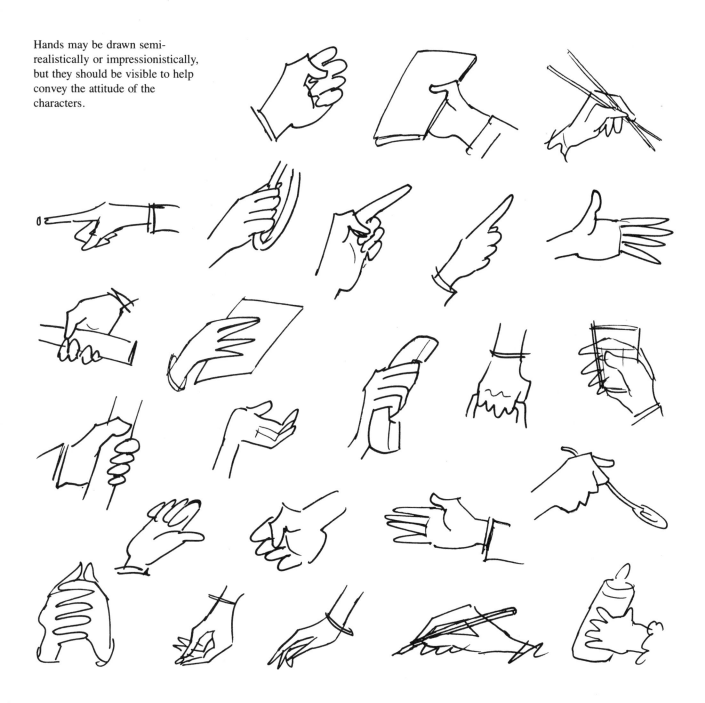

places and things, the element of *setting* I identified in the previous chapter. A cartoon drawing, as I said, chooses clichés and exaggerates them, a visual cliché being something which is instantly recognizable, a form which defines. The dome of the Capitol building "says" Washington, D.C. Traffic lights and cars "say" city streets. Desks and telephones "say" office. Snow and sleet "say" winter.

Once the cartoonist decides where his scene is to be played, he must choose backgrounds, costumes and props which immediately and clearly identify it. Some are more universal than others and might be almost interchangeable, like Modell's courtroom. Notice how little is really needed to "say" courtroom. Ed Fisher's United Nations is instantly identified by the UN emblem and the "foreign"

costumes worn by the background characters. Handelsman's judges' chambers simply have lots of heavy books.

"Wow! Turn to page 252 for something that *really* appeals to prurient interests."

Some settings must be more specific when we need to know more about the characters playing in front of them. The type of restaurant where Frascino's ladies are lunching (page 61) helps define them and reinforces the caption. It means that the right style chair was necessary, the right light fixture, as well as the ladies' clothing. As you will see in Chapter 6, Frascino tried a number of versions before picking what he felt was exactly right.

In Chuck Saxon's drawings settings play a major role because they so closely reflect his characters' personalities. As he puts it, "Certainly environment tells as much about the people as facial expressions." According to Saxon, "There's more to a cartoon than telling a joke or solving a puzzle. You can

say a great deal even though it requires an immediate response . . . and you can do that with the way people dress and where they are."

In designing his drawing, Saxon says, "I think about who the people are, and put them not only in a logical situation, but one which enhances the point of the cartoon." For example, in a recent New Yorker drawing, he has a little girl sitting in a contemporary looking dinette, pouting at her plate as her mother frowns and her father, stern-faced, argues: "Let's review the whole picture, Janine. You don't like milk. You don't like chicken. You don't like anything green. Now tell me, Janine, what does that leave us with?"

"Now in that cartoon," points out Saxon, "the little girl is sitting on a phone book, because these people haven't got high chairs. They don't think that way . . . they wouldn't match the *house* . . . so she's on a regular dining room chair with a book." This is typical of the concern for correctness which makes Saxon's cartoons so successful and individual. It's also well worth noting that Saxon considers the process of designing and drawing these richly wrought environments as "my pleasure."

George Price's bizarre, wonderfully cluttered rooms similarly tell us a great deal about the people who inhabit them. So does the eclectic litter on the lawns of George Booth's houses and in his garages. Charles Addams's settings tells us not only what his people are like, they also set a consistent, expected mood that further helps express the humor. (Without this special environment an Addams cartoon might be an ordinary gag.)

Don't so overdo background details that they intrude and distract from the point of the situation. Draw only what's necessary to make it convincing unless the detail itself is the point of the cartoon and thus requires more emphasis. Also, settings should be drawn in the same style and tone as your characters so that everything is in the same "voice." A realistic rendering of a car or typewriter will look out of place behind a loose cartoon figure. Learn to doodle objects with the same "handwriting" you use for people. Moreover, when you draw a lamp, it should be your personal version of that lamp. George Price's furniture is *his*.

Or animals. Cartooning animals is very challenging. The goal is not something out of a naturalist's notebook; you want a funny impression of that animal, imbued with a definite personality. Booth's dogs and cats. Lorenz's rabbits. MacNelly's birds in

his comic strip, "Shoe." This elephant and these sheep from a children's book I illustrated. Start out by studying the real thing (a great excuse to go to the zoo) and letting yourself experience the most impressive characteristics of the animal. Then concentrate on drawing it in a variety of shapes and poses, and go heavy on the exaggeration. Try to keep your animals as individualistic as your people; as you draw, be conscious and wary of the powerful Disney influence. Ed Koren's animals are unique; they are his original creations. Like this one, for example.

Whatever you're drawing, if you're not sure what something really looks like, don't fake it; research it. Many cartoonists maintain a personal "morgue" for the purpose, an alphabetical file of photographs from "abacus" to "zebra." Drawings are not recommended since they convey another artist's perception of the subject. If you don't want to bother setting up a morgue, use the picture collection of your local library.

The best research, however, is on-the-spot sketching, because it adds your own energy and spontaneity to the subject. The first okay I received from The New Yorker was of a situation inside a high-ceilinged cathedral. I did a finished drawing (beautiful, I thought) based on a dozen photographs of the most famous churches in the world, but it was rejected. I thought about it again, and after some time went to St. Patrick's Cathedral, where I sketched for a couple of hours, producing roughs for a drawing that was eventually accepted and published.

Another okay—an idea about a mailbox—carried the pencilled note, "Be sure this is right." I thought I knew what a mailbox looked like, but when I went outside to check it I realized I was wrong.

The point is not to be photographically exact, but accurate and convincing. The New Yorker, which pays a great deal of attention to its drawings, employs "checkers" to look over drawings and

make sure they contain no errors. Sometimes, says Lorenz, they take a Polaroid camera out on the streets of New York to photograph some questionable detail and pass it on to the artist for his use. Ed Fisher had to correct his drawing of a bus on Wall Street because it was headed the wrong way on a one-way street. A drawing of a mounted policeman was returned to me with a list of eleven mistakes in the uniform and equipment. Barney Tobey recalls his cartoon of a tourist couple descending the steps of a high Mayan pyramid, giving the thumbs down sign to a couple just starting up. "They held the drawing for several weeks," says Barney, "because they thought the man's thumb was too big." (It wasn't.) Don't think of it as nitpicking; think of it as quality control.

Sometimes the clichés and stereotypes should be updated. A cartoonist doing a computer gag today could easily visualize an obsolete version of this fast-changing form. Few therapists nowadays look like Sigmund Freud. And dentists' offices no longer resemble torture chambers but look like something out of a spaceship. If something in your drawing is not convincing, it may distract the reader and cause a breakdown in the "instant communication." So if you're bothering to draw it, bother to get it right.

This leads me to a few words about perspective, a set of visual laws which work like gravity to hold your drawings together and give them a plausible look. To make it simple, perspective is the reason people located far away look smaller, why the flat roof of a building seems to slant down, why parallel railroad tracks seem to meet in the distance. It's a real-life optical illusion.

To reproduce the effect on paper, in two dimensions, try following these simple ideas:

1. Imagine a horizon line, which always will be on the eye level of the viewer (you).

2. Select a "vanishing point" any place along the horizon, which is the spot at which all horizontal lines emanating from the viewer (and all other directions around the compass) converge.

3. The heights of all objects and angles of all horizontal lines are determined by these converging "perspective" lines.

Thus, in Zim's examples, in figure A, the horizon line (H) represents the viewer's eye level, making him about the same height as the standing cowboy. The vanishing point (V) is where all the imaginary (dotted) perspective lines converge, thus determining the angles of the rooftops, sidewalk curbs and windows.

Notice, in figures B and C, that the basic rules of the vanishing point remain the same when the horizon line is raised or lowered, providing a bird's-eye view, or a worm's-eye view. Copy these sketches as warm-up exercises, then create your own scenes along the same lines. Notice in the city street scene, that you can use more than one vanishing point in any single drawing.

Perspective not only holds a drawing together according to physical laws of nature; it also adds visual interest, permitting you to vary your "camera angle" and shoot your scenes from any point of view. Too often beginning cartoonists arrange all their scenes "flat"—viewing them head on, with no

Figure A.

Figure B.

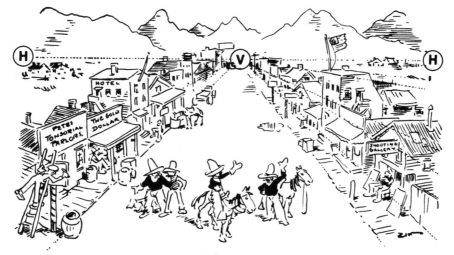

Figure C.

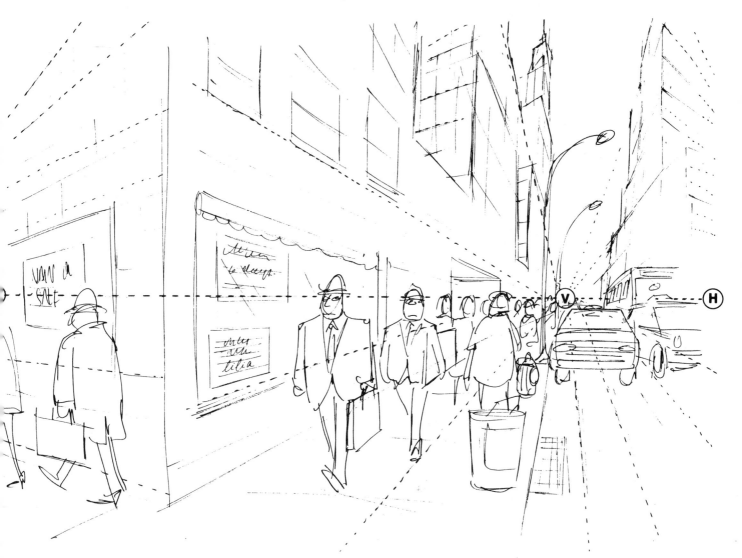

CARTOON DRAWING

depth, so that they resemble a wallpaper design. Looking at a scene even from a slight off-center angle gives it an added degree of excitement and animation and makes for a more interesting composition.

Sometimes a situation will feel more dramatic if we look *up* at it. In other cases it's more effective to see something from above, like a cluttered tabletop. George Price's drawings are often shot from above.

Like other tools of cartoon drawing, perspective should only be used to suggest, to create an effect; it is not meant to be architecturally exact. If your dazzling display of perfectly converging lines has nothing to do with getting a funny idea across, it's a wasted effort.

Cartoonists ordinarily do not sketch out horizon lines, vanishing points and perspective lines when they compose their drawings; they just keep them in mind, so that all the elements flow in the proper direction. Look at the cartoons here of Addams, Tobey, Saxon and Richter and notice how casually they put perspective to work for them.

"Casually" is the ultimate cartoon aesthetic. As you've seen, although there are unlimited approaches, styles and techniques, the best cartoon drawing is disarmingly simple. But, as Modell says, "the easier it looks, the harder it is to do." Try to copy the cartoons in this book and you'll find out, with your own hand, what he means.

It takes a lot of drawing to make it look easy. Start off by doodling and practice the exercises I described. Fill a few sketchbooks with drawings from life as well as from your head. Get comfortable with cartoon drawing.

And then we'll talk about dreaming up cartoon ideas.

5

So How Do You Get Your Ideas?

At lunch not long ago, I was describing to a few other cartoonists what I planned to cover in this book, and mentioned subjects like materials, drawing and getting ideas. Chuck Saxon grinned.

"Ask *me*," he said.

"Ask you what?" I said.

"Ask me how I get my ideas."

"All right," I obliged, "how *do* you get your ideas?"

He paused, savoring the moment.

"With . . . great . . . difficulty," he replied, obviously pleased with the opportunity to deliver a favorite line.

While said jokingly, Saxon's reponse is probably as accurate an answer as any to the question cartooning students ask most. You get cartoon ideas by doing hard work. Inspiration through perspiration. Moreover, the majority of professional cartoonists agree that coming up with ideas is the hardest part of the profession.

As difficult as it is to create ideas, it is even more difficult to teach you *how* to create them. When we discussed cartoon drawings, we could practice exercises which are visible. You could make a sketch, look at it, study it, redraw it, and observe improvement in your skills. Drawings are physical, tangible papers you can collect in a folder or hang on a wall, to look at again and again.

But getting cartoon ideas is an invisible thought process that occurs in seconds and then disappears. It can't be tacked up on a bulletin board or pro-

grammed. It is an extension of being. Individuals who create cartoon ideas perceive life through an altered or alternative vision. The cartoonist sees beyond the world as it *is*, and includes other ways it *might* be. He is able to do this because his mind, either from birth and/or through training, is wired up weirdly, and so makes unusual idea-associations which are regarded as *funny*.

I suppose you have to ask what *funny* is. Well, most people agree that you can't really define it; what's funny to one person is not funny to another (and that includes editors). According to Will Rogers, "Everything is funny, as long as it is happening to somebody else." Webster defines funny as "causing laughter; laughable, amusing; humorous . . . out of the ordinary; strange; queer," and defines humor as "the ability to perceive, appreciate or express that which is funny, amusing or ludicrous."

So cartoonists, by definition, have a "sense" of "humor," which they express visually. They regard situations from angles, points of view, frames of reference, that others do not. They have curious minds that constantly nuzzle behind the headlines, seeking more interesting answers. Cartoonists are problem solvers who come up with unique solutions. They can react in unexpected ways to the "givens" in life; their special talent is their perception of incongruity.

The noncartoonist sees a highway sign reading "Slow, Children Crossing," and he slows. The cartoonist looks at the same sign and his mind skips past that automatic response into what-else-might-that-be-land. And comes up with something that Charles Addams did, visualizing a car stopped in front of that same sign, its occupants staring at an incredibly long line of children crossing the road and stretching far back over the hills out to the horizon.

The cartoonist reacts to ordinary situations in life and gives them little twists to change them into extraordinary situations which are funnier. He violates the cliché, creates an incongruity, surprises you and makes you laugh.

But *how*, you insist. Well, as I said before, it's through some invisible thought process. Saxon gets into "a thinking mood . . . then it starts working; a free-association, a chewing of the cud . . . a regurgitation of something that happened last week or twenty years ago." Brian Savage also talks about "a creative mood," but doesn't always know how to

get exactly into it; if he did, he says, he'd only have to work a few hours a week.

Henry Martin says, "I'm not sure I understand how I get cartoon ideas. I suppose it is a subjective knowledge of what makes humor, combined with a search for what is funny currently. Exactly how an idea is arrived at still mystifies me." Charles Addams is equally unspecific: "You sit and doodle on a blank piece of paper and something relates to another in some strange way and you get an idea." Jack Ziegler gets ideas by "daydreaming and doodling and following these daydreams and doodles through to their natural and logical conclusions." Ed Koren's ideas come from "a strange mixture of my own fantasies and the daily realities."

Frank Modell says that he always has lots of funny ideas, "but it's a lot of work to make them into cartoons. Sometimes an idea will require a three-reel movie to make the point." But to get it into a single scene with a single caption is much more difficult. "Sometimes I can't find the caption to fit the picture or the picture to fit the caption. Cartoonists are always walking around with half-useful ideas."

Although cartoonists use many different approaches to getting ideas, they are all imprecise and elusive. I don't know anyone who has a step-by-step system or secret procedure which guarantees saleable cartoon ideas. I can, however, share with you my own methods and those of some of my colleagues. Of course, because a technique works for one cartoonist doesn't mean it will work for anyone else; it's too personal. Later I'll also describe some other, more impersonal techniques and exercises to help you get started.

There are basically two approaches to getting ideas: verbal and visual; either doodling words or doodling pictures. Both work equally well. My own preference is to write first. I keep a notebook in which I record subjects that attract my interest. They might be current events culled from the newspaper, a phrase from an article, a street sign, a scrap of conversation, an illustration from an advertisement, something I said to someone—anything that for any reason "rings my bell." It's an eclectic collection, as you can see from a typical page reproduced here. (The circled notes about a clothing salesman were worked into a cartoon which appeared in The New Yorker.)

Into the notebook I also copy the quick doodles,

notes and impressions I jot down while walking around the city. You *must* record your observations on the scene; nothing is more maddening than forgetting the thought that was so great you were *sure* you'd remember it. (That's why I always keep a pencil and paper next to my bed; I *never* remember the next morning those great ideas my subconscious whispers to me just as I'm falling asleep.)

When I sit down to develop cartoon ideas I begin by looking over my most recent notebook entries, since these will be the "hottest" subjects on my mind, the ones that "bother" me the most. (The best cartoon ideas always spring from the strongest felt feelings about something.) My "start-off" subjects cover a wide range, but mostly deal with events of timely and relevant interest. Once I have some starting subjects in my head, I then glance back over the previous weeks' entries, letting my imagination roam, seeking some unlikely association between one piece of input and another. It's like an old telephone switchboard, where wires are plugged into holes and a light goes on when a con-

nection is made. So I let my mind "doodle" different combinations of words on my notebook pages, until I make a connection.

When I have plugged into what feels like a good connection, I play with it for a while, thinking of situations that might best dramatize it clearly and quickly—looking for an appropriate cliché. (Actually, I never think in these terms; I'm using language to attempt to describe the process *after* the fact.) Ordinarily the thought sequences that produce a cartoon idea are not chartable; the process of idea-association moves too fast and leaves blurred tracks. Here's one I can reconstruct, though, because I remember it came out of mixing my anger with the postal service with my affection for baseball.

I had jotted down in my notebook a phrase from an article about baseball contracts, which urged fans to "demonstrate their faith" in the game by turning up at the ball park. A few pages later I had made a note that the "damn postal service doesn't work." That complaint became one of my starting subjects, and when I glanced back and saw the earlier entry, I made some connection between them. After trying out several complicated scenes, I finally decided on a simple one, because the idea itself was simple. The result was a New Yorker cartoon of a strolling businessman doing a "take" as he sees a mailbox with a sign over it reading, "Demonstrate Your Faith in the U.S. Postal Service. Mail a Letter."

My idea-writing sessions usually last for several hours at a stretch; I don't keep track of the time,

THE MAGAZINE GAG CARTOON

but rather of what I've done or not done. I set quotas for myself—say, ten good ideas—and simply work until I get them. If I'm "hot"—my mind being fresh and loose and soaring wildly—I might be able to get several ideas from one subject, and then suddenly spin off into a totally unrelated subject for other ideas, without knowing why or how I made the transition. (Or even being the slightest bit interested.) On the other hand, I have sat staring at my subjects for hours and come up with nothing. That's when extra fortitude and discipline are called for, plus some artificial stimulation. It's like pushing your head along the various paths in a maze, seeking a route to the center where an idea lurks. And when you finally get there, it lights up and goes Bingo!

There are occasions, mostly when I'm working on some special, unfamiliar on-assignment project, when I know that getting ideas will be a more "manufactured" process. My approach then is to fill my mind with as much data on the subject as I can—without searching for funny connections. I let everything marinate in my head for a while, allowing my subconscious to simmer on automatic. After a few hours or even a day of "ignoring" the material, an idea will suddenly pop into my mind, and *that's* when I sit down to write—usually with good results. The best efforts are often a result of the least amount of effort. But it takes a lot of practice to become confident enough to relax and have faith that it will all happen.

Only after I've written my quota of ideas do I begin sketching them. If I have time I like to let the idea "age" a while, so I can approach the drawing with a fresh eye and have a better chance of adding an extra visual twist to the idea. My original concept often changes a lot before it reaches "rough" form.

Once in a rare while, I'll experience something that will produce an instant, fully formed cartoon in my mind—I recognize something funny on the spot; an immaculate conception. I remember being in an elevator many years ago when two stuffy businessmen (*my* perception) huffed on with bulging briefcases, making very important small talk. "What a beautiful day," droned one, "it really makes you glad you're alive." That's probably what he really did say, but I didn't hear that timeworn cliché. What I heard, and the picture that sprang to my mind with it, was this cartoon, published a few months later in Harper's magazine.

"What a beautiful day! Kind of makes you wish you were alive."

On another occasion, I remember driving past a phone booth and glimpsing in it a chic young woman wearing incredibly high platform shoes and holding an austere French poodle on a leash. In my brain, though, I saw this same young woman parading down the street, followed by her French poodle wearing the same platform shoes on *his* feet. The drawing appeared in Cosmopolitan.

These are interesting examples for several reasons. First, as I said, they are rare instances of looking at life and immediately seeing a fully formed cartoon that sells. It is a "natural" method of getting ideas that cartoonists dream about but all too infrequently experience. For another thing, both cartoons are situations in which only a small half-twist was all that was needed to violate the cliché, to create an incongruity. I simply rearranged a couple of words in the hackneyed phrase. The poodle cartoon involved a slight visual change, putting the mistress's shoes on the dog.

I like to think that this kind of response to life has something to do with the fact that I am a little hard of hearing and also have poor eyesight. My theory is that because I don't always hear and see what is *really* there, my mind automatically fills in the missing spaces with *something*. And maybe, because my head is wired a bit weirdly, my substitutions produce cartoon ideas. Maybe it's just a romanticized explanation of creative thinking, but it might strike familiar chords in the experiences and

methods of other cartoonists. After all, everyone works through some sort of personal filter or bias. Listen to a few other cartoonists talking about getting ideas.

Bob Weber is one of many cartoonists who create ideas through the "word first" approach. Often, to get himself started, he looks at other cartoons, to get back "into the world of cartoons." He looks at the people "and sometimes I'll hear them—not what they're saying in the picture, but they'll remind me of something else.

"I just look for something which sets off a piece of dialogue, a sentence or a cliché. I think of the words and search in my mind for a picture to go with it, fool around with it, put it down in a little drawing—but I think of the caption first." A cartoon, says Weber, "is like a little play. I get to cast it . . . decorate it, do the scene designs and the props. I get a kick out of it."

Dana Fradon, who deals primarily with topical events, begins his idea sessions with a big piece of blank paper and goes through newspapers, magazines and the television news, jotting down subjects of interest. "I don't work from phrases," says Fradon, "just subjects, like gross national product, or poor people not voting. Then I start thinking about what I like or don't like about that, looking for twists . . . for something funny . . . that comes out of what I feel."

Fradon makes a fresh start at each idea writing session. He doesn't switch ideas. "I don't even look at other cartoons for stimulation . . . I sit and doodle at this big table for hours, and if I get stuck I get up and walk around, then come back and sit down again." Fradon's personal filter is "things political," since an early desire of his was to be a newspaper political cartoonist.

Mischa Richter's ideas also come "when I feel strongly about anything. Good ideas don't come from indifference. But I do have to work at them. To start off I sometimes draw doodles—a cow, a turtle—even if it's corny. Writing ideas is association; I'll read a column and think, What's the idea? Sometimes I look at some of my old stuff for stimulation. I prefer the captionless cartoons, because drawing is more important to me personally."

Bud Handelsman's definition of a cartoon has a verbal emphasis—"a humorous idea presented in the form of one or more drawings. The big ingredients are . . . two apparently contradictory elements which startle the reader by their seeming incongruousness, causing both laughter and a recognition of some truth underlying the situation." In getting ideas, says Handelsman, "it is often helpful to associate with people whose minds are closed and who speak pure cant, especially when they are educated enough to speak it fluently. I usually start with a caption, and the drawing follows. To get my thinking started—when I have exhausted the jottings in my notebook—I choose a subject and let my thoughts (if any) run with it. The cartoonist David Langdon calls this process 'controlled mind-wandering'—as good a description as any."

Ed Koren speaks of being concerned with "good drawings—endowing a drawing with a certain complicated aura that bears more looking." The challenge in doing a successful cartoon, he says, is "timing—knowing when to come in, precisely" to what's going on; and depicting "a moment frozen in time." Koren feels that his ideas come out of his anger and that "all cartoonists should have a certain degree of anger within them—after all, they hold human behavior up to ridicule. I think that cartoons should do more than make you laugh; they should make you think about things. Cartoonists, after all, have original perceptions of things . . . larger conceptions of the world. I feel disenchanted with the way things are and so I want to shout, That's not right! Maybe it's my self-defense; I get back by being funny. I take perverse pleasure in uncertainty. Maybe because I can assume several different attitudes at the same time.

"I get ideas all over; everybody says these stupid things; and if I don't actually hear it, I make it up. I collect funny things I hear or see and put them in a notebook and sometimes work from that. Sometimes I just do a drawing and a line comes from it; I get ideas either way. I think they all come from the fact that I am highly self-righteous, highly moral. For me, a cartoon should carry some social message, and so, in a way, can be an illuminating force But whatever I do is very personal, very much a part of me."

Sam Gross, one of the most disciplined, businesslike cartoonists, sets aside Friday afternoons for creating ideas. "I turn off the phone and start to doodle . . . I look over doodles that I did three months ago to set me off on a subject . . . sometimes with a caption, sometimes with a drawing. If I can't get an idea then I go on to another subject. When I get an idea I sketch it out . . . then go back

to doodling again. I do this for about four or five hours and at the end of that time I usually have about eight to fifteen ideas that I can work with. If I don't have enough ideas then I do the same thing again on Saturday, only in order to zero in on a subject. I look through some cartoon books because by then I've exhausted my supply of doodles."

George Booth describes his creative sessions more casually. "I get my ideas by reading, looking or listening," he says. "I do not sit and stare at a blank paper. Usually a phrase, two words or a thought comes first—sometimes I begin visually. To get my thinking started I clear my mind, then get comfortable. Clearing one's mind may mean making an orderly list of the daily or weekly responsibilities, feeding the livestock or scooping snow. Or it may mean ignoring very pressing but not so important responsibilities. The main thing to get thinking started is to sit at the board and start working."

(You might find it rewarding to pair Booth's comment with Bill Woodman's doodle sheets on page 86.)

A cartoon, for Booth, should be invested with "a good idea as opposed to one that is merely saleable. The inkling idea should be worked on until it becomes a worthwhile idea. The beginning idea should be common knowledge to folks' lives. If that element is present in the beginning, it will generally remain no matter how much nuttiness is added. The opposite of this common element is to begin with an idea which no one knows nor cares about—the result may be funny but of no real interest. Diseased chickens are somehow funny to me in cartoons, but the world is not on the wavelength of diseased chickens."

Chuck Saxon regards cartoons as comments ("What good are cartoons if they don't say something?") and cartoonists as "the Old World prophets of our age."

"When I sit down to do ideas, it's a process of thinking of many ideas and rejecting them out of hand—I know what's right in my area and what I *can't* say—I know what I'm comfortable with and what I enjoy doing. I keep hoping that each idea is going to be a social statement—it very seldom is, but you keep hoping."

To get himself started, Saxon may "look at newspapers, other drawings, old roughs—not to switch ideas but to say, Oh, I remember what I was think-ing when I did that, and find an area I hadn't considered. I used to go through Helen Hokinson's book, not really looking at ideas as much as areas—opening up areas of thought. I like to think in terms of situations, as opposed to other humor which depends on words, or catchphrases that are in vogue for the moment."

Lee Lorenz claims that "you can learn mechanically how to produce gags—there is a knack to doing that. The difference between being a hack and being a really good cartoonist is how much you bring to it that's uniquely your own, and that's something a person might develop, but not manufacture; you can only develop what is innately part of you."

Lorenz's concept of a cartoon is a "kind of pivot point in a little drama. I imagine situations," he says, "and imagine people talking to each other. You choose your own cast of characters, and you start hearing this dialogue, and sooner or later somebody's going to say something that sort of sums up the situation . . . in an epiphany of sorts."

To get started Lorenz flips through the newspaper or magazines and writes down "topics that I'd *like* to do something on—something that irritates me. . . . Or I'll write down catchphrases. Fortunately, people speak in a kind of jargon which is ready-made material for the cartoonist. All you have to do is pick up the right phrase and make something out of it." While he's doodling through all this, it's always in terms of words first. "I've never done a drawing first and put a caption under it." Here are a few idea jottings from some Lorenz doodle sheets. Notice that even though the drawings are minimal, they already suggest specific characters.

Some "idea doodles" by Lee Lorenz, jotted down with soft pencil on rough surface drawing paper. Notice the scribbled words and the skeletal units of situations, like a cocktail party. Lorenz may doodle through stacks of paper to create a useable gag.

Jules Feiffer has been drawing his strip cartoon for twenty-six years now, yet still experiences anxiety over getting ideas. "I don't find a subject," he says, "the subject finds me. I have a deadline, a day or two away. I sit down at six in the morning, when I've just awakened, and I'm scared, because I know I have to stop fooling around. I'm starting early because I'm too sleepy for my resistance to set in . . . I'm doing an end run around my own desire not to get the work done . . . and I start improvising on paper the way an actor might on the floor of a cabaret . . . throwing out drawings and words, doodles, subjects—anything, until I hit on a key that starts something in motion."

The development of the "Wheel of Life" cartoon is a good case in point. "I was stuck . . . I didn't have any ideas and I did a drawing of a lady pointing, saying, 'Now, the wheel of life . . .' That's the way it began, because here I am in the morning and I have to come up with an idea and the circle

goes on all of my life . . . and I draw this wheel, more of an act of boredom rather than anything else. It's a cliché and what can I do with it, and I thought, Well, I can tie her to the wheel, and the wheel, instead of rolling, does awful things." One leads to another, winding up with the payoff line delivered by the same woman, now on crutches.

"For me," says Feiffer, "it's the most successful cartoon, certainly on a personal level, like none in a long time—because it takes in lots of complicated stuff, and somehow compresses time and space . . . it gives me and the readers who responded strongly to it the sense of having lived this very experience."

In creating ideas, says Feiffer, "I almost never will know the ending before the beginning, but I might know the ending a second *after* the beginning. Once I know the first line, I may know the end but not how to get there. I may have to do a number of drafts to get there, but the ending as often as not will be inevitable."

"Sometimes it works the other way; the first five or six panels will go very smoothly, but I won't have a way out of the situation, or the original way out is not good enough for the material . . . and I have to go back and change not only the last panel but the stuff earlier on . . . or redo the whole thing."

Arnie Levin talks a lot about going for "physical form," for gags where "something in nature happens," and generating ideas from spotting "abstract actions" all around him. "I take notice of unusual actions," explains Levin, "physical things we all do, that have no particular meaning, but everyone's aware of doing them—like shaking a sheet and making a bubble of air under it—and whenever I come across it myself, I try to think about whether it affects others, too . . . is it a recognizable, physical, abstract cliché? And I catalogue it in my mind and try to think how to use it metaphorically."

For example, Levin used the bubble-of-air abstraction in a cartoon of a king walking on a long

rug. Behind him, the queen has a grip on the rug and has given it a shake, making a large wave which is just about to engulf him. "This is what I mean by a physical gag," Levin says. His cartoon of the queen's page carrying the shopping receipt is another example, and he vividly recalls its origin.

"My wife and I were shopping in a supermarket, and she had just picked up two bags of groceries, and the woman stuck the tape in the bag and it trailed out. I reached out to grab it and I suddenly realized I was walking behind her holding the tape and immediately saw the connection . . . It was a moment that was interesting enough for me to freeze . . . I knew I had something . . . and then I connected the clichés to get the cartoon . . ."

"A cartoon," says Levin, "is basically a story. It's a moment that's been singled out as different from the next moment . . . recognizable, but there has to be something different and important about that instant to make it more interesting. To do that you must be able to recognize the patterns of life, the natural rhythms, the clichés, and when they're broken, because the broken ones are the interesting ones . . . By being able to train your senses to react, whenever that sequence of normalcy is broken is very important. Otherwise, everything will look the same; nothing out of the ordinary will happen."

Levin always tries "to be aware of what's happening to me personally. I catalogue in my mind little instances—people's instantaneous reactions—par-

ticularly ones that are story-telling." At the same time he makes little drawings of things, then does a series of "subsequent drawings—closeups, a hand, a flower, and if it was of further interest, I'd illuminate the image, even if it didn't mean anything. Then I'd stare at it and free-associate." To a "meaningless" drawing of a couple sitting quietly at a restaurant table Levin added a sign reading "Reserved" and then an adjoining table with a sign reading "Rowdy" at which another couple was being boisterous.

As you can see, although each cartoonist describes his creative experiences differently, all are pretty much saying the same things. Ideally, one of them will speak most clearly to you and you'll connect with his technique and use it as a basis for your own idea sessions. The "process" may still sound unspecific; let me add some practical considerations and exercises that may get you off square one.

In my classes, for the purpose of discussion and practice, I separate cartoons into three groups: the caption cartoon, where what is *said* is most important in delivering the idea; the captionless cartoon, where what is *seen* delivers the idea; and the multipanel, where a time sequence is most important to the idea.

Look through this book and study the captioned cartoons, dwelling on the words: how they sound,

what they look like together, how specific each one is, the rhythm and timing of the line, how the "payoff" comes at the end of the sentence, the use of jargon, how short and to the point most captions are, how they seem to represent the situation you see and how they spin off old cliché phrases.

Notice, too, how authentic they sound in the characters' mouths. Listen especially to the Fradon, Frascino, Weber and Saxon. A simple test for an authentic sound in your captions is to read them out loud—even actually "act" them in the appropriate emotion of your character and situation. After all, it is dialogue and if it doesn't sound right, it probably won't read right. Remember Weber and Lorenz saying that they imagine hearing people talking. They make up entire conversations around some situation which continue, as in a movie, through a series of frames until they reach the "cartoon frame"—the frozen moment in time that sums it all up. What one person says in that frame is the caption. (Obviously, *all* the elements of a cartoon—character, dialogue, gesture, and so forth—are important; it's a question of emphasis. Remember that the best caption won't "play" unless the character speaking is "set up" correctly.) I "auditioned" a number of females for this cartoon before finding one who would be "right" speaking the line.

Because it must be so precise and timed perfectly with the drawing, a caption has to be the product of highly disciplined writing. "A cartoon with a punch line," says Arnie Levin, "has to go through a certain amount of visual setting up, taking just the right amount of time to get you to the gag line, and then back to the picture." Levin thinks of captioned gags in the same "physical" way he thinks of visual gags. "I get joy from the English language," he says, "I'm conscious of the *sounds* of words, of the way they

"All else notwithstanding, Jerome, you have my gratitude for validating me as a sexual entity."

SO HOW DO YOU GET YOUR IDEAS?

look. I'm always listening to speech; I savor a good phrase."

As I said earlier, a cartoonist, among other things, must be a good writer, and in my experience that means rewriting over and over. Often you find that your drawing says what you said originally in your caption, which means that you have to change the caption. Sometimes the adjustments continue back and forth and result in something far removed from what you started with. The point is that you should never say the same thing in both the drawing and the caption; otherwise you undermine the rhythm and surprise of the idea. Suppose the Addams caption read, "There's no cause for panic, Mrs. Munson, even though you see those men sitting on the rooftops." Ugh. As an exercise, try substituting different words in any other captioned cartoons in this book, and see how they change the entire cartoon.

To many cartoonists, captionless cartoons are the purest form, the most they can aim for; the action tells the whole story. Charles Addams says he's conscious of trying to come up with scenes that stand by themselves. Among his personal favorites are the famous scene of a skier going around a tree, with the ski tracks passing on either side, and the Christmas cartoon of his "monster" family on the roof of their house, pouring boiling oil on carolers below. There is nothing a caption could add to these classics. At first glance they are familiar, reassuring pictures which have been transformed by an unexpected twist into something unusual and funny.

Sam Gross's man in a bathtub (ordinary enough) sees a tiny man on a desert island (itself a classic cliché). My drawing of a little boy playing with boats in his bathtub came out of the news stories about oil spills. Gross's scooter ride takes on escalated overtones when tanks are substituted for expected little cars. Notice that in all these cartoons there is a logical relationship between the original cliché and its altered (what else could this be?) image. Bathtub . . . water . . . island. Bathtub . . . toy boats . . . colliding oil tankers. Scooter ride . . . little cars circling . . . tanks circling. There is some visual concept in each which is also inherent in a second image. The second image had been stored, or catalogued, in the head as a cliché and, through the process of association, was called up to relate to, make a connection with, the first image, thereby turning it into a gag. (It takes longer to try to describe than for it to happen, but this is the method in the madness.)

In the multi-panel cartoon it's essential to the humor for the reader to experience some time sequence, presented in two panels or more. If the

single-panel cartoon is a freeze frame depicting the quintessential moment in an action, the multi-panel is *several* freeze frames depicting *several* quintessential moments of an action, usually ending with a final twist. The multi-panel frames do *not* occur consecutively; they occur selectively and represent some lapsed time.

Mischa Richter's movie line must first be seen by the reader to be straggly and disordered so it can then (after a minute or so in real time) be shaped up by the general. Unless we experience the first two panels, the final payoff panel will make no sense to us. The action in George Booth's three-panel of the dancing dog and the owner takes longer. We know, by insinuation, that the dog must have done a lot more dancing between panels one and two. Again, the third panel isn't funny unless we are "set up" by the first two panels. Obviously, precise timing and the choice of which frames are needed is essential.

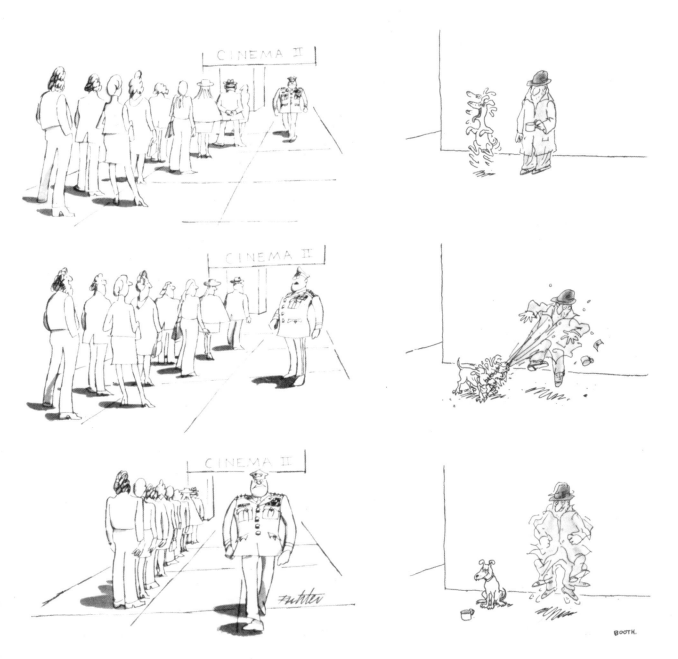

Most multi-panel cartoons are captionless, but some use a word or caption with one or two of the panels. An example of this variation is a Bob Merz two-panel cartoon. In the first panel, three Toulouse-Lautrec lookalikes are seated behind desks, and an off-camera balloon says to them, "Will the real Toulouse-Lautrec please stand!" And in the second panel the same picture is repeated, except that only the hat of the middle figure is now visible.

In yet other multi-panels, like the characteristic cartoons of Jules Feiffer and Ed Sorel, one-line captions expand into full-fledged dialogue, which not only sets up the payoff panel, but entertains through the entire sequence. Feiffer says that he cannot work in the gag cartoon form, that he's "not able to say it all in one text. I've always thought in terms of sequence; a beginning, middle and end. I might see how to take a one-panel cartoon and create panels building up to the payoff, but I couldn't put my work into a one-panel form." Certainly, in the "Wheel of Life" example, where he suggests an entire lifetime, more than one seems appropriate. In Sorel's cartoon, the multi-panel form helps convey the feeling that Nixon is (characteristically) rambling for several minutes, which helps strengthen the satiric thrust of the ideas.

Bud Handelsman takes the multi-panel cartoon form about as far as it can go in his weekly "Freaky Fable" series for Punch. His subjects are familiar stories from the Bible, Aesop, Grimm, upon which he wreaks his customary Handelsmanic havoc. The time span of these cartoons can be epic (among his cliché subjects is Homer's *Iliad*), but all the action, narrative and interior dialogue is played out in just eleven frames. It's an exceptional example of selectivity—choosing and rendering those few dramatic moments which tell the complete story—with disarming simplicity.

These three forms are fairly basic to all cartoons. Practice them and soon you might be originating your own, which is the name of the game. Try this exercise. Sit down and create one cartoon, in whatever form it comes. Once you've got it, then do the same idea in the other two forms. When you've done those, start all over with a fresh idea, and repeat the process. This will push you into thinking of cartoons in ways you might not have considered, and will open up other possibilities. You might discover that one form comes much more easily than others, or that one is absolutely impossible for you to do. Great. Once you know that for sure, you won't have to waste time considering it, and you'll have more energy to devote to the forms which come naturally.

As I said before, there are basically two approaches to getting ideas, verbal and visual; up to

now, most of the discussion has concentrated on the verbal. Now I'd like you to consider the visual and show you some examples.

The "drawing first" approach is like the idea-sketching exercise from my class which I described in Chapter 3. The main difference here is that your starting point is often from inside your head, rather than from a posed model.

Ed Koren's idea doodles are fine examples. He fills 11-by-14-inch sheets with all kinds of scraps, just like these. Koren has file drawers literally over-flowing with them. They may not mean too much to you, but they weren't intended for an audience; what's relevant is that the doodles have meaning for Koren; they're snapshots of what he was thinking. Some of the sketches have words scribbled near them. Notice the drawing with the note, "You have a wonderful body." It eventually became a cartoon in The New Yorker.

Bill Woodman's idea doodles have a closer relationship to his "finished product." Many of them, in fact, are accepted "as is." Woodman, who is "constantly making drawings," likes to sit and take off on one subject at a time, doodling from memory various aspects and objects from it. "I take a mental picture of things," says Woodman. "I don't sketch on the spot so I don't become a slave to the thing. Drawing from memory is what comes out first, it's what makes it different from others' drawings." Among his favorite subjects, as you can see from this selection and on page 51, are diners, bars and outdoor life reminiscent of his native Maine.

Woodman works directly, mostly using a felt tip pen, with no pencil underneath, and keeps redrawing from scratch until he gets what he likes. Notice the little notes to himself scribbled among the drawings, shopping lists and a schedule of things to do. It recalls George Booth's advice about "clearing your head," as part of the process of getting ideas.

The Sam Gross doodles on page 87 are isolated, focused images—likely germs of ideas. Notice his note on the sailboat drawing, a directional signal to himself.

The selection from an Arnie Levin sketchbook on page 88 gives you a glimpse of how visual association might work. A doodle of a bird and some shape that might be a worm or a microphone is then followed by a doodle of an alligator and then a bird pecking inside the alligator's mouth, then a dentist treating an alligator with a pecking bird . . . and so it goes. Levin is incredibly prolific. When he first began submitting to The New Yorker he averaged thirty-five ideas per week.

Jack Ziegler's doodles on page 89 seem to be less accessible to a casual viewer; but as he said, they are only the visible indications of his in-process daydreams: his cartoons are the ultimate results. Ziegler often "speaks" in an original cartoon vocabulary, beyond those three arbitrary groups I outlined. His "In the Caviar Fields" on page 48 is an example of his cartoons which use "titles" instead of ordinary captions.

Whether you work with words first or pictures first, you're doodling; allowing your mind to wander around, making incongruous associations. You've heard the way a number of professional cartoonists describe their approaches to that experi-

Pen and ink doodles from one of Arnie Levin's sketchbooks. Like many cartoonists, Levin carries a small 5½″ × 8½″ sketchbook to record visual notes, both observed and imagined.

Jack Ziegler begins writing
cartoon ideas with free
association doodles like these,
done on typing paper and
stray stationery.

ence. Now try it for yourself. You might want to follow several simple exercises, similar to those I've used in my classes, that have proved to be successful in starting a flow going. They are arbitrarily named and designed, and even overlap. I offer them not as "systems" but as opportunities to let your mind practice "free fall" on the way to producing funny ideas. In a very fundamental way, this is what all the famous cartoonists are talking about.

1. Free association. Think of something you're interested in. Write down the first thing that comes to mind. Tennis? Okay. Think about that for a second and write down the first thing that comes in mind. Or draw it. Sprained knee. Okay. And that reminds you of . . . the country doctor, which reminds you of the icebag that you put on it. Or *Iceberg*. *Iceberg?* Playing tennis on an *iceberg?* Wait a second, there's something funny there . . . maybe. Get it? You continue on until your mind sticks someplace, which is where you fool around for a while. And see if you can make some connection, some way.

2. Controlled association. Pick a subject of interest or annoyance and stay with it, letting your mind explore all the associations connected with it. Say you begin with supermarkets. Start listing things like cash registers, shopping carts, food displays, a maze of aisles, checking prices, the express sign that says ten items or less. This "controlled" association approach is a kind of "slanting" which is often done when you are working with a specific market or a special assignment in mind. I used this technique when I was drawing my "Hang In There!" syndicated daily gag panel, which dealt primarily with economic and financial matters. So when I heard an elevator man calling, "Going up!" I thought of a waiting woman with a thought balloon reading "Prices." It's a kind of mind-set.

3. Situation twist. List familiar situations—clichés. You might break them down into categories, like domestic (couple at breakfast, couple watching television); business (boss berating employee, secretary taking dictation); historic (Paul Revere's ride, Washington crossing the Delaware); even famous cartoon clichés (the desert island, the Indian snake charmer). The list of cliché situations is endless. But make sure your subject is truly a cliché—something that's instantly recognizable to everyone. Then change something in it a little bit. Washington's rowboat with an outboard motor. The snake charmer with a tape recorder instead of a horn. The boss dictating his letters holding a roving microphone. It doesn't take much to violate the cliché, but be sure that the violation is something familiar.

4. Object twist. Using this approach you begin with a familiar object and doodle it into some unusual variation. Think of the object being used in an incongruous way, or in a much larger or smaller form, or in unexpected numbers, or in place of something else which looks similar. In one Charles Addams cartoon we see an ordinary symphony orchestra, with one musician poised over the handle of a detonator wired to explosives. An old Playboy cartoon of mine showed two bald eagles, one of which was wearing a toupee and explaining that he realized that "in this day and age, no one *has* to be bald." Another of mine, from the Saturday Review, had a half-naked woman fishing for money in her purse as she stands on a "1¢, Your Weight and Fate" scale in an examining room, and complaining to the internist, "You doctors don't miss a trick, do you." Or my drawing of hundreds of identical little Dutch boys, one behind the other, stretching off to the horizon, all with their thumbs in the dike. There are no limits to the methods of twisting any simple object to make its appearance or use seem incongruous.

5. The game. This is a fun exercise which I use in class which "forces" spontaneous creativity. Any number can play, but a small group is also needed for input. I first ask for someone to call out a location: any specific physical place in space or time. It could be a swimming pool, home plate on a baseball field, the Washington Monument. The player writes it down on his sketchpad. Next I ask for a profession, which could be plumbing, medicine, construction, or housekeeping. The player writes that down. Finally, I call for any active verb like tap dance, run, cook, kiss, and the player adds that to his list. Then, within five minutes, the player must use all three elements to create a cartoon in any form, with or without a caption. While the results may not be the best cartoons ever produced, the exercise demonstrates that it is possible to associate something, from any arbitrary combination of ingredients. Obviously, what you must do in playing the game is to mix the given input through any or

all of the previously described methods. The time limit forces you to think quickly and not edit out what you might consider too crazy or too silly. The object is to experience some sort of incongruous connection. If you want to try this approach on your own, you need only make up your own lists of locations, professions and verbs, arbitrarily pick three of them (perhaps pull them out of envelopes without looking) and let them run wild in your head. If nothing happens, make a substitution for one of them and try it again.

The "game" is obviously a variation of others. Lee Lorenz tells me he remembers a semi-pro cartoonist from about fifteen years ago who used to peddle a newsletter and all kinds of strange tricks of the trade, "like how to sketch with your hands in your pocket, and he sold a thing like a roulette wheel that had situations on one side—like the North Pole, cavemen—and cliché phrases on the other, and you'd spin it and mix things together and you'd get these crazy ideas. Of course they didn't make any sense at all—they were absolutely crazy."

If you find that you're having difficulty writing ideas by the more "natural" methods described earlier by various cartoonists, you might try these methods of artificial stimulation to get yourself in the mood. Once you start writing ideas regularly,

the various methods will soon overlap and you'll be unaware and uncaring of *how* you begin. You'll be using your own personal approach, incorporating and going beyond others, which is the only way you'll be able to mine the special material that is uniquely yours. Maybe after a few thousand ideas or so you'll begin to select a particular type of association over others. You might choose the more subtle incongruity instead of the broad one. Your type of ideas will become distinctively yours—you might create your own cartoon vocabulary and establish your own voice. Your own style. That should be your goal.

But it all begins with staring at a blank piece of paper for hours and hours.

One final word. If, after a reasonable length of time the ideas do not flow, no matter what approaches you use, you might want to console yourself with the fact that this is a difficult thing to do, that not everybody can do it well. A successful cartoonist who does not write his own ideas is a rare breed. There *are* professional cartoonists who occasionally use the services of gag writers, but they first established themselves in their own "write." Once you appear in print the gag writers will seek you out. But you must do it yourself first.

Which brings you back to the blank paper.

6

Putting It
All Together

Cartoon students devote a great deal of attention to ideas and art styles, but there's more to creating a cartoon than writing and drawing funny; you must also know how to present the material properly.

Just because a movie maker has a star-studded cast and a brilliant script doesn't mean that he's sure to produce a hit. Screen actors have to enter and exit at the right moment, speak their lines with the proper intonations, move in an appropriate manner in front of settings which are convincing and be viewed from a dramatic camera angle. Movie scenes are shot only after they are staged precisely.

A single panel cartoon, itself a freeze frame from a movie, should be staged with no less concern. The cartoonist, like a Fellini working on paper, moves his characters around, changes their clothing, gestures, expressions, adjusts settings and props, and tries many "takes" before he completes the drawing he wants to print.

Staging is composition, which I noted in Chapter 3—a process of artfully designing and arranging a drawing so that it reads at a glance—so that it effects "instant communication." It is the invisible but crucial part of a cartoon; poor composition can kill humor, no matter how good the material.

Good composition is simple and logical. It evolves from your being clear about what is important to your cartoon and what is not; what to throw out, what to leave in and where to put it. Knowing what elements the joke revolves around, what are its "focal points."

These focal points—a character speaking, an action, a reaction, an object—are those which you must draw with emphasis and to which you direct the reader's eye. Less important elements should be played down so that they are supporting, not distracting. In order to move the reader's eye around the frame cartoonists use a variety of design techniques and devices. Among them are blacks and grays, left to right, silhouettes and shape, body direction, perspective and camera angle.

BLACKS AND GRAYS

In a black-and-white drawing, any area of solid black will instantly pull the reader's eye to it. Solid black is the most powerful visual magnet and so should be used principally on the focal points of your drawing. You'll use gray in decreasing values from heavy to light in areas of corresponding importance.

In Frascino's cartoon, for example, the woman speaking—the main focal point—has black hair and wears black shoes. Squint at the drawing and you'll see her first. Her companion, second in importance, wears a dark gray dress. Lighter grays are used for the background.

In my lighter pen and ink drawing, I used small spots of solid black on the speaker not only to pull your eye to him, but to also force you to notice the details—his sunglasses and little cigar—that help to define his character.

"Lately I've begun to dabble in quality."

Addams (next page) uses blacks and grays more subtly, which slows down your perception of the cartoon. The speaker has black hair, black-rimmed glasses and sits underneath a dark board, to attract the reader's first glance. The "payoff" focal points, though, are the men perched on the building ledges, far away, rendered in black, but half-hidden in a checkerboard design of gray windows, so that they are seen only after a second look. The slight camouflage delays their discovery—and heightens the surprise factor.

LEFT TO RIGHT

Since most language is read from left to right, that's also the natural direction for a viewer's eye to move through a drawing. Therefore, elements within the frame that should be seen by the reader *first*—the scene-setting clichés—are usually placed on the extreme left, while the elements which should be seen *last*—the "punch lines" or visual twists—are found

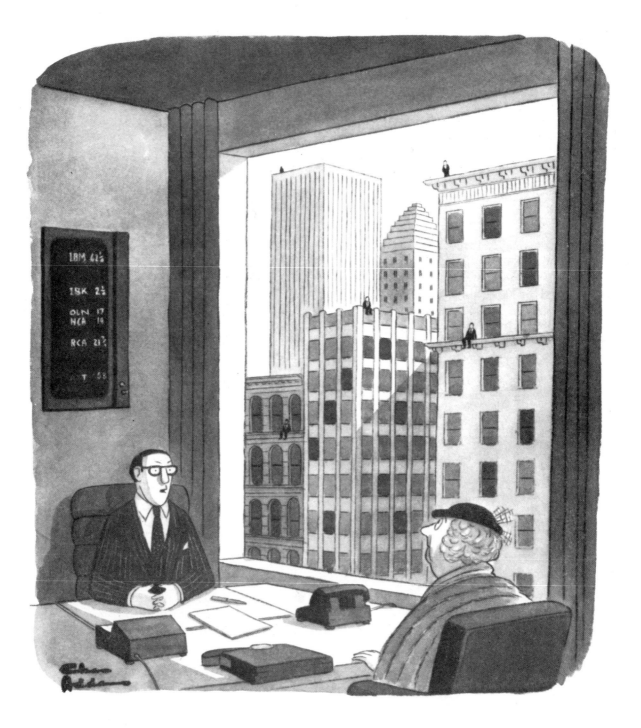

on the extreme right. This, of course, is not an absolute rule; it is a judgment of how to present information in the most effective order.

In Arnie Levin's cartoon we must first see the queen carrying a bag of groceries, so that when we look at the cash register tape trailing behind her it "makes sense" to then perceive it "changing" into a train when it ends up in the page's hands. The joke naturally flows from left to right. Do this: Trace the cartoon, turn it over and hold it up to the light and look at it reversed, and you will see that it doesn't work as well.

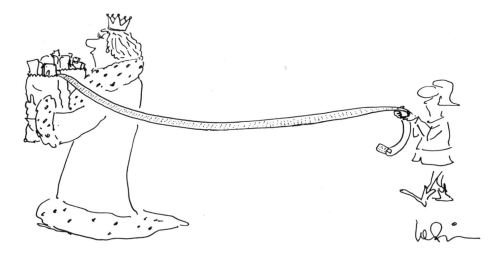

Similarly, in my safari cartoon, the guide and Land Rover are on the left, to set the scene; the man taking the picture is in the center, performing the action; and the posing animals, the visual twist, are on the right.

Lee Lorenz's cartoon depends on the reader

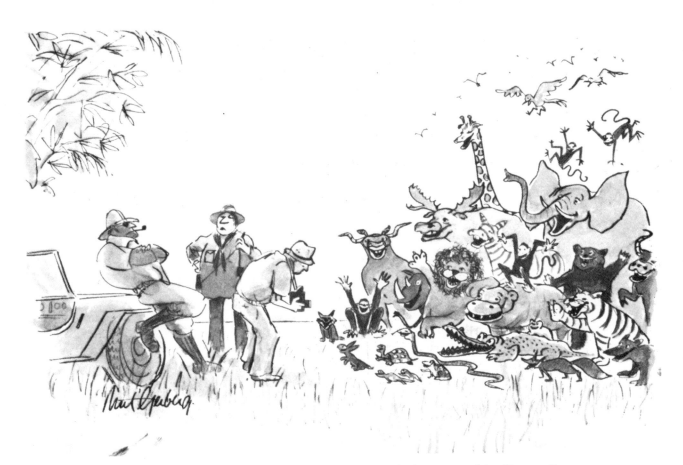

"I take it, then, that we are __not__ the first safari ever to visit this area."

knowing that it takes place in prehistoric times, so that the defining elements—the cavemen, clubs, exploding volcano—are on the left, seen first. Moving to the center we see the speaker in a position of emphasis, and finally, on the right, the modern man as the visual joke.

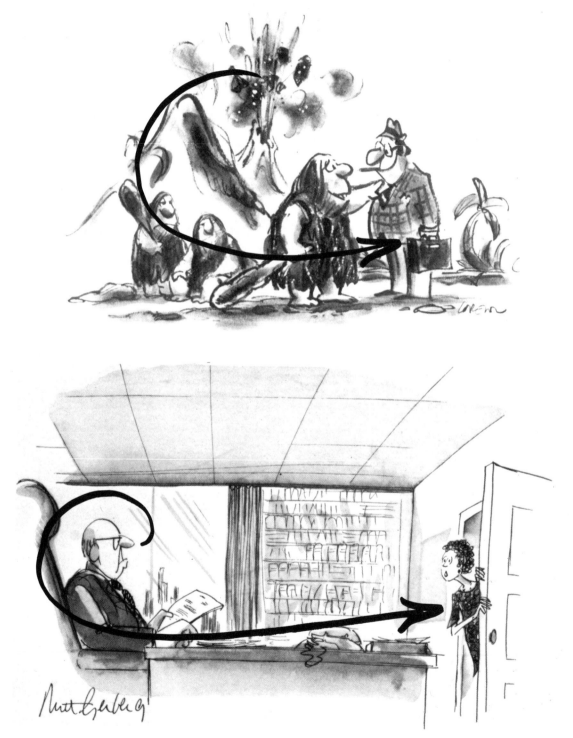

In my office scene, my first priority was to clearly establish the character of the executive, because that is what the gag depends upon. I placed him on the left and accented him with dark grays and blacks. A series of props—the papers he holds, the telephone and the paper in the "in" box—then leads the eye to the right where the secretary speaks the line that knits it all together.

The eye may be moved more than just from left to right. Look again at the Addams drawing and see how your eye travels almost in a circle, from left to right then around left again as you discover the men on the buildings.

The greater the number of focal points in your drawing, the more important it is to put them in the order you wish them to be seen.

SILHOUETTE AND SHAPE

One method of making sure the focal point is seen swiftly is to silhouette it—to leave an area of white space around it so it cannot be confused with any background running into it. You may choose to *not* draw a particular portion of the background or to position the focal point in "frames" formed by objects. James Stevenson's speaker is silhouetted in the natural frame of the window behind him. The husband in Charles Saxon's drawing is silhouetted precisely between a dark shadow behind him and the gray tone that cuts off just at the bridge of his nose. Notice that the wife's head is in a white area inside the dark shapes in the painting. In my office scene, the executive is silhouetted in a window;

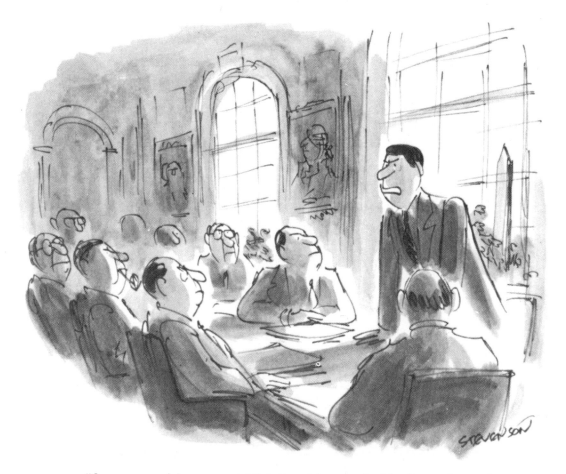

"One moment! I never said I believed in supply-side theory. I merely said we should give supply-side theory a fair hearing."

PUTTING IT ALL TOGETHER

The husband and wife—the focal points—in Saxon's drawing stand out clearly because they are positioned so that no background elements run into them. The man's head is silhouetted between two gray tones and the woman's head is located in front of a white space in the painting behind her.

Lorenz's modern man has no background at all behind him. In Koren's drawing the lampshade behind the speaker's head is unfinished, to avoid confusing lines running into his face. Brian Savage's speaker-doctor is framed in the window behind him.

In renderings where an overall wash technique is used, the areas behind the focal points are usually left white, as in the drawings of Frascino and To-bey. In the Addams cartoon, the background building lines behind the woman fade away just before they touch her face.

You can make sure the focal points in your drawings are silhouetted by outlining them with a slender white paint line, separating them from all other lines running into them.

While the focal points in drawings should be silhouetted, props and backgrounds may overlap one

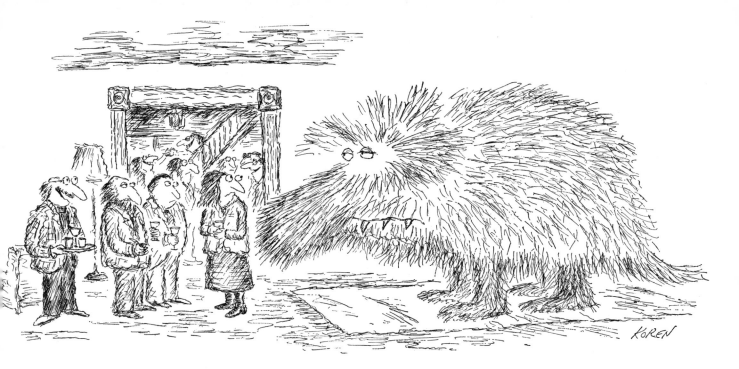

"*He loves to be petted.*"

In Koren's cartoon (above) there is no background detail behind the speaker, so he is seen easily. The diagonal and horizontal lines of the unfinished lampshade frame his head. Similarly, in Savage's cartoon (right) the speaker is silhouetted and framed in the white space of the window. In both examples, note also that the speakers' mouths are open while their listeners' are closed.

"*A desire to 'be on the winning side,'
Mr. Walsh, is not sufficient justification
for a sex-change operation.*"

another to form geometric shapes that point and frame. In Hoest's office scene, the door and the desk become an "L" shape that connects the wife to the secretary. In Lorenz's drawing, the volcano, the

"Mr. Brewster's wife? Why, he isn't married, silly!"

mountain, smoke, cavemen and clubs form a "C" leading to the modern man.

The shapes of all the elements produce the overall design of the drawing. A well-designed cartoon, one which has great eye appeal, is usually asymmetrical. Its internal components trace zigzagged paths and its outside silhouette is irregular. It is an arrangement which is not only more interesting to look at, it's easier to read.

Trace the silhouettes of any of the cartoon drawings here. You will find that none of them forms a regular rectangle. Also, while some will be more vertical and some more horizontal, cartoons almost never are square. In cartooning square is not interesting—it is not unusual. For the same reason, Frank Modell says that a pretty or good-looking face is the hardest to draw, and not as much fun, as a strange-looking one.

BODY DIRECTION

In real life people usually look at what is going on around them. Cartoon characters, behaving the same way, can help "point out" the action to a reader by the direction they face, the position of their eyes, the shape of their bodies and their gestures, even in static situations.

Look at Stevenson's drawing again. The men at the conference table are all looking (from left to right) in the direction of the speaker, implicitly suggesting that the reader look at him, too. The body direction in Saxon's scene is more subtle. The positions of the couple's arms and legs form a zigzag, up and down movement, which seems perfectly suited to the atmosphere of the situation.

At Koren's party scene, all the people are really *looking* at the beast, which is only what anyone would do in real life. And the man speaking is the only one with his mouth *open*, so it's absolutely clear who is talking. This point may seem obvious, but too many beginners' cartoons have the wrong characters with their mouths open. Speakers open their mouths. Listeners keep them closed. On the other hand, don't overdo it by drawing mouths stretched wide open in ordinary conversation. Do it "in a quiet manner," as Weber says. "There's no need for a character to shout at another who is standing right next to him."

In Dana Fradon's party scene the angle of the listener's nose and the direction of his stare urge our eyes to the general's medals, the "object" focal point of the cartoon.

PERSPECTIVE

The use of perspective is important to help invest drawings with the illusion of real life. Perspective is a visual cliché. Our eyes automatically expect an object to look smaller when it is farther away from us. Cartoons not only conform to this rule but exaggerate it, to emphasize the focal points. In Ed Fisher's U.N. scene, the people in the far background are the smallest and the principal figures in the foreground are the largest. The same principle applies to the Frascino, Tobey and Stevenson drawings, where there are also a number of props drawn smaller and larger to suggest lifelike three dimensions. Notice how these drawings utilize the straight edges of table tops, counters, picture frames, papers, chairs and windows as vanishing point lines, urging the eye forward and backward, creating a depth of field while leading the eye to the principal figures.

Perspective is also used to create dramatic

In Fradon's cartoon (left) the listener's nose and the direction of his stare help move the reader's eye to the general's medals. In Ed Fisher's U.N. scene (below), the principal actors, in front, are largest; the supporting characters diminish in size, giving the illusion of depth through perspective.

"I'll tell you one thing. I didn't get them looking for political solutions!"

PUTTING IT ALL TOGETHER

effects. In the Addams cartoon the men on the buildings in the distance must be tiny, so we don't see them immediately. We "find" them and this sense of participation increases our pleasure.

CAMERA ANGLE

This is a pure cinematic consideration. From which point of view will the scene be "played" with the most impact? Who should be in the foreground? Would a tight closeup or a long shot be more effective? High or low angle? Choosing the best angle to shoot a scene can make the difference.

Look at the Addams again. Imagine it in reverse, with the men on the buildings in the foreground and the broker and his customer in the distance. It wouldn't work. The timing would be thrown off. The choice of camera angle is guided by how much a reader needs to see in order to get the joke. "You have to create diversions," says Arnie Levin, "to lead the eye from one point to another if it's just visual and if it's got a gag line, to go through a certain amount of visual setting up, timing it perfectly to the gag line, and then back to the picture."

My cartoon of the coffee house couple centers on their hair style, and the closeup shot helps focus attention on it. If I had pulled back further, their heads would have been smaller and I would have had to draw a lot more background detail, which would have been distracting and unnecessary.

Tobey's cartoon, though, depends on our seeing the vast variety of food in the delicatessen, so he chose a medium range shot that allowed him to show it all clearly. In the Lorenz, the Koren and my safari cartoon, it was necessary to pull back even further, in order to suggest the atmosphere of a larger scene. Ziegler's scene suggests great open space in the background, which heightens the drama in the foreground.

Sam Gross's desert island in the bathtub (page 104) presented a different problem. If he had not shot down on it from above, we would not have been able to see the surface of the water at all—and so not see the joke.

Camera angles, as the great movie director, Alfred Hitchcock, proved, also contribute greatly to the dramatic tension of a scene. I shot my office cartoon (page 96) from a slightly lower angle, to suggest the power of the executive; we look up at him just a little. Saxon (page 98) chooses a long shot and puts space between the couple and the reader, echoing an emotional distance between them; they are far away from us and from each other. Notice how the ottoman in the foreground helps establish the depth of field.

Although I've arbitrarily separated and individualized them, for purposes of discussion, all of these techniques are really part of one process of composition—making artistic choices and experimenting with them to achieve a desired result. However, as Saxon says, "so much of this is instinctive." The cartoonist "knows which is wrong and which is right. People come up to you at parties and give you an idea for a cartoon. They tell you a story, but they pick the wrong moment."

To help sharpen your composition abilities, you might try this "dictation" exercise. You will need a sketchbook, pencil, a magazine or book with cartoons you are not familiar with and a person willing to assist you. Ask your friend to select a cartoon at random and, without letting you see it, or identifying the cartoonist, "dictate" it to you—describe its essential elements and read the caption, if it has one. Then, within five minutes, you must sketch the scene as you envision it, deciding what the most important ingredients are and arranging them in the most effective composition. Don't go over the five-minute limit, or else you'll get involved in drawing, which is not the purpose of this exercise. When time is up, your friend shows you the pub-

*"The real question for you and me,
Ron, is whether the same hair stylist can truly
be right for both of us."*

A medium-range camera shot was best for Tobey's drawing (right) enabling us to simultaneously see a large area of the delicatessen and identify some of the food. A slightly longer shot in Ziegler's drawing (below) shows more background and open space, heightening the drama played in the foreground.

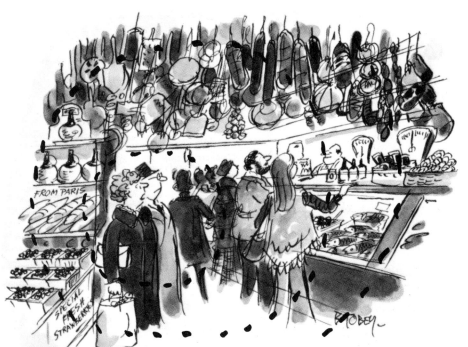

PUTTING IT ALL TOGETHER

Scene "shot" from above so focal point is visible

lished cartoon, which you should compare with your own.

Cartoons should be "dictated" accurately but tersely, in a style used by professional gag writers. For example, I would dictate Sam Gross's cartoon like this: "A man in a bathtub looks surprised to see a tiny man on a desert island floating in the bath water." That's all. You have to choose the camera angle, the gestures of the figures, the details and props, and so on. Barney Tobey's cartoon could be dictated this way: "A middle-aged couple is in a crowded delicatessen filled with all kinds of food in display cases, on counters and hanging from above. The woman says, 'I'll feel silly buying just a quarter of a pound of Swiss cheese.'" Or Brian Savage's: "A young woman is peeping through the keyhole of a door being bashed in off its hinges, through chains and police bars, by a raging gorilla in the hall. She smiles and asks, 'Who is it?'"

In comparing your composition with the published one, don't feel yours is "wrong" if it's different. Yours may have actually been one of the many preliminary attempts which the professional

tried. The importance of the dictation is that it gives you the conscious experience of composition and the awareness that there is more than one way to arrange a scene.

Saxon recalls that Frank Modell once said that most people think there's a closed door between an idea and its fruition. They keep pounding and pulling on the door trying to get through it, but the truth is that there are many doors in a wall all around the solution, and you can go through any of them.

When "taking" the dictation, listen very carefully to the material being given. It is startling to discover that often we do not receive information accurately. Remember the game where you whisper something to the person next to you, and the whisper goes all around a circle, coming back to you totally different. You must train yourself to really be aware of what's out there, to see fresh input; otherwise you'll be working off memories and associations which may not be currently applicable.

Bob Weber remembers an art school exercise called "contour drawing" in which one sketches

from life without looking at one's drawing paper. "You get the weirdest drawings," says Bob, "but you're really concentrating on what you're seeing. When I first did it, I looked at the paper; I kept relying on my prior knowledge . . . what I already knew . . . so everything had a kind of sameness. My drawings were good and solid, but they didn't have any particular vitality. I resisted this method at first because the drawings were ridiculous . . . but then I got to like it; for I developed the ability to really look and see what's going on."

Most established cartoonists do not spend a great deal of time and effort composing their roughs, since editors are familiar with their work and can envision the finished product from their idea sketch. However, when they get an okay, they invest much thought and effort in producing a finished drawing.

"I put as little into a rough as I can," says Saxon. "The process of designing a picture is a great pleasure for me, and I don't want to waste it on roughs I'm not going to finish."

To get a sense of what the process looks like, study some of Ed Frascino's preliminary sketches for his cartoon I have been referring to. Notice the variations in setting, camera angle, perspective, props, costume, tone, and particularly the ladies themselves. Each change of expression and gesture lends a slightly different feeling to the sound of the

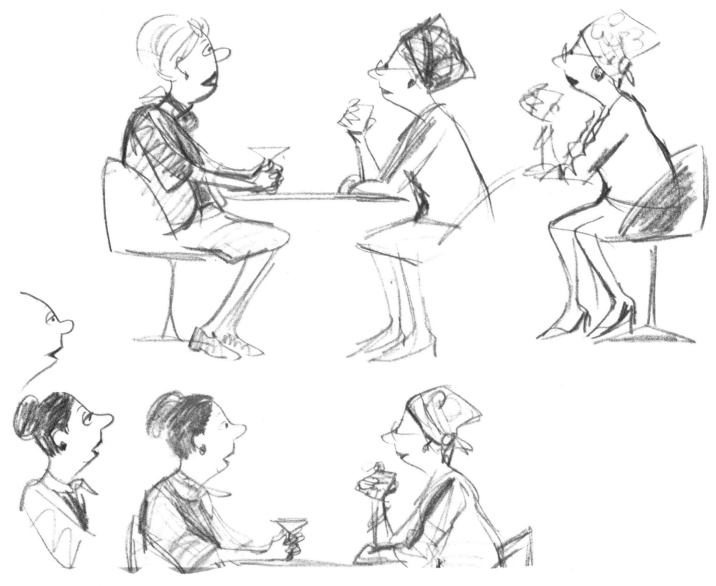

line being spoken. Frascino felt that in this cartoon, the ladies should not be so strongly characterized as some of the other women he draws, so he was particularly concerned with creating more subtle, down-played types who "would not overshadow the gag line."

These sketches were done in pencil on 11-by-14-inch tracing paper, one on top of the other. He arrived at his final design by cutting pieces from several different versions and taping them together. He then placed the composite on a light box, traced it faintly onto a ledger bond paper and drew over it in pen and ink. The gray tones were added with a brush and lampblack wash.

Dana Fradon creates his composition by making lots of little trial pencil sketches. "I can lay out an idea in twenty different ways," he says. "The hard decision is which one to use." After choosing one, he works up a finished pencil sketch, then transfers it via a light box onto a heavy ledger bond paper. With a medium size felt tip pen he draws loosely over the pencil guide. "I do part inking, then I stop and put the tone in, using gray felt tips for washes, then go back to the outline, then the grays again. I might do something I don't like, but it's fun to get into a hole and then get out of it." Fradon corrects his mistakes by patching. He keeps the finish around for a few days and may do four or five versions before he's satisfied.

There are numerous other approaches to mak-

More of Ed Frascino's
development doodles for
the characters in his cartoon.
The smallest difference in a
line of the mouth,
angle of eyebrow, tilt of head
or position of a hand affects
the emotional feeling conveyed
by the drawing.

ing a finished drawing and they are often used in combinations with one another. Whitney Darrow, Jr. says that a drawing is a two- or three-day process. "I begin by blocking out the whole drawing and then I change the arrangements of the different sections by making lots of tiny little thumbnail sketches," he says. When he gets the versions he likes he then scales them up geometrically to the needed size of his finished drawing, so that they retain their original proportions, much by the same system used by mural artists. He does many drawings to refine the original rough so that it finally looks simple and spontaneous, using an array of graphite pencils, Wolff pencils, pastels, chalks, charcoal and a loose wash—and "lots and lots of fixative."

Some artists make their finished drawings directly, without guidelines, looking for a completely spontaneous effect. If the result is unsatisfactory they try again from the beginning. Again, and again.

Bob Weber works that way. "When I draw," he says, "it's all pretty unplanned. I have only a vague

idea of what it is I'm going to do. I never pencil, or make a rough light drawing on the paper, or trace or anything. I just take the charcoal and start drawing on the left side of the paper and move across. [Meaning that everything that belongs on the left—background, props, figure, tone—is drawn completely; then everything in the middle section; finally everything on the right.] Because it's charcoal, I can't draw a figure here and then go over there and start doing something else; my hand would smear the drawing; it would all get mushed up. I just draw from left to right and the picture kind of emerges. If the first guy is wrong I give up right there; I throw it away and just start over. I

hate to patch drawings. So it often takes more than one; sometimes five or six."

Other cartoonists choose paper that is lightweight enough to see through (a 16-pound layout bond) and make new, direct drawings on sheets laid over previous drawings, which function as guides. The effect is still spontaneous but the placement of the components is more controlled. Saxon is among those who work this way, his final drawing incorporating the refinements of all those that precede it. He makes an underdrawing in graphite pencil "because it's easier to erase," and then builds the drawing up with a variety of Wolff pencils, spraying with fixative as he goes along. His aim is for spontaneity in the drawing but, he points out, "it's like a Bob Hope routine: the spontaneity must be rehearsed. If it looks easy, it's difficult."

When he has completed a drawing, sometimes going through sixteen overlays, he will then take several days to look at it, searching for ways to improve it. One drawing, he remembers, irked him

because although the figures were satisfactory the entire drawing didn't work. After the fourth day of staring, he realized that the people didn't relate properly to the background, so he did the whole thing over. "Good," he says, "is the mortal enemy of excellent."

We have referred to the technique of patching, small-scale and large. Sometimes I have been satisfied with the overall effect of a sketchy drawing, except for the expression on a character's face. Instead of making an entirely new drawing, particularly if it is a complicated one, I merely redraw the character's head on a separate piece of paper, then cut it out and paste it over the original one. To make certain the new head is the right size, I place the edge of the new paper on the original shoulders. Thus I see a headless figure and then draw to fit. The head of the executive in my "vow vengeance" must have been about the fifteenth one I did. It is patched the way I've marked it here.

Many cartoonists patch their drawings on a small scale like this. They will change heads, noses, hands, briefcases—any part of a drawing which is otherwise perfectly acceptable. My first experience with patching coincided with my first okay at The New Yorker. The drawing was an elaborate rendering of the interior of a cathedral, complete with vaulted ceilings, fluted columns, stained glass windows, paintings, saints, angels—the works. Looking up at all this are two women, one commenting to the other, as you can see on the opposite page. There was one difference, though. In the drawing I handed in to Jim Geraghty, the two women were standing in a *side* aisle, on the *left*.

Geraghty studied it in silence for what felt like an eternity, then finally looked up and said, "Move the women into the *center* aisle." I was stunned. All I could think was, "I'm going to have to draw this entire cathedral all over again!"

I cleared my throat. "What about the rest of it," I ventured, "you know, the windows and everything?" "Oh, that's all right," Geraghty said. "Just move the ladies." So I went out and asked somebody how to do that without redrawing everything and learned about patching. This is the final version, as it was published. Notice how the shape of the patch followed the lines of the drawing.

Patches can also mean more than a part or two. Sometimes entire drawings are pieced together like quilts. George Booth has been a practitioner of this

"I've always been partial to high ceilings."

PUTTING IT ALL TOGETHER

approach, making scores of drawings of figures and assorted clutter, moving them around from one place to another and cementing them down. Here is an early version of one of his cartoons, with his main character cut out so that he could be moved around for positioning. Patching allows the cartoonist to be fully spontaneous in his drawing, since he knows he can always replace any part of it.

"Attention please, Mister Lyle Ferguson! Due to a disabled train stalled in the tunnel your train will not be running at all tonight."

THE MAGAZINE GAG CARTOON

Booth has also found patching a technique of choice in watercolors since it eliminates the problem of awkward brush strokes in ending the area of one color as it meets the edge of another color. He draws and paints his background first, in broad, smooth, uninterrupted strokes. Then, on separate pieces of paper, he draws, paints and cuts out every other element and rubber cements them in their proper position. The technique is similar to that in creating a color cel for an animated film. A fine example of the technique is Booth's New Yorker cover for December 1, 1975, portraying a beautifully laid Thanksgiving table.

Few artists, though, use the patching approach to the degree that R. O. Blechman does. He has practically elevated it to an art form. Blechman uses so few lines in his drawings that every single one is of the utmost concern to him, and he will redraw the tiniest of his characteristically squiggly lines countless times, until he produces one that meets his high standards. A Blechman drawing of a man's nose may be patched together from many individual little lines. Even this black silhouette drawing which appeared in the New York *Times*, is composed of about twenty separate pieces, taped in place for quicker and easier replacement. I have outlined the pieces so that you can see them.

Whatever the approach and technique, the aim of the "finish" is the same—a drawing that is better than the "rough." This can be a challenge, for a rough sketch often contains a vitality difficult to recapture in another drawing. It is one reason why many professionals keep their roughs as "rough" as they can, saving the spontaneous energy for the finish. (This doesn't work for beginners, though, since their work is unknown, and editors can't tell from their roughs what the finishes will look like.) "Always remember the rough," says Saxon. "No matter how little you put into it, there's something marvelously spontaneous that you don't want to lose."

How do you better a rough, then? Don't redraw it, re-create it. Go back in your mind to the place where you got the idea and start drawing it from the beginning.

Brian Savage says, "When I do a finish, I try to get back to the mood I was in. I want a strong line, lashing back and forth. I want it to look like I just slapped it down. To get the effect, I keep drawing it over again. Sometimes it doesn't work. If you're not drawing well that day, put it away—it won't have the exuberance in it."

Beginners often make the mistake of thinking that a "finished" drawing is a neatened up version of the rough. But by merely tracing and redrawing a sketch to make it look cleaner and neater, you often take all the life out of it. Often, no matter how many finished versions an artist tries, his original rough will still be the best and that's the one the magazine will print. A number of magazines do not even request finishes if the rough is readable enough for them, which is an argument in support of the "finished" rough. Since I had to produce six acceptable ideas a week for my syndicated panel, "Hang In There!", I always did "finished" roughs, in the proper proportions, so that they could be used "as is" if they were okayed.

Giving a drawing a fresh last look provides you with the opportunity to spot errors or non-essentials you might have missed while you were working on it. Like six fingers on a hand, or an inaccurate prop, an out-of-proportion arm, a too-heavy tone, a confusing intersection of lines, a misdirected gaze—anything that might slow down or block the "instant communication" between you and your reader. Remember, if in doubt, leave it out.

Read the cartoon one more time. Is there anything in the drawing that you are repeating unnecessarily in the caption? Is there anything said in the caption that would be better seen in the drawing? Read the caption out loud, with feeling. Is the punch at the end, where it belongs? Does the line flow and have a natural rhythm to it? If one of the words should be emphasized did you underline it? Consider the names you have used. Does using a name really add something to your caption?

Names can be as important as clothing in helping to define a character. Names should be worn naturally, and should be accurate, but they should also be unobtrusive and written with restraint. Unless there's a good reason to the contrary, Dugan is preferable to Timothy Q. O'Houlihan. If you've drawn a sexy young woman convincingly, there's no need to name her "Miss Honeybottom." Or a very wealthy man "Mr. Lotsagelt." Don't get cute, particularly with ethnic names. Be aware of overused cliché names, like Chauncey or Fifi, to describe certain personalities. Try for more original names to fit your particular characters.

Sounds in cartoon names are important, too, just as the sounds of words are as important as their meaning in a poem. Weber's "Miss Creel" adds a quiet, flavorful note of truth to the totality of his character. Addams's "Mrs. Munson" is rhythmic and in keeping with the mood. Lorenz's "Sid" is a natural, snappy evolution from "Oog."

Names in captions can occasionally cause small problems. A cartoon of mine from Playboy showed a male executive in a Yellow Pages office pinching a secretary who shrieks, "Please, Mr. Moore, let your fingers do their walking someplace else!" Playboy subsequently received—and published—a letter of protest from a Mr. Moore who was actually employed as a personnel executive with the Yellow Pages. One of my very first published cartoons, in The Realist, concerned the old woman in the shoe seeking an abortion. The doctor's name was quite common, something that came to my mind as being ordinary. It turned out, according to his lawyer's letter, threatening suit (this being 1962 when abortions were not even mentioned out loud) that it was the name of a gynecologist listed in the A.M.A. On the other hand, a cartoon of mine in The New Yorker with the name "Bosworth" produced six requests to buy the original drawing. All pure coincidence.

While you try for some character, accuracy and the right sound to a name, it is safer to decide on one that is common. Or pick the name of a friend or relative whom you're reasonably sure won't sue you.

Finally, what's in a name that's your own? The last thing you'll usually do with a drawing is to sign it, and there are several considerations to bear in mind when you do so. First, remember that your signature is another visual element and so must be part of your drawing's overall composition. Place it where it will not distract from the cartoon itself, but will help compose it. Use restraint and do not adopt a signature that looks as though it belongs on the Declaration of Independence. Sign your name simply so that it's not only legible, but will still be

after you have done it a few thousand times. I say this because I know my own signature—and those of several of my colleagues—is virtually indecipherable, and probably bad business. Your name in print is a great advertisement for yourself—so let it be read.

And that is it—a good deal of what you always wanted to know about how to create magazine cartoons. Now, since you have come this far, you are probably interested in how to go about selling them . . .

7
Selling Them: The Way It Is

In the magazine cartoon world freelance cartoonists work on "spec," producing unsolicited material which is mostly rejected by the magazines which see it.

Tens of thousands of cartoons compete every month for only a few hundred spaces. At the top, it's a *very* tight squeeze. The New Yorker sees about twenty-five hundred ideas every week, from which fifteen to twenty are bought. That's about a one percent acceptance rate. Meaning that ninety-nine percent of the work submitted (mostly from the top professionals in the country) is rejected. Playboy probably receives even more submissions from a larger group of cartoonists and buys proportionately fewer.

Even at the middle and lower paying markets, there are many more cartoons being submitted than can possibly be bought. Looking at it mathematically, the chances of anyone—particularly a beginner—selling one cartoon from a batch to any given magazine are indeed small. This is the numerical reality of the business; it's simply what's so, and the sooner you digest that the better off you'll be.

Over the past fifteen or twenty years, the changing nature of magazines caused cartoonists to adjust their marketing approaches. In the fifties, any batch of cartoon roughs might have appealed to a dozen or so "general interest" magazines, so the cartoonist had that many "first" chances to sell his weekly output.

Most of today's magazines, however, appeal to different special interest groups—so the same batch of ideas will not "travel" around as far, and a "category" of magazines might mean only three. The cartoonist who chooses to sell a range of magazines must take the time to study them and assemble his batch for submission with care. Submitting cartoons which are editorially inappropriate for a magazine's audience makes a poor impression on an editor; it implies that you do not have the magazine's needs in mind. Good Housekeeping material is not welcomed at Playboy, and vice is certainly versa.

There are other realities about the cartooning business to bear in mind. Editors change. The one who bought so much of your work is replaced by another who hates every line you draw. (Of course, the reverse is also true.) The money comes in slowly, irregularly and, if you compare it with the income of lawyers, brain surgeons and computer programmers, inequitably. Frequently a magazine folds, or doesn't pay you, or rejects something it has held for six months, or loses a drawing, or spills coffee on it, and sometimes the post office mutilates it. Murphy's Law certainly applies to freelance cartooning: if things can go wrong, they will. My philosophy is, "In freelancing, nothing has happened until you see it in print, or the check has cleared at the bank." (That used to be "until you receive the check," until one of them bounced.)

But the most important everyday reality to face is that a cartoonist is a freelancer, which means he has, or develops, certain special personality and working traits; freelancers do not make it on talent alone.

For one thing, the professional cartoonist incorporates systematic rejection into his life—he handles it, one way or another, and lives with it so that it somehow works *for* him instead of getting in his way.

The freelance cartoonist must have strong self-discipline and self-motivation. He tells himself *what* to do, *when* to do it and how much time to do it in, every day of his life. This is not as easy as it sounds. The ability to structure and manage time effectively is crucial to the success of a freelancer. And that includes the capacity for creative goofing off, when on one of those terrible days, you cannot think or draw a thing.

Some cartoonists find that they write best in the morning and draw best at night. Some work all night long while others keep regular nine-to-five hours. It doesn't matter *what* your work schedule is, as long as it works for *you*. Part of the self-discipline is to be able to work on a timetable that's often out of synch with the rest of the world. And then to be able to change it and work in a different way.

Cartoonists are resourceful. They can take an idea used in one form and reshape it for something else. Mischa Richter took his New Yorker multi-panel cartoon about a quacking duck and turned it into a children's book. My syndicated cartoon panel, "Hang In There!" was first a rejected book idea.

Beyond anything else, the successful cartoonist is persistent. I think it was Woody Allen who, when asked what the secret was to being a successful freelancer, replied, "Just showing up." Week after week, the cartoonist sits down in front of a stack of blank paper and regularly turns out a dozen new ideas, even though each time he begins he wonders if he'll come up with even one. And then, week after

week, he offers them for sale, knowing that most will never be bought.

So why go through all this? What's the return? Well, it basically comes down to this: a cartoonist is a person who *enjoys* sitting alone in a room when he chooses to, making funny drawings on small pieces of paper. It's a world of his creation, under his control, and he loves living it more than any other. While most people are unhappy working at what they do, the cartoonist does his thing twenty-four hours a day and is happy. And even if he didn't get paid for it, he would probably draw anyway; it's almost a reflex. He doesn't think of cartooning as work—to him it's mostly play. And that's difficult to value in dollars.

There are, of course, more tangible payoffs. The successful cartoonists who sell the big markets regularly can earn quite respectable livings; some, also working in allied, higher-paying fields like advertising, can become very comfortable. In addition, the well-published cartoonist has an avenue of self-expression open to him and audiences of millions. He chooses his own subjects and uses a variety of forms in which to communicate them. He is limited only by his imagination, ambition and talents. He may possibly achieve some degree of world fame, but even if he doesn't, he gains the recognition and friendship of his peers, a most valuable reward. I know of no finer group of human beings than cartoonists. I may be prejudiced, of course.

It's not easy to be a freelance cartoonist. You really have to want to do it, no matter what the difficulties, problems, resistance; no matter what the numerical odds are against you. Most professionals have not chosen cartooning as much as cartooning has chosen them. If you'd like to be a cartoonist because you think it's a fast and easy way to get rich and famous; if you think of writing and drawing as a chore; if you don't like being alone during most of the day; if you cannot handle rejection and get discouraged easily—if you even have to ask yourself, "*Shall* I be a cartoonist?" then, as Mischa Richter says, "It's better you shouldn't be one."

Once you've acknowledged to yourself that you really are—and must be—a freelance cartoonist, than go about it in an efficient, businesslike manner. It may be a bit dull, but learn the mechanical procedures and details and how to handle them. Then when you get rich enough to hire a staff to take care of things for you, you won't feel a thing.

PREPARING BATCHES FOR SUBMISSION

There are about eight to fifteen roughs in an "average" batch, but there's nothing wrong with showing more or less. The purpose of a rough is to sell an idea; it should look presentable and in no way distract from its content. Roughs should always be clean (no coffee stains, folded edges or teardrops, please), with plenty of white "breathing" space around the drawing, with the caption underneath, lettered neatly in pencil (because it's easier to re-write), with no misspellings, inside quotation marks. The back of each drawing should be rubber-stamped with your name, address and telephone number.

Cartoon roughs are most commonly drawn on white, 8½-by-11-inch paper, at least sixteen-pound weight. Heavy typing paper is popular because of its sturdiness and versatility in use with many media. This size, most comfortably handled by editors, fits into standard boxes, folders and files and is less likely to be crumpled or lost.

Cartoon roughs are your wares, your inventory, and since they'll probably get a lot of handling, they should be packaged to stand up to abuse. Roughs are mailed flat, in manila envelopes, 9-by-12-inch for 8½-by-11-inch size roughs, with a *heavy* 8½-by-11-inch cardboard stiffener to protect them against post office attacks. (Another reason for the popularity of 8½-by-11-inch size roughs is that they cost less to produce and mail. Larger sheets of paper cost more, require larger cardboard and envelopes, and so become heavier packages, thus requiring more postage.)

Along with the roughs and cardboard, fold in a self-addressed envelope of the same size and with the same amount of stamps. This is what's known as an "SASE," and should be used for all your unsolicited submissions. Work not accompanied by an SASE may be lost or delayed in getting back to you.

Address your envelope to a specific name at a magazine (look it up); it's much preferable to the less interested "Cartoon Editor." Both envelopes should also bear your name and return address, be marked First Class or Third Class, and carry the plea, in large, thick block letters that a six-year-old could read, PLEASE DO NOT BEND. Unfortunately, some postal employees regard this the way a bull views a red cape, but it may afford some protection. And buy yourself a small postage scale so you can stamp your envelopes in your studio,

instead of constantly having to run out to the post office and wait in line. Get used to the idea that a freelancer's time is valuable.

Students often ask about including explanatory notes. It's really not necessary, since it's obvious that you are offering cartoons for sale. If you are a yet-unknown cartoonist there's no need to introduce yourself as such; the editor will know it. Once you establish a relationship with an editor, of course, a short greeting is fine. But forget the long soap operas about your ambitions, your grandmother who needs an operation or your longtime admiration for the editorial direction of the magazine. Your creativity should be reserved for your cartoons. Nothing else is going to influence its sale or rejection. To strengthen your initial presentations, though, you could include a clip of some previously published work or a finished drawing that will show an editor what your best efforts look like.

KEEPING RECORDS

During his career a professional cartoonist creates thousands of cartoon roughs, which he circulates among dozens of markets. To keep track of them, he must use some kind of record-keeping system. My own is simple and ordinary. I have a ledger notebook ($2.49 at Woolworth's), set up with columns for the date when I did the rough, its chronological number (my last one was #6503), a description or abbreviated caption and where and when it was sold or "held." The rough itself is numbered on the back, under my address stamp.

When I prepare a batch for submission, I make a list of the cartoon numbers for my own records, and file them in the corresponding market folder.

Sam Gross, who is one of the more organized cartoonists I know, keeps all his roughs (or copies) in chronological order (after twenty years he has over eight thousand, not counting the thousand he's already thrown out), in twenty stacks of loose-leaf notebooks. He notes directly on each one all pertinent data about a rough's adventures in the marketplace.

Most cartoonists also devise a system recording which magazine has seen any one cartoon. Some use tiny numbers from 1 to 50, shaped in a square, stamped on the back under their address stamp. Each number represents a different market, and the number is dotted or circled when the rough is returned. Others (like me) mark the letters and numbers in their address stamp, according to a "secret" code. And some don't mark the roughs at all, but record all submissions in tiny notebooks (like Handelsman) or card files. A few, who do little marketing, keep no records at all.

If you intend to sell your cartoon to a number of markets, devise *some* system. It not only makes the selling effort easier, it can also be the basis of your annual income record which, for a freelancer earning from many sources, can get complicated.

It is also useful to set up a filing system which gives you quick and easy access to your roughs. I set up a folder for each magazine I intend to submit to and stock it with appropriate roughs. I also have folders containing cartoons in subject categories like "Politics," "Business," "Winter," etc. It's not perfect, but it's good enough for me, for the marketing I do.

Keep your own system simple, whatever it is, but set it up right at the beginning. Later on, when you're knee-deep in roughs, it will be impossible.

So much for mechanical considerations.

METHODS OF SUBMITTING

Cartoonists submit their work through the mail or by visiting magazines on "look" days, traditionally Wednesdays, set aside by editors to see freelancers, with no appointment necessary. Students often ask if they have a better chance of selling work in person. I don't think it makes much difference in single-panel cartoons. I've had them bought and rejected both ways. Sometimes being unseen is a plus.

One of my very first sales was made to Esquire on a submission I mailed from San Miguel de Allende in Mexico. Encouraged by the acceptance, a few months later I returned to New York, brimming with optimism as a brand-new freelancer, and went straight to Esquire to offer my work in person. The editor, Jerome Beatty, Jr., raised his eyebrows.

"Mort Gerberg?" he scowled. "What are you doing here? I thought you were living in Mexico."

"I was, but I came back," I said weakly.

"You should have stayed in Mexico," he shrugged.

And for one reason or another, I didn't sell another cartoon to Esquire for another ten months.

When you visit an editor on look days, it's usually on a first-come-first-served basis; you go in when it's your turn. You hand the editor your batch of roughs and sit and watch (or pretend not to) as he

leafs through your drawings, holds out a couple and gives most of them back. After he's selected the "holds" for the week from all the cartoons he's seen, he weeds the batch down, then presents them in a meeting with other editors, where the okays are decided. On your next visit you pick up your holds and any okays, show another batch and the process is repeated. Finished drawings of previous okays are also handled here.

In submitting through the mail, the hold stage is often eliminated. The magazine simply returns them, with or without an okay. Some magazines include notes about holds, which ideas "almost made it" and other hints, but generally your drawings are returned to you with an impersonal, printed rejection slip.

Rejection, as I've explained before, is an integral part of the cartooning business, and while nobody loves it, you must recognize it as a fact of life and try not to take it personally. That, of course, is much more easily said than done. But just because your work is turned down doesn't mean you're a bad person. Cartoons may be rejected for many reasons other than quality. For one thing, the magazine may have published another cartoon similar to yours. Or just bought one the previous day. (Believe it, cartoonists *do* come up with exactly the same idea independently of each other.) The editor may be suffering from a hangover. Or have a secret loathing for the subject of your joke. It may simply be a matter of bad timing and what the competition was like that week.

Professional cartoonists often resubmit roughs which they feel particularly strongly about, either in their original form or with some slight alterations. Some are resubmitted many times to the same magazine and sold years later. Cartoonists, since they're always thinking "What if?" often anticipate real life far in advance. Remember, there's really no such thing as a rejected cartoon; it's merely an idea whose time has not yet come.

Sam Gross tells of Lee Lorenz, the editor at The New Yorker, looking through a batch of Sam's roughs, holding one up and asking, "Haven't I seen this before, Sam?" To which Sam replied, "You're damn right, and you'll *keep* seeing it until you buy it!"

One advantage to submitting your work in person is that you get an instant decision, thus enabling you to circulate the rejects to other markets right away. There is also an opportunity to talk to the editor to learn what you're doing well or poorly as far as that magazine is concerned. But before you do, ask the editor if and when such a conversation would be appropriate.

Another attraction to "making rounds" is meeting your colleagues. Although today's rounds do not compare with those of the fifties in size, cartoonists still enjoy and get value from simply joining with the only other people in the world who really understand what it is to be a cartoonist.

Marketing through the mail is a more lengthy process. While professional practices suggest that magazines process and return submissions within two weeks, many take much longer. Knowing and anticipating which are slower is a consideration when you set up a marketing plan, particularly when you're offering seasonal cartoons, which may be bought five months in advance of publication. Also, waiting for the postal system to deliver mail on time is like waiting for Godot. On the other hand, submitting through the mail permits you to react to rejections in the privacy of your own studio, allowing you to scream out your anger and frustration, which is not considered good form to do at an editor's feet. There are pluses and minuses to everything.

MARKETING APPROACHES

The approaches to marketing cartoons span two extremes. At one end is the cartoonist who offers his work only to a few top markets, returning the rejects to his files for reworking, for use in other forms or just for "aging," later to be resubmitted. The time and effort this cartoonist might expend in more extensive marketing is devoted instead to working in other "out-of-the-box" areas, which I'll discuss in Part Two. Ed Koren, for example, submits his cartoons exclusively to The New Yorker and does commissioned illustrations for advertising, articles and books.

At the other extreme is the cartoonist who covers as many markets as he has time and roughs for. Between making rounds and full-scale mailings, he can keep fifty batches of ten cartoons each constantly circulating. Henry Martin and Sid Harris are particularly successful at searching out and hitting large numbers of magazines, large and small, covering a wide variety of interests.

Obviously, most cartoonists fall somewhere in between, and also vary their approaches as their pro-

fessional needs change. But whether you're trying to sell a few or many markets, it's important to follow a regular schedule, to establish yourself to an editor as someone who is serious about cartooning. You make an impression by submitting every week or so, not just two or three times a year. Set a production quota for yourself and stick to it, whether it be five or twenty-five a week.

Given the mathematics of the competition, it takes more than one batch to make a sale or a career; this is where your desire and persistence are tested. For example, many of the top cartoonists at The New Yorker tell similar stories of religiously submitting their work for months, sometimes years, before even receiving an acknowledgment, let alone a sale. For some, even the second and third sale came only after another long stretch of silent rejections.

Bob Weber's path to the top of cartooning, for example, was full of twists and turns. He was a fashion illustrator, disliking it most of the time and started cartooning.

He began doing roughs about 1953 and took them around to magazines like the Saturday Evening Post and Collier's. In that first year he sold only eight cartoons, not nearly enough to quit fashion illustration. "I realized," says Weber, "that I had trouble with ideas that would sell to that kind of market . . . but I felt I could draw well, so I made up a portfolio of just cartoon drawings and started taking that around to art studios and advertising agencies and getting assignments."

For about eight years he earned a living from ad and magazine spot drawings, film strips and slides, and didn't bother with cartooning until Harold Hayes, the editor of Esquire, called. He had noticed Weber's drawings in Pageant and asked if he had any cartoon ideas.

"Well, I *did* have some stuck away somewhere," recalls Weber, "so I drew them up fast and took them over. . . . He called me back in a matter of hours and said they were buying four of them. That really juiced me up. I started to do work for Esquire and really enjoyed it."

The sales to Esquire were "a kind of validation . . . and I thought, the Saturday Evening Post doesn't want this kind of stuff but maybe The New Yorker would. So I started doing ideas and leaving them at the twentieth floor. I got into it very seriously . . . it was a big campaign for me . . . I decided that if I was going to get into The New Yorker, from everything I'd heard I was going to have to do it consistently.

"I told myself this was going to take a long time and I would have to put my need for acceptance and my terrible distaste for rejection in the closet for a while and just plow through. I did a batch of seven or eight every single week . . . never sold anything. Once I wrote a little note saying, I've been doing this for six months now, what do you think of my stuff? The note came back with the same old rejection slip.

"And then, one day a year later, they called me and said they wanted to buy two of the ideas . . . it was okay for me to draw one . . . they wanted to buy the idea for the other and give it to someone else and I asked if I could draw both of them, and they said, oh, okay. So they bought both drawings . . . That unlocked the floodgates of my creativity, and I started getting ideas coming out of my eyebrows . . . and I sold them a year's worth of work . . . about forty drawings . . . in a couple of months."

Weber's is certainly a success story but it didn't happen overnight from one batch.

Henry Martin, for another, remembers submitting twenty cartoon roughs every week for four years to The New Yorker before hitting.

Of course, bear in mind that both were selling to other markets at the same time. Bob was doing spot illustrations, and Henry was selling spot drawings and illustrations to almost every other magazine, including one called Dare, whose title was printed backwards so that it could be easily read in the mirrors of barber shops, where it was mostly distributed.

Since the competition at the top is, naturally, the toughest, most beginners break into the field by offering their first work to smaller, lower-paying publications. Here you have a better chance to sell, receive critical reactions to your work and learn how it looks in print. Beginners might still submit to the tops, to indulge the long-shot, instant-stardom fantasy, but the smaller markets are closer to reality.

If you're seriously interested in a career in cartooning, you must explore it in a businesslike manner, as Lee Lorenz advises: "Anybody starting out should pick out at least a dozen, twenty markets, if they can, and begin to circulate every week. The key to a career here or anywhere else is consistency. Many people can sit down and do two or three

good ideas and say, Wow! Hey, how come you don't buy one of these? Well, I *might* buy one of them but I'm much more likely to buy something if week after week I see the stuff coming, and I'll say, Hey, he's got something; but I can't see that from three ideas or three weeks of ideas.

"My standard reply to people who say they want to cartoon," says Lorenz, "is fine, pick out your markets, commit yourself to producing at least twelve cartoons a week and start sending them out, and do that every week for six months and then see what you've got. And if you don't get any response from anybody, maybe you'd just better forget it."

Make sure you know your markets before you approach them. Leaf through back issues of magazines in libraries; browse the new ones at newsstands. Learn what magazines look like, what kinds of cartoons and articles they run, how much space a drawing is allowed, how good the reproduction is. In addition, look at professional guides like Al Gottlieb's Gag Recap publications (described fully in the Marketplace and Resources section), which are excellent aids to discovering a magazine's cartoon tastes. Every month the Recap describes and credits all the cartoons published in about thirty magazines, and includes the address, the name of the editor and the rate of pay.

You'll usually compile your market plan according to a pecking order of price and prestige; the top markets getting first look, and so on down the line. You should also check through lists of trade magazines, which appeal to audiences with highly specialized interests, like tractors, computers or flowers.

While the pay scale of the trades is much lower than the wider-circulation general interest magazines, if there's a trade journal that speaks directly to your own secret passion, it could become a natural showcase for your cartoons and a launching pad for your career. For one thing, it's easier to create from your own personal experiences, so you'll feel comfortable with the material and be able to produce enough roughs to make frequent submissions and confidence-building sales, and learn from seeing your work in print. Also, while the trades don't pay much, in the freelance world there's a lot to be said for *any* regular income.

And this leads to the obvious question: How much money can a freelance cartoonist make from magazines? In general, the answer is not nearly as much as you imagine. From sales to magazines only, the highest percentage of professional cartoonists probably earn less than $12,000 a year. Of course, as in the case of any profession, the top two percent can earn double and triple that.

The rates paid for cartoons are almost always determined by the magazines; professional practices suggest that the same minimum rate be offered to all, and that individual cartoonists may ask for and negotiate a higher rate. Minimum rates at trade publications can go as low as $5 per drawing and range up to $50; an average trade rate might be $20. An average minimum rate for a one-panel black-and-white cartoon at the larger general magazines is about $150 and ranges up to $400 at The New Yorker and $350 at Playboy. However, artists under contract to these two magazines receive higher minimum rates plus incremental increases tied to the number of cartoons sold, bonuses and other benefits. With or without a contract, the amount a cartoonist earns still depends on how many he sells and where he sells them. Obviously, it's more desirable to sell five at $200 each than two hundred at $5 each.

Cartoonists, particularly those who appear frequently in the more prestigious, large-circulation magazines, earn additional income when their cartoons are reprinted by other magazines, book publishers, foreign journals, advertisers and others who use the cartoon to support their special interests. Reprint fees are more negotiable and are determined by the type of use, ranging from about $25 for a small college bulletin to $300 for use in Newsweek and $500 or more for an appearance in an advertising promotion.

Cartoons can earn additional money in advances and royalties when they are published in book collections.

Still other income accrues from the sale of originals to a public which has recently become more aware and appreciative of the art in cartooning. Drawings that appeared in The New Yorker, Playboy, Ladies' Home Journal and National Lampoon, for example, are now bought regularly for $200 and up, depending on reputation and skill at negotiation.

While you cannot count on it, this ancillary income—beyond what you receive from the initial sale—is always possible, so it's very important that you learn right from the outset to reserve "second rights" when you sell your cartoons. This means

that if anybody other than the original publisher wants to use that cartoon for any purpose, you have the authority to grant the permission and the conditions of use.

The simplest way to accomplish this is to specify, wherever possible, when you deal with a magazine, that you are selling "first publication rights" only. Most established, reputable magazines, such as those listed in the Marketplace and Resources section, respect and follow this practice automatically; the smaller ones may have to be reminded. (The New Yorker and Playboy buy all rights, but in practice turn over all reprint fees, "original" sales and other referrals to the individual artists.) The amount of ancillary money involved is normally not comparable to the royalties from the sale of a book, a movie or a song, but a cartoon does have once and future value.

The matter of second rights can be confusing, but it's essential that a cartoonist understand clearly the terms of his sales agreement. You may choose to sell your cartoons under "work-for-hire" and other undesirable conditions—as an independent contractor, it's your privilege—but you should not do so out of ignorance or the feeling that it's not important. The classic case in point is that of Jerry Siegel and Joe Shuster who, as young artists in their twenties, created a cartoon character called Superman, signed away their proprietary rights to it and lost a fortune.

Learn about second rights and the copyright laws governing the use of cartoons and begin practicing proper professional marketing habits. They'll not only benefit you, they'll also help your colleagues and continue the elevation of the cartooning profession. For detailed information on the subject, look at Tad Crawford's book, *A Legal Guide for the Visual Artist*, and contact the several professional organizations listed in the appendix.

In addition to rights, there are certain desirable practices developed by professional organizations in cooperation with many magazines, which you should know about and observe. Among them are the following:

1. Magazines should pay on acceptance of your drawing, never upon publication. (The magazine may go out of business, the drawing may get lost, a new editor may arrive and hate it, and you never get paid.)

2. After the drawing is published, it should automatically be returned to you. (The magazine buys publication rights, not original art, unless otherwise specified.)

3. Roughs should be returned within two to three weeks.

4. All requests for reprint or sale of originals should be forwarded to you for handling, unless you arrange it otherwise with a publication.

5. Editors should never rewrite your captions or change your drawings without your prior consent. (When Norman Cousins edited the Saturday Review, he would drive cartoonists crazy by occasionally "improving" captions. Cartoonists never thought the changes were for the better and protested loudly until he stopped.)

6. It is not considered good form for a cartoonist to submit the same cartoon idea to more than one magazine at a time. (How would you explain retracting your offer from magazine A if magazine B buys it?)

7. It is bad form to offer a magazine a cartoon which you have previously published, unless you specify that you are selling a reprint.

8. It is *very* bad form to offer a magazine a cartoon which was published first by another cartoonist. (It's a very small field, remember, and everybody sees everything.)

A complete guide to professional practices may be obtained by writing The Cartoonists Association, Inc., the organization of professional magazine cartoonists listed in Part III. In that section you'll also find a list of selected magazine markets that will help you get oriented and set up your marketing plan. Consider this your push in the right direction.

And now, in Peter Arno's words, back to the drawing board.

Part Two
BEYOND THE MAGAZINES: OUT OF THE BOX

As I've already pointed out, over the past twenty-five years there has been a large increase in a magazine cartoonist's work "out of the box." While gag cartoonists of the fifties could make a comfortable living solely by selling magazines, today most of them do other things as well. Working in different forms is also stretching creatively, and cartooning skills learned in one area are always transferable to another.

Of course, this is a matter of personal taste; not everyone likes to work in all of these out-of-the box areas. You should at least try them out, though; you'll never know whether or not you'll actually *enjoy* doing a strip, for example, unless you have the first-hand experience. It may even happen that you'll discover, to your surprise, that you're better suited to a form other than one you've been concentrating on.

Nor should you limit yourself to activities described here; this is not the definitive list. These "other areas" were selected because they are the most popular, and because I've had some personal experience with them. The discussions are only overviews. Each area could fill its own book, but here I aimed mainly to relate them to gag cartoons.

An enterprising cartoonist will always find some new way to put his special talents to work for him. So start with the following, and then invent a few of your own. After all, being a freelancer only means that in your life *you* get to make up your own "games" and play them until it's time to create new ones.

8
Spot Drawings

Spot drawings are used in thousands of newspapers, magazines and books, as well as in promotion and advertising material, and therefore form an important "other" market for the magazine cartoonist. The payment for spot drawings is usually lower than for cartoons, but spots are used more consistently; a cartoonist may eventually develop clients who use his drawings regularly. For freelancers, any kind of steady income is highly desirable.

Spot drawings are basically decorative or conceptual, and while there are many varieties, all serve the same purpose of providing visual support to editorial material. Unlike cartoons, which stand on their own, spots are created to be used with text. An art director can make an article more attractive and understandable to readers by adding a visual dimension to it—a drawing that enhances or interprets. The magazine gag cartoonist, an expert in solving problems visually, is ideally suited for this work. In a sense, a cartoonist doing spots creates a type of captionless cartoon. Like a cartoon, the spot drawing should communicate an idea instantly, though it need not be funny. Imaginative and clever will do.

Decorative spots, like these by Henry Martin from The New Yorker, are design elements on a page. They can be of any subject and often come right from a cartoonist's sketchbook or doodles. The New Yorker uses a great number of spots in a wide variety of styles and shapes. Look through a

As I've already pointed out, over the past twenty-five years there has been a large increase in a magazine cartoonist's work "out of the box." While gag cartoonists of the fifties could make a comfortable living solely by selling magazines, today most of them do other things as well. Working in different forms is also stretching creatively, and cartooning skills learned in one area are always transferable to another.

Of course, this is a matter of personal taste; not everyone likes to work in all of these out-of-the box areas. You should at least try them out, though; you'll never know whether or not you'll actually *enjoy* doing a strip, for example, unless you have the first-hand experience. It may even happen that you'll discover, to your surprise, that you're better suited to a form other than one you've been concentrating on.

Nor should you limit yourself to activities described here; this is not the definitive list. These "other areas" were selected because they are the most popular, and because I've had some personal experience with them. The discussions are only overviews. Each area could fill its own book, but here I aimed mainly to relate them to gag cartoons.

An enterprising cartoonist will always find some new way to put his special talents to work for him. So start with the following, and then invent a few of your own. After all, being a freelancer only means that in your life *you* get to make up your own "games" and play them until it's time to create new ones.

8
Spot
Drawings

Spot drawings are used in thousands of newspapers, magazines and books, as well as in promotion and advertising material, and therefore form an important "other" market for the magazine cartoonist. The payment for spot drawings is usually lower than for cartoons, but spots are used more consistently; a cartoonist may eventually develop clients who use his drawings regularly. For freelancers, any kind of steady income is highly desirable.

Spot drawings are basically decorative or conceptual, and while there are many varieties, all serve the same purpose of providing visual support to editorial material. Unlike cartoons, which stand on their own, spots are created to be used with text. An art director can make an article more attractive and understandable to readers by adding a visual dimension to it—a drawing that enhances or interprets. The magazine gag cartoonist, an expert in solving problems visually, is ideally suited for this work. In a sense, a cartoonist doing spots creates a type of captionless cartoon. Like a cartoon, the spot drawing should communicate an idea instantly, though it need not be funny. Imaginative and clever will do.

Decorative spots, like these by Henry Martin from The New Yorker, are design elements on a page. They can be of any subject and often come right from a cartoonist's sketchbook or doodles. The New Yorker uses a great number of spots in a wide variety of styles and shapes. Look through a

few back issues of the magazine to get a feel of what is run. While many spots are done by established cartoonists, others may be the work of beginners trying to break in. Spots are submitted to and reviewed by the art director, Lee Lorenz, along with

the cartoons and covers. The New Yorker now pays $100 for a spot drawing and retains the right of rerunning it without limit, paying an additional

$10 for each use. If you've sold enough spots, and they continue to be rerun, the end of the year may bring you a respectable royalty check.

Other magazines may use decorative spots within special generic interests such as food, fashion, health and sports. (Many Sunday newspapers have special entertainment sections which use entertain-

ment-oriented decorative spots. This one from the New York *Times* by Liza Donnelly, for example.)

The majority of spots are used to help convey editorial ideas. There are drawings in newspapers and magazines which accompany columns on

everything from advice to Zen. They also run spots to illustrate articles, particularly when the subject is humorous.

The "ideas" in this type of spot are usually obvious; they simply visualize some aspect of an arti-

cle or feature, perhaps dramatizing a situation, like a person in a leotard standing on a scale, or hammering a nail, or looking through a microscope, or

watching television. These cooking drawings by Nicolae Asciu, which ran with food articles in the New York *Times*, are fine examples. Asciu's drawing style is humorous; his ideas range from simple to complex, so his work is as suitable for feature as for political material.

Newspapers also use spots whose "ideas" have more dimension, which resonate beyond the first glance. These are the drawings on the Letters and Op Ed pages of the paper, which seek to portray a concept, a point of view or statement about some topical issue. However, the statement must be that of the author of the article, not yours. Since you are being asked to illustrate someone else's opinion you must think from an "alien" point of view. That's part of the challenge in doing spots. It's also, says Nurit Karlin, who frequently illustrates for the New York *Times*, sometimes the most difficult.

The crux of this work is to distill a piece of writing to its essence, visualizing it dramatically and simply. For this reason, spots employ well-known abstract symbols, like dollar signs and national flags, and cliché situations like panhandlers and television viewers. (That's why cartoonists whose heads are filled with clichés are successful at spots.)

There are a few other considerations special to spot drawings in newspapers. Your drawing will often be reproduced small, perhaps two inches square, which means that not only must its concept

Mort Gerberg

Postal Reflections

To the Editor:

Jackson's chances of beating Ford hould be assessed in light of th

City obligations were telling us the New York Constitution requires that

these bonds and notes represented a paramount, first lien upon all revenues

ti
th
the
cor
dilu
R
cont
incr
give
unde
vital
othe
to a
troll
sup
stat
spr

which could be expropriate...

The Communist bloc countries view the financial prolem of the West with mixed feelings. As an oil exporter the Soviet Union benefits from higher oil prices, earning

Mort Gerberg

America, it constitutes 30 per cent of

ses
unch
few
e first
holders
mployes
ose re-

and, the
tax revy is to be
ligations
t to purf its label
r its conand been
e up

dollars raised. For cultural organiza
health and hospitals

Prof. Robert Axelrod in the American Political Science Review of March

cu
desp
More
the
sure
turn
Pres.
"coa
amo
split
cast
cand
Th
phre
Car
the
me
of

k
ect
leaughotion
plead
fact
they
other,
stem.
d inpoint
He is
ed by
s nor
imself
He is
y, and
plead
knows
ation,
e does
e.
ay be
says
l for
tion
ben.

1972, "by 1968 the unions contributed only one and a half times as many

tence, if they insisted on their innocence. Does a guilty plea under such circumstances have any relation to a defendant's actual guilt or innoce
custom of plea-bargain

be clear, it must be rendered sharply. Work in black and white line is generally preferred to tricky wash drawings; it's much safer. Newspaper tone can easily get muddy and illegible. The small space also limits you to using only the essentials; there is no room for frills.

Another part of the challenge of newspaper spots is that you must be able to produce *fast*—to "think on your feet." For a newspaper art editor, every day brings a new set of design and layout problems and a new deadline that must be met. The artist who gets the assignment to do a drawing for the following day is one who not only can be depended upon to come up with imaginative solu-tions and render them successfully, but who can do so in a matter of hours.

Spots often deal in abstract concepts which are not easily visualized, and it's worthwhile for you to try a few exercises for the experience. For example, can you come up with a single, eye-arresting drawing that says "Freedom" or "Tyranny" or "Truth" or "Exploitation"? Test your doodles on an audience. Show your sketch and ask, "What does this drawing say to you?" and see what responses you get. You'll quickly see that it's much more than a game; it's a great challenge. For your raw material, try picking subject headings at random from Roget's *Thesaurus*.

Excess fertility combined with selective elimination of offspring appears to be the mechanism by which organisms (including mammals)

New York Timeses are no longer dogeared. Obviously, all your news is not fit for Prince! Your best friend, PRINCE

Art directors keep card files of the names of illustrators and cartoonists whom they have worked with. From experience the art director knows what kind of visual solutions each artist favors (humorous, heavy-handed, profound); what art styles he uses; what type of article he is most comfortable with; how reliable he is and how prompt. These factors, plus the degree of rapport the art director has with the artist, are those which affect the art director's decision on whom he calls.

About nine years ago I used to work fairly regularly with an art director at the New York *Times* named Eric Seidman, who was, at various times, in charge of the News of the Week In Review section, Letters, and the Business and Finance section. I began by dropping off a batch of topical, captionless cartoons, asking him to consider them for the Letters page. Then, as part of my Wednesday rounds, I would phone Seidman to ask if he needed me to illustrate something for him. When he did, I would appear at the *Times*, read an article which he would hand me and, within a few minutes, hand him back some rough ideas. We would discuss them, Seidman would pick one, rush off to his editor to get approval, return to me and give me the go-ahead to finish the drawing. Sometimes I had until the morning. More often, I had to complete the drawing right on the spot. Seidman and I eventually developed such a rapport that we could decide on what I would draw within a three-minute call from a phone booth. I'm sure Seidman has similar relationships with other artists.

On Pages 128 and 129 are some spots of mine that accompanied New York *Times* letters several years ago, as did drawings here by Nicolae Ascui

and Lou Myers. At this writing, says Karlin, the *Times* is trying to plan ahead a little better, and sometimes assigns one artist a week's worth of Letter spots. The editor will usually choose which are to be illustrated; the rest is up to Karlin herself. For the record, the *Times* now pays $60 for a Letters spot; it may go a little higher in some of the other sections.

NICULAE ASCIU

Drawings which appear on the Op Ed page are like spots which have grown up. They are usually political in nature and deal with large and universal issues. These drawings by R. O. Blechman and Lou Myers are from the Op Ed page. Blechman's deals with French nationalism, Myers's with communism. Op Ed drawings usually are assigned a little further in advance of deadline and pay about $150.

I found doing newspaper spots very valuable. The process was always stimulating and served to remind me of the importance of concentrating on essentials. Also, the physical act of calling an editor

Nicolae Asciu (left),
R. O. Blechman (below),
Lou Myers (opposite top),
Arnold Roth (opposite bottom).

up and requesting an assignment gave me the illusion of being in control of my career. Besides, a drawing of mine in the newspaper was a good advertisement; you never know who will call you later with a job that really pays well. (That's the argument the *Times* offers to justify its low rates.)

For those whose work is not known, the best method of getting assignments is to prepare a portfolio and show it to the art director. The portfolio should be made up of examples of what your work would look like *in context*. If you'd like to do decorative spots for the Garden column, draw a dozen and cement them down in an actual column from the paper. Or select some favorite Letters to the Editor to illustrate and mount your drawings in the proper place on the newspaper page. If you're feeling particularly confident, pick a letter which was already illustrated and show the editor a better solution—yours. After you've shown the art director your portfolio, follow it by mailing another letter with your illustration until you get your first assignment.

The main difference between spot drawings for newspapers and those for magazines (besides money: magazines pay more) is time; usually you'll have more of it to complete your magazine assignment. Also, magazines are printed on much better

paper than newspapers, which means that your drawings will reproduce better, allowing you to use more detail and gray tones if you need them. These line and wash drawings by Arnold Roth, done for Esquire, utilize subtle gradations in tone which would probably have turned muddy on

newsprint. Arnold Roth's humorous illustrations also frequently appear in four color in a variety of magazines ranging from spots in TV Guide to larger display in Playboy.

Good reproduction is necessary also for delicate pen and ink drawings, like these by chas b slackman from New York and Forbes magazines. Slackman, whom I think of as the "Crosshatch King," draws "same size"; the original art is about 2½ inches square. When he delivers his finishes, he carries them in his wallet. (slackman works deliberately on a white, nearly transparent tracing paper, very lightweight, with a Hunt #104 pen point, which gives him a thin, uniform line; he redraws the line to add thickness.)

"Cartoonists create their own situation," he says. "I respond to other people's work." Slackman began as a cartoonist, but did not want to work "on spec." Now, having created his own style and a demand for it (he has done over three hundred movie review drawings for New York magazine) he commands top prices among illustrators.

Small spot drawings can lead to larger drawings, and many cartoonists have also ventured into full-size illustrations for newspapers and magazines.

Fine-line pen and ink drawings by chas b slackman (top right and right). Line and gray wash illustration by Arnold Roth (top left).

Obviously, these will pay even better. Prices vary, depending on the publication and the actual size of the drawing, whether black-and-white or color, and how it will be used. For more specific pricing information, look at the *Graphic Artists Guild Handbook, Pricing and Ethical Guidelines*, 4th edition, available from the Graphic Artists Guild. (See appendix.)

Books comprise another popular area for spot drawings. The subjects run the gamut, from self-help books on meditation, yoga, care of plants or pets, dictionaries or science. To get a direct sense of what kinds of books use spots—and how—invest an hour browsing in your local bookstore. The largest use is probably in light subjects and outright humor, where funny drawings play an important role in the success of a book. Recent examples which come to mind now are Lee Lorenz's cartoons for *Real Men Don't Eat Quiche* and its sequels, Ed

Koren's drawings for *How to Eat Like a Child*, Roy McKie's for *Sailing*, and Lou Myers's for *The Coward's Almanac* (one of which is shown here). In this type of book there may be between fifteen and thirty drawings. Other books, like a small French dictionary I once illustrated, or a book of limericks, or a diet book, may require only about a dozen drawings.

Payment for illustrating books is made in two basic ways. You may be paid a flat fee or an "up-front" advance against royalties from future sales of the book. When you accept a flat fee you relinquish any proprietary interest in it; you will not expect any additional payments from sales or merchandising spinoffs, if any, no matter how much the book may earn. For this reason, if you accept a flat fee, it should be large enough to compensate you not only for your time and talent in doing the drawings but include some additional money from

expected sales. Exactly how much is a matter of negotiation and the reputation and experience of the artist, as well as how much work is involved. The *Graphic Artists Guild Handbook* will assist you here.

If you think the book has potential for being a best seller, you might want to press hard for a percentage of its sales and spinoffs. Again, this will vary according to the value of the drawings to the overall presentation and the reputation—the "box office" appeal—of the artist. If you agree to receive a percentage, you'll probably receive less money up front. And if the book falls flat, you've gambled and lost. On the other hand, there are a lot of books on the best seller lists that are illustrated . . .

One other area to include under the heading of spots is reportage: going on location with a sketchbook to report—in drawings and some accompanying text—on some event or phenomenon. The sketches are quick, on-the-spot impressions, which may be used as is or as the basis for more finished work back at the studio. The usual approach is to fill a sketchbook with drawings, covering different aspects of the scene and then picking the ones that work best in a layout, the way a photographer will shoot several rolls of film for a picture spread.

Reportage is almost always done on assignment, since the investment of time, effort and money goes beyond the cartoonist's normal "spec" ventures. My own approach has been to go to a magazine and present an editorial idea as clearly as possible, outlining the areas of interest I would investigate. If the magazine is interested, I negotiate a fee for the final piece as well as a "kill fee," a lesser amount which is guaranteed in the event the material is rejected, and, if possible, reimbursement for some expenses.

My favorite reportage assignments were those connected with visits to foreign countries; in fact, many of my visits to foreign countries originated with magazine story ideas. Among those were pieces on an African safari, driving through Yugoslavia, and "swinging London" in the late sixties. On the domestic scene I did reportage on skiing in the Catskills, a tennis tournament, pro

Judith takes her spotting stance in the forward hatch . . .

Ann surveying the savanna with her ever-present binoculars.

basketball fans, karate championships, Greek nightclubs featuring bellydancing and the 1968 Democratic Convention in Chicago, the last being drawings only, to accompany someone else's article in the Saturday Review. This kind of reportage necessitated several pages in a magazine, something which was available in a number of magazines in the sixties. Shel Silverstein, Peter Porges and Ronald Searle are among others who used to do multi-page travel cartoon reportage.

Today, magazines have space limitations, so the reportage form is not used frequently as such. Variations are common, though, like these visual observations by Jim Stevenson about people watching the rain, from the Notes and Comments section

Pretzel man outside the Garden. A Milwaukee game means more business.

"All right, who's got 'em? Who's got Knick tickets? Who needs tickets tonight?"

Where else would you find a basketball fan with a lucite cane? Yeah — lucite.

"No question. Reed is a definite presence tonight... he's really muscling Jabbar around."

Mort Gerberg, from Greek Night Club reportage (drawings and text) from Hi Life magazine. Small drawings from sketchbooks can be cut apart and pasted together to form larger scenes. The couple at the table in the foreground was sketched separately from the dancer and the band.

The melody they're playing has a 500-year-old traditional flavor about it, but it's only a rock'n roll tune that was popular in Athens in 1962. And Sultana is doing variations on the twist.

of The New Yorker. Stevenson has spot illustrated a number of pieces in that section in the same way. Calvin Trillin and Ed Koren have collaborated on humorous reportage for The New Yorker.

To get yourself a reportage assignment you'll have to *show* an editor what you're talking about; few can imagine it. Give yourself some assignment; grab a sketchbook and go out and do it. To make it easy for yourself, choose a simple idea like "The Checkout Counter," of unquestionable interest to a woman's service magazine. Photostat the drawings you like best, then cut them up and paste up some layout, in proper magazine page size, including the text.

One of the attractions of this form is that it forces you to get out of the house and changes your pace, which is always refreshing. On-the-spot drawing also exercises your ability to think on your feet and to test your powers of observation. When you go out with your sketchbook, though, make sure you leave your self-consciousness in the closet. The surest way to attract attention in public (without getting arrested) is to start drawing. So be prepared to have people leaning over your shoulder as you work; they come with the territory.

In all cases your aim in spot drawings is to assist an art director in doing his job. You are being

Mort Gerberg, Democratic Convention reportage (drawings and captions) in Cavalier magazine.

An alternate delegate waiting with practised patience for a chance to get on the floor

Waiting for Hubert at the Hilton. He wore a gray suit, with white sweatsocks and brown shoes — and he never moved

Reading the daily Ramparts Wall Poster for news of the 'underground' activities. Like, "Where do I go?" "What shall I do?"

the morning after the nominations, with his generation in Grant Park — truly bloody but unbowed.

On the convention floor most of the faces were of old-line professional politicians — but here and there you could see some fresher, newer ones

Gerberg

large thoughts: a welcome opportunity to get it together metaphysically. An-

other man (*Fig. H*) seemed simply suspended, possibly hypnotized, perhaps unaware that it was raining. A seated man

in a battered hat and wearing no shoes (*Fig. I*) reflected general indifference. A lot of people used the lobby's col-

umns for support, executing the Moderate Lean (*Fig. J*); the Partial Lean

(*Fig. K*); the Full Lean (*Fig. L*);

or the Multi-Purpose Lean—leaning

plus eating plus reading the paper (*Fig. M*). Some people performed the

Free-Standing Eat, such as a man with an ice-cream cone (*Fig. N*). There

were several Two-Person Conference Units (*Figs. O, P, Q*), who would

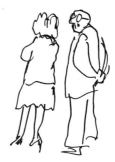

gaze at the rain for a while, then dis-

cuss it with each other, then look at it some more. A discordant note was

struck by a woman with an umbrella (*Fig. R*), who clearly had the option of going somewhere but chose not to. She created visible umbrella-envy. Fi-

nally, out on the sidewalk, there were the Umbrella Haves (*Fig. S*), the carefree few who were barrelling by, completing their errands, making their meetings, the rain rattling off their umbrellas, as the dry, captive Have-Nots stared at them from a few yards away.

asked to write and draw something that will satisfy a set of specific requirements, imposed upon your head by an outside source. You must "respond," as slackman says, to given material. The unique flavor of your solutions, your reliability and ability to work under pressure deadline situations, will largely determine your success in this area. Plus, of course, your willingness to invest time and energy in creating samples, then banging on doors to show them.

Overall, the experience of doing spot assignments will help sharpen your cartoon conceptions and also open your eyes to even other areas. Like children's books . . .

Opposite: Jim Stevenson's spot drawings from the Notes and Comments section of The New Yorker.

9
Children's Books

A magazine gag cartoonist has two talents that make him a natural for work in children's books: he communicates an idea instantly and he draws funny. Children's literature, from the elementary picture books through the I Can Read beginner books, requires that drawings be "read" and understood quickly, while simultaneously holding the child's interest and participation.

There used to be some resistance by publishers—it might have been a certain snobbism—to assign cartoonists as illustrators. That kind of work was reserved for "finer artists." The fact is, though, that children like funny pictures and funny pictures are best drawn by cartoonists. Today bookstore shelves are filled with children's books illustrated with cartoons. Many are done by illustrators who have adopted a cartoon style; many more are by well-known cartoonists, past and present, including Jim Stevenson, Frank Modell, Ed Frascino, Ed Arno, Gahan Wilson, Ed Koren, Syd Hoff, Shel Silverstein, Mike Thaler, Bill Woodman, Whitney Darrow, Jr., Bud Handelsman, Barney Tobey, Lee Lorenz, Mischa Richter, Maurice Sendak, José Aruego, Bob Kraus and myself. Several of these, notably Sendak, Aruego, Thaler and Kraus, now devote themselves exclusively to the children's field.

Cartoonists can work in several ways in children's books: they may illustrate somebody else's story, they may write and illustrate their own story, or they may write a story that somebody else illustrates.

Cartoonists who illustrate another's story are usually called upon because their drawing style, already known to the editor or writer, seems most appropriate to the book. Examples of this are Bill Woodman's zany drawings for *The Spider and Other Stories* and Ed Frascino's warm cartoons for *It'll All Come Out in the Wash*. The first children's book I illustrated was a joke-and-riddle book called *Ghostly*

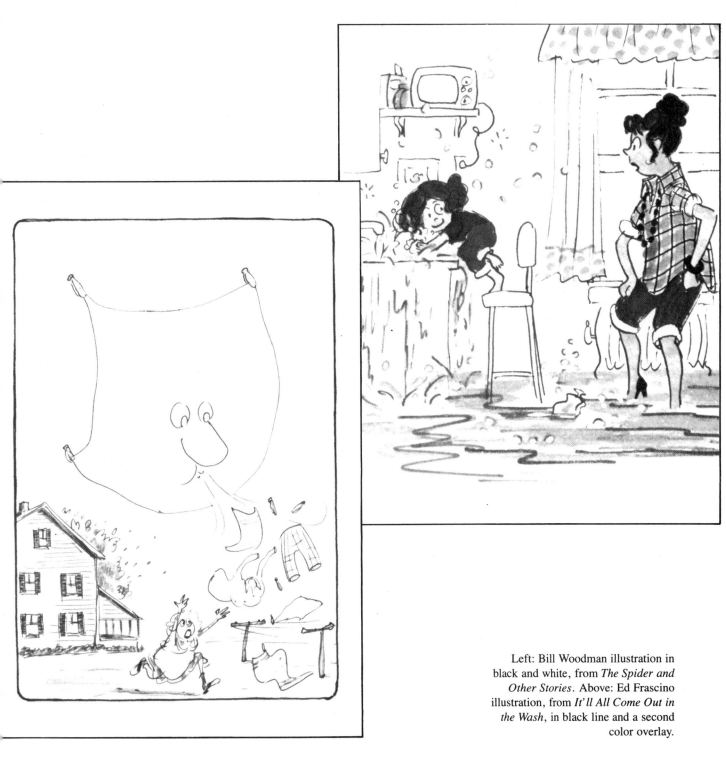

Left: Bill Woodman illustration in black and white, from *The Spider and Other Stories*. Above: Ed Frascino illustration, from *It'll All Come Out in the Wash*, in black line and a second color overlay.

Giggles, written by Ann McGovern, who wanted loose, sketchy line drawings, like mine. She called and asked if I'd be interested in illustrating it. So I did a few sample drawings of her text and presented them, along with some of my published cartoons, to the publisher's art director, who gave me the assignment. Barney Tobey recalls that his first children's book assignment was on the strength of the children he had drawn in several New Yorker cartoons.

Ed Frascino called on publishers for his first assignments, showing them only his published cartoons; he hadn't drawn anything special in the children's book mode. He was given a manuscript and asked to select a page and illustrate it however he wished, using three-color separations. He did so, passed the "test" and got the book. Other assignments followed regularly; by now Frascino has done about twenty-five books.

If you have never illustrated a children's book and are preparing a portfolio, the bulk of your samples should be your cartoons. The way you draw your cartoons is your basic style; it's what you are "selling." You might also, however, include examples of techniques other than those you usually work in—pencil, crayon, brush and wash—to indicate a technical range. And, if you have expertise in some special interest area, include a selection of drawings about it; for example, tropical fish, or birds, or skiing. It's always possible that the pub-lisher will receive a manuscript on that subject in need of authoritative illustrations like yours. Another good example for a portfolio is a color separation (which I'll discuss a bit later). It's also useful to include a rough dummy of a picture book to give an editor an idea of how you handle design and continuity.

The ability to maintain continuity over thirty-two or forty-eight pages is essential to illustrating children's books. It's something which cartoonists who have concentrated on single panels may need to work on. As an exercise, which then can be used as a sample, choose some favorite well-known story, like *Goldilocks*, and do a dummy of it. The aim would be to create a certain pacing, a rhythm that blends the words and pictures so they become a single, seamless unit, flowing smoothly from the first page to the last. Regard spreads (facing pages) as one large space and arrange drawings, text blocks and white space so they help move the eye, in the same way you consider various elements in the composition of a one-panel cartoon.

I find it most convenient to work small, perhaps half-size, in making a dummy. I'll take eight sheets of 8½-by-11-inch paper and fold them in half, then number the resulting pages from 1 to 32. The subject matter might help determine if the book should be horizontal or vertical. Title and copyright take a few pages, so begin the story on page 3 or 5 (odd numbers are always on the right).

Break it apart and arrange the paragraphs so that the text and pictures move your eye from left to right. Indicate text by drawing horizontal lines or by pasting down copies of the actual typescript. Make sure the pictures on the spread relate to the words they illustrate. If you don't like a particular spread and wish to change it, you can always patch it or redo it entirely on another sheet and paste it into position.

The drawings in a dummy are usually very rough; they're "thumbnails"—doodles of figures and indications of expressions, which may also be cut out and pasted down. My dummy for *The Biggest Sandwich Ever* was very small (four-by-three inches) with minimal sketches that only hinted at what I knew was going to be a series of detailed, complicated spreads. Since this was my third book for the publisher, these jottings were enough to tell the art director what my final art would look like. Notice how I just scribbled in the text to indicate where it would break.

My dummy for *Mr. Skinner's Skinny House*, which

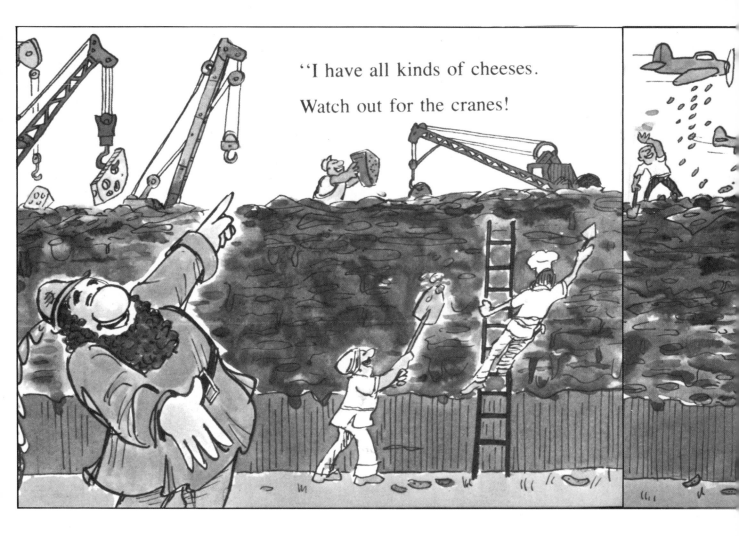

And plenty of pickles.
Just look at
those planes!''

The dummy (pages 144, 145) for
The Biggest Sandwich Ever was
actually about half the size of the
final art and contained only the
barest indication of what the
complicated action would
eventually look like. Compare the
roughs with the finishes here.

Then he banged
on his pot
and he shouted,
''I'm through!
My sandwich is
ready.
I love it.
I do!''

And we shouted
right back at him,
''We love it too.''

was also written by Ann McGovern, though, was more comprehensive. The long, thin shape was integral to the design concept of *Mr. Skinner's*, and I wanted a clear agreement with the editor about that right at the start. The final art was very much like the original rough.

Whether it's rough or finished, a dummy is like an outline to a writer; it's a blueprint of what you will draw. The more "realized" the dummy, the closer you will be to the finished drawing.

When doing one-panel gags, the cartoonist treats each as separate and independent of the next. In a children's book, however, he must concern himself with creating a continuity through a number of drawings.

Lee Lorenz, who has illustrated a variety of chil-

dren's books, thinks that "It's more demanding than doing a cartoon in a lot of ways. You're illustrating a story over thirty-two pages, so the character has to look the same on every page. You can't have a doorknob on one side of one page and on the other side on the next page. You have to take the kind of pains you don't ordinarily take in cartoons, which doesn't mean you're not careful in a cartoon; you have to pay a different kind of attention to what you're doing to make these things consistent, like doing a little movie."

Also, children's book editors like a lot of detail in their illustrations; "extra" objects, characters and even background action that makes just looking at the picture an adventure for a child. In my *Biggest Sandwich* book, the accumulation of "things," in

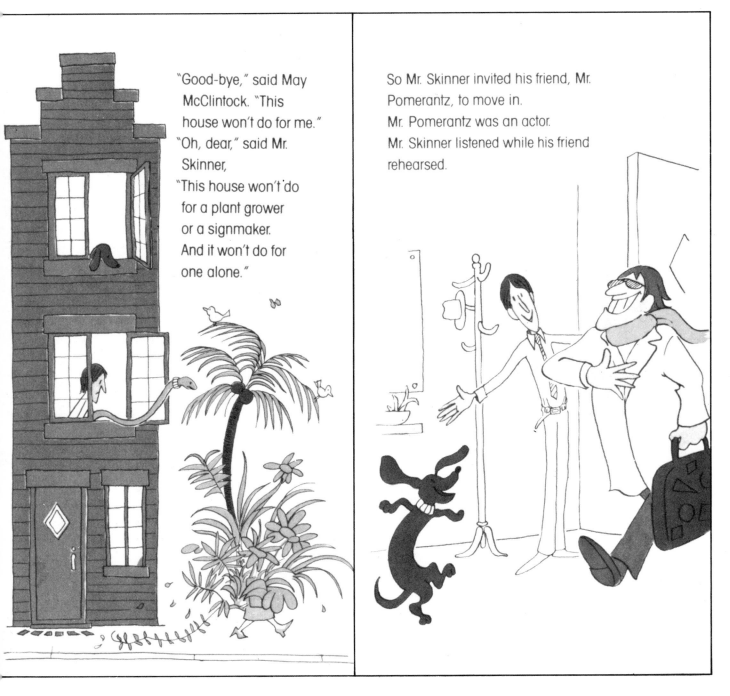

"Good-bye," said May McClintock. "This house won't do for me."
"Oh, dear," said Mr. Skinner,
"This house won't do for a plant grower or a signmaker. And it won't do for one alone."

So Mr. Skinner invited his friend, Mr. Pomerantz, to move in.
Mr. Pomerantz was an actor.
Mr. Skinner listened while his friend rehearsed.

fact, is central to the basic idea of the story, and the source of the crazy fun in it.

In drawing for children you have to spell things out very clearly. "A cartoon is a kind of shorthand," says Lorenz. "In The New Yorker we can assume that a reader brings an awful lot to it, but in kids' books you have to assume they're not bringing anything to it, and a cartoon that seems consistent to you may not be consistent to a six-year-old."

Another difference between drawing magazine cartoons and illustrating children's books are the mechanical production considerations. Cartoons are almost always black-and-white renderings on a single sheet of paper. Children's illustrations often have at least one color besides black and are invariably more involved. There is, as Ed Frascino says, "the technical aspect of preparing the art work."

A simple two-color book, for example, where an area of solid color or percentages of that color are printed over a drawing in a first color (like black),

requires that you provide overlays for the second color. This is color separation. A common way of doing it is to tape a piece of heavy tracing paper, vellum or clear acetate over the drawing and on it "color in," using gray tones, the areas where the second color should go. There are also various mechanical aids for doing this, like acetate sheets with adhesive backing such as Ruby Lith, which you press on the second color area. Make sure your overlay is properly registered beforehand; draw or paste (from a roll you buy in an art store) cross-hair registration marks on the drawing, then position others on the overlay so they are exactly aligned with those underneath. The overlay art is photographed by itself and made into a separate plate that prints the second color.

If you have two colors to work with, you can create a third, by mixing the two in varying percentages. For example, a forty percent red mixed with a thirty percent black might give you a rust brown, depending on which red ink (out of hun-

(A) This is the 100 percent black line drawing, on illustration board, of the scene on page 29 of *Mr. Skinner's Skinny House*.

(B) The 50 percent blue overlay. The drummer's shirt appeared in this color; the asparagus stalk emblem, printed on the 100 percent yellow drum, appeared as a light green.

(C) The 100 percent blue overlay. The bass player's pants appeared in this color; the electric guitarist's pants, mixed with 100 percent yellow, became a darker green.

(D) The 80 percent red overlay w used on the bass and the speaker combination with the 30 percent black and the 100 percent yellow produce a brown; and on the electric guitar with the 100 perce yellow only to produce an orange

dreds) you choose, and the percentage of black or gray you render on your overlays.

When you get into three- and four-color illustrations that must be color separated, it gets more complicated and burdensome for the artist. Each color in your drawing must be broken down—separated—into its component colors by percentages, and rendered in shades of gray on a separate overlay. Four-color printing, of course, is done by combining percentages of red, yellow, blue and black.

Mr. Skinner's Skinny House was published in four colors, preseparated, in flat tones, with no shadings. Each overlay area was painted in a solid black, and represented a specified percentage of one of the four chosen color inks.

These are the overlays for page 29 of *Mr. Skinner's Skinny House.* There are six: fifty percent blue, one-hundred percent blue, eighty percent red, thirty percent black, one-hundred percent yellow and twenty percent red, as marked. And underneath, on an illustration board, my line drawing, in

one-hundred percent black. The bass fiddle was deep brown, created from a thirty percent black, a one-hundred percent yellow and an eighty percent red. By studying the overlays you should be able to figure out what all the published colors on this page were. The book was forty-eight pages long and each page had to be color separated the same way.

As you can see, the process is intricate and time-consuming. There are several other methods of color separation including working on "blues," which are prints of your black-and-white drawings reproduced on paper suitable for gray wash drawings, one for each of the four-color plates. In this case the percentage of color is determined by the shade of gray in your overlay art. I won't bother going into further details; if you are interested in doing this work, you'll learn it best by experience.

The point is that most publishers ask the artist to do color separations, so you should be prepared for the request. Given a choice, an artist will always

The 30 percent black overlay, d on the bass and the speaker to p create the brown color.

(F) The 100 percent yellow overlay was used as the full color for the bass player's shirt and shoes and all the drums; and as part of the combination of colors for the bass, the speaker, the electric guitar and the guitarist's pants.

(G) The 20 percent red overlay was used alone for all the flesh tones.

(H) This is the finished art, presented as a black and white halftone, to suggest how all six overlays were combined to produce an illustration in eight colors (plus black) by using only four colors. It is essential, of course, that each overlay is precisely registered with all others; requiring several crosshair registration marks on each overlay and on the board. These overlays were rendered in black India ink on either clear acetate or heavy vellum.

choose to do a full-color painting of his art, in colors of his choice and without regard for printer's inks, on a single piece of paper on board. This art can then be camera-separated by photographing it four times, using filters to isolate, on separate plates, the black, red, yellow and blue colors broken down into tiny "screened" dots wherever they exist in the picture. The reason that publishers do not use the photographic process very often is that they claim it is too expensive, and that preseparated art will save them money. This, naturally, does not take into account the artist's time, which makes the question arguable.

Still, there are a number of books where the art-

till Max said "BE STILL!"
and tamed them with the magic trick

ist does work in full color; most of these are in the picture book category, on quality paper, hardcover, designed for younger children. Study all the work of Maurice Sendak and William Steig; most of it is full-color. Because this book is in black-and-white, these examples, from Sendak's *Where the Wild Things Are* and Steig's *The Amazing Bone*, serve only

A spread from *Where the Wild Things Are*, written and illustrated by Maurice Sendak. Sendak's books invariably begin with some idea from his past; the writing then follows, with no thought about the pictures that will follow. Pen and ink is the prime technique for Sendak; his colors are often tempera paint, used full strength for opaque areas and thinned with water for more transparent effects.

of staring into all their yellow eyes without blinking once and they were frightened and called him the most wild thing of all

"I'll help you look in outer space if you'll carry me on your back," said Arthur. "You see, I can't fly."

Opposite top: A scene from *The Amazing Bone*, written and illustrated by William Steig. Steig says that he doesn't have to struggle to get into the right frame of mind for writing for children: "It comes from a part of me that's been around a long time." His drawings achieve an innocence, joy and spontaneity usually associated with children's art—a quality which Pablo Picasso actively sought. Above: A page from *Unidentified Flying Elephant*, written by Robert Kraus, illustrated by Whitney Darrow, Jr., in full color, using a combination of charcoal, watercolors, colored chalk, pastels and anything else that was at hand. Art techniques like these could not be reproduced effectively except through a camera-separated, four-color process.

The bone kept quiet the rest of the way, and so did Pearl.

to identify their work; you must look at the original material to fully appreciate them. This drawing by Whitney Darrow, Jr., for *Unidentified Flying Elephant*, was done in full color in every imaginable medium. The story was by Bob Kraus. Occasionally, full-color art will also be used in large-printing paperback publishing, such as *The Biggest Sandwich Ever*. I did it in watercolor inks and it was printed on a medium-grade paper as a paperback original by Scholastic for mass-market distribution (over 100,000 sales).

Many cartoonists and other artists who illustrate children's books may write them as well. Children's books generally fall into three categories: the picture books, which are for the very young child and are read to him; the beginner books, which the child, in the first three grades of school, reads himself; and the juveniles, for the older children.

Because they carry relatively few words of text, the picture books seem the easiest to write (look at the opening pages of Kraus's *Daddy Long Ears*), but it isn't the case at all. I know a number of cartoonists and illustrators who, having drawn a number of them, have tried to write one too, but have not succeeded; so don't underestimate the challenge.

Once there was a rabbit who was called Daddy Long Ears because he had many children and long ears.

You can take courses in children's writing, but to begin, invest some time in the children's sections of libraries and bookstores and get acquainted with the form by studying a few dozen books.

There are many types of books in all the categories, and just looking at them will help you decide which interests you the most. Riddle books, for example, are always popular, are fun to do and usually sell well. The riddles themselves are often well-worn; what makes them fresh are the visuals which, given the nature of the material, are nearly always drawings by a cartoonist.

Here are a few pages from *Favorite Riddles and Knock Knocks*, which I illustrated for Scholastic. Few cartoonists, though, have plunged into the riddle book genre as intensely as Mike Thaler, who, with over sixty joke, riddle and cartoon books to his credit, has been called the Riddle King. This is a sample spread from a recent one, *The Chocolate Marshmelephant Sundae*. Thaler began as a "regular" cartoonist for adults, making Wednesday rounds, then naturally gravitated toward children's humor.

Some cartoonists work more easily than others with children's material. Bob Kraus has observed that when he was concentrating on cartoons for The New Yorker, many of them dealt with fairytale themes, pirates and kings, so that it was no great surprise that eventually he became a children's book author-artist-publisher. On the other

What do you say to a three-headed monster?

Nice to meet you. Nice to meet you. Nice to meet you.

Why are elephants so wrinkled?

Have you ever tried to iron one?

Opposite left: Mort Gerberg illustrations from *Favorite Riddles and Knock-Knocks*. Drawings were made with an Ebony Jet Black Extra Smooth pencil on bond paper. A second color overlay was done with the Ebony pencil on vellum. Everything was photographed as a halftone.

Above and right: A three-page spread from *The Chocolate Marshmelephant Sundae*, a riddle book written and illustrated by Mike Thaler.

hand, Shel Silverstein started his career roving the world as a cartoonist for Playboy, mining decidedly grown-up themes. Today he is known as the author of a children's classic, *The Giving Tree*, as well as several other best sellers, including *Where the Sidewalk Ends*, from which this selection is taken. Syd Hoff's cartoons about tenement and metropolitan life in New York appeared regularly in The New Yorker from the 1930s until he began writing and drawing children's books like *Barkley*, an early I Can Read book.

If you decide to submit an idea for an original children's book, put the greater amount of effort

Drawing accompanying the poem
"The Crocodile's Toothache,"
from *Where the Sidewalk Ends*, written
and illustrated by Shel Silverstein.
The poem begins:
The Crocodile
Went to the dentist
And sat down in the chair,
And the dentist said, "Now tell me, sir,
Why does it hurt and where?"
And the Crocodile said, "I'll tell you the truth,
I have a terrible ache in my tooth,"
And he opened his jaws so wide, so wide,
That the dentist, he climbed right inside,
And the dentist laughed, "Oh, isn't this fun?"
As he pulled the teeth out, one by one.

Page from *Barkley*, written and illustrated by Syd Hoff.

He walked and walked
for a long time.

21

into your story rather than the pictures. Ed Frascino suggests that you can submit a manuscript with only a minimal dummy or less, if you're known to the editor. I might add a few rough sketches of the central character and maybe one spread done more comprehensively. The point is that books are bought on the strength of the idea and the story; the illustrations always come later, so don't work on developing them until you have to. Naturally, there are always exceptions to the rule. José Aruego submitted his first book in a totally finished state—forty pages, fully illustrated in color and hand-lettered—and it was accepted. He did his second book the same way. Now he does roughs.

William Steig, in an interview in Publishers Weekly, stated that once his editor approved an idea for a children's book (when you've achieved the status of Steig, who won a Caldecott Medal in 1970 for *Sylvester and the Magic Pebble*, you need only submit ideas) it takes him about a week to write it and a month to do the illustrations. "Which is one reason why I enjoy writing more than illustrating," he said. "I like to draw; I don't like to illustrate. In the latter, I'm tied down to the facts of the story, to making the characters and settings look pretty much as they did on the preceding pages. There are no such restrictions in writing a story—or in drawing cartoons."

Juvenile books ordinarily provide more opportunity for the writer aspect of you than the artist. These books, aimed at perhaps nine- and ten-year-olds, are short, simple novels which are illustrated with perhaps a dozen spots. Ed Frascino, after trying unsuccessfully (so far) to write a picture book, did write (and illustrate) a juvenile called *Eddie Spaghetti*. Like all children's books, juveniles look deceptively simple, so study a few before you try your hand. Jerome Beatty, Jr. has a number of titles to his credit; you might check those for a start. The Bobbsey Twins and Nancy Drew are still going strong.

Before submitting your proposal for a children's book (assuming you're doing it on your own, without an agent), do some research on the various publishers you intend to show it to. Different houses tend to publish different kinds of books, so some will be naturally more receptive—or rejecting—of your work. Besides the always valuable practice of bookstore browsing, save and check through the New York *Times Book Review Children's Book Supplement*. Find the books you like and send yours to the house that publishes them.

Finally, a word about the financial aspects of children's books. No single book is going to be a big money maker for you. Generally, a publisher will pay an advance against royalties of about $5,000 for a picture book, divided evenly between the artist and the writer. A royalty of ten percent of list price on hardcover is also split, as is all other income, from paperback and other sales. A children's book editor once estimated that a book which did well over its lifetime might earn a total of $15,000, divided between the artist and the writer. (These numbers, of course, are only averages, and can vary widely depending on many factors, such as your reputation.) To make a substantial income in children's books, you must do many books—twenty or forty—and hope that they stay in print and continually earn royalties for you. Unfortunately, most children's books barely earn back their advances. Still, there are exceptions. Children's book publishers exist because of their backlists, the books that are reordered by libraries and stay in print. The average life of a children's book may be about ten years, compared to the average life of an adult book of under two years. I'm speaking, of course, of books from which you would receive a royalty, either as illustrator, writer or, best of all, in both roles. In some cases you may receive a flat fee for the illustrations, in which case you should obviously try to get as much money as you can. Fees, however, do not run high. To illustrate a juvenile novel—a job comprising twelve to fifteen spots—publishers might offer about $1,500. Check the *Graphic Artists Guild Handbook* I mentioned earlier. Everything is negotiable, of course, and the name of the game is reaching a position where you can negotiate from strength.

While children's books may not be big money makers, they do offer an opportunity of expression which is challenging and different from gag cartooning, but which is closely related to it. Since the field is so unpredictable and risky, it would be wise to be clear about why you want to get into it. Like gag cartooning, if you think you're interested in children's books solely to make money, perhaps you'd better think again. As a solid out-of-the-box activity, for all other reasons though, it's quite rewarding.

10
Newspaper Syndication: Comic Strips and Panels

Newspaper syndication is the glamor arena of the cartooning profession. Of all cartoon forms, the comics are the most widely read, the most celebrated and have the greatest potential for making a cartoonist rich and famous. (It's a long shot, for sure, but at least it's *possible*.)

To satisfy the universal interest in the comics, scores of books about them are available: histories, anthologies, biographies, collections, sociological studies, behind-the-scenes insights, as well as many complete "how-to" courses. For the devoted comics student, I've listed several titles in the bibliography in the appendix. For the purposes of this book, I'll concentrate on the basics of comics and their close relationship to the gag cartoon.

Not surprisingly, a large number of successful strip cartoonists were first successful magazine cartoonists, on the pages of the Saturday Evening Post, Collier's and the like. Among the best-known are Charles Schulz ("Peanuts"), Mell Lazarus ("Miss Peach," "Momma"), Mort Walker ("Beetle Bailey," "Hi and Lois," "Boner's Ark," "Sam and Silo"), Johnny Hart ("B.C.," "Wizard of Id"), Bill Hoest ("The Lockhorns," "Agatha Crumm") and Hank Ketchum ("Dennis the Menace"). (It doesn't seem to work in reverse, though; I can't think of a cartoonist who began by drawing a comic strip and then moved on to the magazine field.)

Syndicated comics are either panels or strips. The panels fall into two groups: those about a single subject and those revolving around a continu-

ing character. Sometimes a syndicated panel develops from a cartoonist's body of magazine work. For example, Henry Martin, who for years normally drew many businessmen gags for magazines, collected a number of them under the title *Good News, Bad News* and, after first publishing them as a book, sold them as a panel to the Tribune Syndicate. That syndicate also distributed a panel of mine, called "Hang In There!" created from my magazine cartoons about people's financial woes. Ed Fisher has a panel called "Toppix," "magazine" cartoons on contemporary themes, drawn by him and a regular group of fifteen colleagues. Other examples of panels on "subjects" are Jeff Keate's "Time Out," about sports, and Bill Keane's "Channel Chuckles," about television.

Among the panels featuring a continuing character are Jerry Marcus's "Trudy," Hank Ketchum's "Dennis The Menace," Bill Hoest's "The Lockhorns," Jim Unger's "Herman" and Charlie Rodriguez's "Charlie."

Comic strips also fall into two broad categories: the continuity-adventure strip and the gag-a-day humor strip. The first group is exemplified by "Steve Canyon," "Brenda Starr," "Gasoline Alley," "Little Orphan Annie" and "Winnie Winkle," to name a few, in which a story running over a period of weeks is told in daily episodes that tease and hold the reader's interest.

The gag-a-day group includes such features as "B.C.," "Wizard of Id," "Miss Peach," "Momma," "Blondie," "Hagar the Horrible," "Beetle Bailey," and "Peanuts." These strips complete their action with a laugh in every installment, sometimes suggesting continuity through a series of gags on the same subject over consecutive days.

Hang In There!

Hang In There!

"WELL, THEN, HOW ABOUT A COST OF EXISTING INCREASE?"

The basic similarity between the magazine cartoon and the comic strip is that both must communicate a funny idea quickly, and do so by utilizing visual and verbal clichés. All the elements in a gag cartoon that we discussed in Chapter 3 are also found in the comics, to lesser and greater degrees: cast, dialogue, gesture, setting, composition, atmosphere, calligraphy, texture and selectivity.

THE LOCKHORNS

"IF YOU NEED ANYTHING, MISS VON FLAME, LEROY CAN GET YOU A SENIOR CITIZEN'S DISCOUNT."

THE WIZARD OF ID **by Brant parker and Johnny hart**

B.C. **by johnny hart**

NEWSPAPER SYNDICATION: COMIC STRIPS AND PANELS

There are also conceptual differences between magazine panels and comic strips. For one thing, a comic strip has the added dimension of time; it is sequential. If the single-panel magazine cartoon is a freeze frame from a continuous action, the comic strip is the mini-film. Second, the comic strip always deals with the same world; it repeats characters and themes for a lifetime, unlike the magazine cartoon which always presents different characters and themes. Third, the comic strip appeals to a broad general audience, a vast readership that shares common interests; today's magazines are mostly published for smaller audiences with special interests.

There are other differences, too. The comic strip is drawn within a fixed, predetermined shape, whereas the magazine panel is not so restricted. Because it is printed on coarse newsprint, the comic strip must be rendered in certain techniques which assure it clear reproduction; almost any techniques are possible in drawings for magazines. And, once a strip begins, the cartoonist must deliver daily and Sunday sequences every week until he dies or the contract is ended; there are no such mandates in magazine cartooning. However, as long as a strip is running, its cartoonist-creator is guaranteed a regular income, something which doesn't exist in the magazine field.

MISS PEACH By Mell Lazarus

Momma By Mell Lazarus

CREATING A STRIP

In creating a new comic strip you should bear in mind three major considerations: characters, subject of universal appeal and longevity.

Comic strip characters must be many things simultaneously. They must be lovable and interesting; by their looks, personalities and what they do, they must be appealing to millions of people. Successful comic characters have an underlying, genuine humanity, familiar traits with which readers can identify emotionally. The more powerful that attachment, the stronger the strip. The personality of a character must also be so clear and consistent that the reader will *expect* a certain behavior from him.

The classic example of a well-defined comic character was the one the great comedian, Jack Benny, created for himself. The whole world came to know that Benny was stingy and vain, so these traits became reliable clichés on which Benny based his jokes for over sixty years. Because audiences anticipated Benny's reactions they, in a sense, participated in the creation of his humor, and tightened their "friendship" with him. In his most famous radio sequence, a holdup man threatens Benny with, "Your money or your life!" Benny remains silent for several minutes while the audience roars in laughter. The joke could not have worked with anyone else except Benny; his character was unique.

Successful comic strip characters are similarly clear. You *know* that Charlie Brown is a loser, Lucy is pushy and Beetle Bailey is a goof-off. Not only

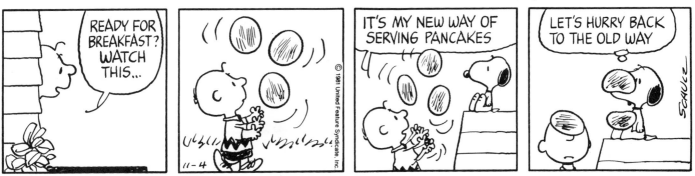

are they strong characters standing alone; they also relate chemically to other characters in the cast. A lovesick Daisy Mae chased a girl-shy Li'l Abner. Lucy bullies a nice-guy Charlie Brown. Gung-ho Sarge tries to shape up a goldbricking Beetle. Every character should have some special "mission" which serves as his central motivation. Where characters have "missions" that contrast and are at cross purposes, there are fertile opportunities for plot and humor.

The strip's subject, its area of interest in which all the characters play, must have a universal appeal to be attractive to the many different kinds of daily newspaper readers. A comic strip is a numbers game, like a TV situation comedy, which aims at making millions of people laugh at the same jokes. In order to even attempt this your subject must first *interest* them, reaching them on some personal level when they are reading the newspaper.

The greatest human interest subject is the family, because almost everybody can easily identify with it. The possibilities of strips about family life are vast, which is why so many have already been done; the differences lie only in the originality of the focus. Husbands, wives, bills, babies, school, jobs, meals, teenagers, neighbors all provide an endless supply of material. Proof of the power of the family theme is the fact that the all-time most popular strip is "Blondie," which appears in seventeen hundred newspapers, the most that's possible in the country, and has been running continuously for over fifty-two years.

Obviously, not every successful strip has been about family life, but every subject has had broad appeal, not like coal mining or needlepoint, which automatically narrows potential audiences. Strips which require special knowledge or sensibilities from their readers don't win the really big audiences which syndicates want, no matter how popular they are with their following. "Krazy Kat," for example, which is widely regarded as *the* classic strip, was never widely syndicated; it was thought to be too sophisticated for the masses. "Barnaby" and "Pogo" were two other strips beloved and acclaimed by a fervent, though relatively small, syndicated audience. Moreover, the special "magic" quality of these strips could never be duplicated by anyone other than their creators. When they died, so did the strips. The broad-appeal strips, though, do continue under hands other than the originating cartoonist's. Examples of these are the long-running "Little Orphan Annie," "Nancy," "Henry," "Blondie," "Dick Tracy," "Winnie Winkle" and "Gasoline Alley."

The third important consideration in the creation of a strip is its potential for longevity. A strip's theme must be broad and its framework flexible enough to accommodate a wide range of ideas in 365 sequences a year for twenty-five years. Its principal characters must have a depth and vitality that will enable them to adapt in a quickly changing world, and survive trends that come and go. And the strip's creator must be comfortable enough with his material to live and breathe it day in, day out.

A successful comic strip, then, has a cast of characters who are lovable, durable and easily identified with, who interact with one another in situations of universal and long-lasting appeal.

At a comic strip convention several years ago, Bob Reed of the Tribune Syndicate said that in starting a new strip he thought it helpful to first identify a "need" within a newspaper readership and then aim to satisfy it. This was the approach followed in "Koky," the strip which Richard O'Brien and I did for that syndicate. O'Brien had initially submitted a regular family strip, but in meeting with Reed it became a working wife and mother strip to address the "needs" of that then-burgeoning audience. O'Brien then invited me to help develop and draw the strip and after we did about seventy-five sequences, the syndicate decided to take it on.

Other syndicate editors feel similarly that, given the tightness of the market, a strip has a much better chance of success if it is aimed primarily at a specific large population group while simultaneously including all others. "Cathy," for example, addresses single young women readers whose concerns and interests are peculiar to them, but also familiar enough to have universal appeal. (Everybody is or was single once.) The strip thus works on several levels simultaneously.

An opposite approach to creating a strip is to begin with some personal spark: a subject, character or attitude that is an autobiographical part of you. The characters and themes of "Peanuts" flow directly from the personality and childhood of Charles Schulz; he drew them in earlier forms in cartoons for the Saturday Evening Post. (It was, in fact, a collection of these cartoons, called "Li'l Folks" and sent to United Features Syndicate,

which was the beginning of "Peanuts.") "Dennis the Menace" is based on Hank Ketchum's real-life son, Dennis, who, according to one story, climbed up on a stool one day, reaching for cookies, prompting his mother to exclaim, "Oh, Dennis, you menace!"

Sid Goldberg, comics editor of United Media, feels that the best strips are those which are closest to their originators, developed from within, not from what any syndicate editor suggests. "Very few editors really know what they want," says Goldberg. "A good editor is simply one who recognizes something good when he sees it, and moves quickly to develop it."

It is generally agreed that a cast of strong characters is the most important element of a strip. One way to begin developing yours is to study all the gag cartoons you've done and notice which characters and subjects you've repeated most. Without being aware of it, you might have already created a cast: lawyers in courtrooms, executives and secretaries in offices, singles in bars. Remember, in a strip you are, in effect, playing God, creating an entire world from nothing: people, places and events existing according to your own interior logic. Obviously the more you know about your world, the easier it will be to keep it alive.

Once you decide on a central character, others should immediately suggest themselves. If you start with a newspaper reporter, it follows that much of the action would take place in the newspaper office and involve characters like an editor, a photographer, a copy boy. A strip about a restaurant would have a cook, a waiter and some regular customers.

While magazine cartoon characters usually don't appear more than once, comic strip characters are seen every day. To help keep them consistent, it's useful to write detailed biographies about them and maintain files on their background for reference. Include things like your character's middle name, age, birthplace, education, family background, hobbies, habits, goals and relationships to the other characters. You may never use the material in an actual strip, but having it means your gag ideas will always be based on the same "givens."

Characters may represent several different archetypes: Good Guy, Bad Guy, Wise Guy, Goof-off—so the appeal of the strip extends to the broadest audience, even if some characters seem unattractive. Andy Capp has no redeeming social qualities, yet he is one of the most popular comic characters. He's rude, lazy, self-centered—perhaps the kind of person everybody would secretly like to be once in a while.

As soon as you've settled on three or four characters and on your subject, start writing gags. Getting the characters into action will define and develop them quickest and before long they should come alive and start "talking to you" on their own. The methods of writing ideas for strips are as varied and unstructured as those for magazine panels. The same basic principles of generating ideas can apply, with the additional technique of thinking *sequentially*, using the dimension of extended time. Remember, in a magazine cartoon you have only one panel in which to represent the action of a specific moment and to suggest what led up to it, and sometimes even what will occur after it. In a strip you can actually depict the buildup action. This gives you the opportunity to add more drama to gags, as in the "Koky" examples here, as well as

KOKY
by Richard O'Brien and Mort Gerberg

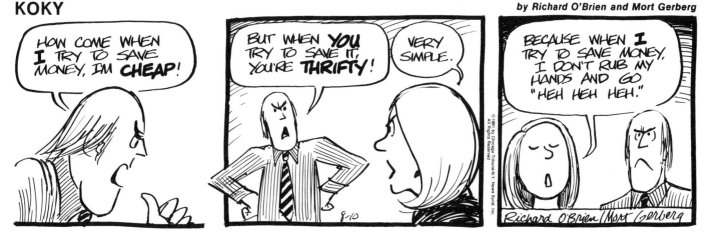

KOKY

by Richard O'Brien and Mort Gerberg

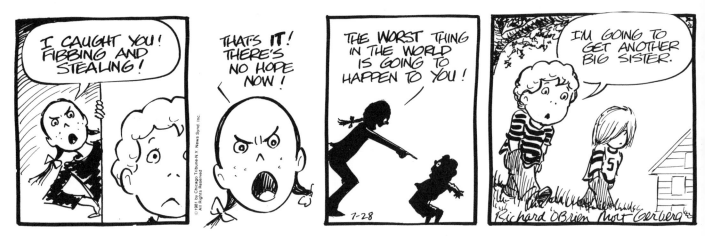

KOKY

by Richard O'Brien and Mort Gerberg

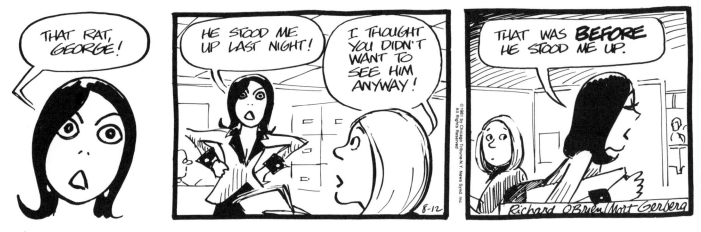

to create other cinematic-visual humor, as in the "Hagar" and "Peanuts" examples.

There are also styles and rhythms of comic strip humor that are special to the form. Study your favorite strips and learn what they are. "Doonesbury" has a different "sound" than "B.C." The point is, there is more to writing a comic strip than simply creating "buildup" panels to precede a standard single-panel gag. You must think dramatically, from a character's point of view, plotting situations to which your characters will react according to their personalities. Characters endure and live through constant repetition of the same

themes about their human traits, not from jokes they make. The daily gags will be forgotten, but the total impression they build—the emotional attachment we have for the character—will remain. Today it's a pancake that falls on Charlie Brown; tomorrow something else will happen to him. We might not remember Jack Benny's funny lines, but we do remember that he was stingy.

Every character should have his individual areas of humor, a type of joke reserved for him and used by no other character. A Charlie Brown reaction simply won't fit on Lucy. Different characters may also *speak* in different voices, using cadences and

phrases consistent with their backgrounds and which further distinguish them from other characters. A college professor can't sound like a cab driver; a society matron's language differs from a showgirl's. For example, imagine what words each of those four characters would shout if something astounding happened to them. (We *know* about Orphan Annie's "Leapin' Lizards!" or Jack Benny's "Well!" or Charlie Brown's "Good grief!") After you've written some dialogue, test it out. Read the lines out loud—with feeling. Do they sound natural, convincing, in *character?* Always search for the *exact* word; it makes all the difference.

DRAWING A STRIP

One of your first considerations will be to decide on a look that will best reflect your material. Comic art styles vary widely, from the realism of "Steve Canyon" and "Mary Worth," through the semi-realism of "Brenda Starr," "Gasoline Alley," and "Dick Tracy" to the funnier drawings of "Broom-Hilda," "Wizard of Id" and "Miss Peach." If you're doing slapstick humor, the drawings should be broad; something more sophisticated might work better with quieter drawings.

As in gag cartoons, the words and pictures must be harmonious. Clearly, good art is important to a strip, but as Bill Yates, comics editor at King Features, points out, the concept and appeal comes first. Good jokes can be harmed by bad "telling," but strong characters and writing can support

lesser quality art. There are several successful strips with "unprofessional" looking art which works because it feels genuine and perfectly reflects the emotional "feel" of the strip. As much as possible, try to stay with a style of drawing which is natural to you; it's as much an autobiographical expression as your words. Inventing a convincing artificial style is difficult. If you're going to draw a strip fifty-two weeks a year, you should feel comfortable doing it.

Whatever your "look," keep it simple. Remember that comic strips are squeezed into small spaces between other strips on crowded newspaper pages. Complicated drawings don't read well, nor do they have as much "eye appeal" as those that are done more simply. As in a gag cartoon, it often takes great talent to draw less rather than more. Study the comics pages and notice which strips attract your eye first—and why.

You should certainly design your characters simply. If you're successful, you'll have to draw them thousands of times, from every possible camera angle, and they'll always have to look the same. As long as you are making it up, make it easy on yourself. Characters should *look* distinctive. While representing a certain *type,* your character should be particular within that cliché. You might draw eyes a certain way, or hair. Think of Orphan Annie's curls, Dennis's hair falling over his face, the tiny bodies in "Miss Peach"—features that are instantly recognizable.

You can also suggest individuality to your

BROOM-HILDA

by *Russell Myers*

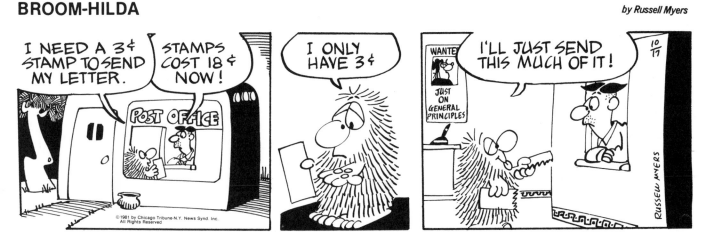

characters in the way you clothe them and through props assigned to them. Think how much a part of Charlie Brown is his white sweater with the black zigzag stripe across it. Or Hagar's Viking helmet (which instantly defines him, too), Beetle's hat, forever covering his eyes, the cigarette butt always

hanging from Andy Capp's lip, or Popeye's pipe. Make sure, though, that a prop is natural to your character. Check his biography and decide if it's "right" for him to have a beard, wear glasses, be fat, have blond hair, curly or straight. Even certain gestures and actions can add distinction to your characters. Think of Jack Benny again, this time with his arms folded, his head turned to the side, doing a "take." It's not unlike Charlie Brown's look of frustration.

Obviously, the possibilities of what a character should look like are infinite, and you'll fill sketchbooks trying out noses, hairstyles, weight and hats before you settle on one combination. A trick I've found helpful in visualizing the "look" of a character is to imagine which movie star would play him best, and work from that model. Your final decision is not irrevocable, though. The way your character looks on day one of your comic strip will almost certainly *not* be the way he'll look on day six hundred. The process of drawing the same character every day automatically produces changes of one degree or another. This is what Koky looked

liked in her first appearance, and here she is two years later. Compare the early and later versions of any strip and you'll see similar variations. So don't worry about getting your character to look exactly "right" before you start; he *will* be right for your start. Then, as he grows, he'll change, just as real people do.

Design your principal characters as a permanent company of actors who complement and harmonize with each other visually as well as conceptually. It should always be immediately obvious to a reader who the lead characters are; they'll look more heroic or beautiful or animated, or will be rendered with more black areas. Bear in mind that even though a comic strip appears every day and has a large audience that knows it well, there may be new readers looking at it for the first time. For that reason, it's also a good idea, especially when the strip is first starting, to have the characters address each other by name as often as possible.

DESIGNING A STRIP

I pointed out the importance in a single-panel cartoon of composing the drawing so that its elements are seen by a reader in a particular order which delivers the idea in a glance. In a comic strip, you apply the same considerations to several panels so they not only read well alone, but also balance with the others.

Camera angle is a most useful device to help tell your story. Mixing closeups, medium and long shots, exaggerated perspectives, bird's-eye and worm's-eye views helps dramatize the sequence while adding visual interest. The variations in camera angles, though, depend on the material. Generally, the simpler it is, the more static the reader's point of view; the more realistic or involved, the more varied. In "Peanuts," the camera angle usually remains the same through all the panels, to underline its quiet humor. The camera angle is usually constant, too, in "Doonesbury" and "Miss Peach," where much of the humor is verbal. I liked to vary the camera angles in "Koky" to imply nervous agitation in the characters. In "Hagar the Horrible," many of the jokes are visual, "told" through camera moves, as in this example, a pullback after two closeups. In "Brenda Starr," an adventure strip, as in others like "Steve Canyon" and "Mary Worth," extremely high and tight camera angles convey melodramatic mood.

DOONESBURY

by Garry Trudeau

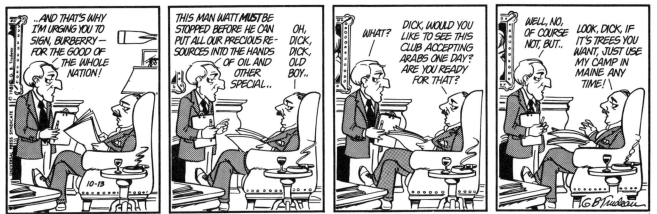

HÄGAR the Horrible

By Dik Browne

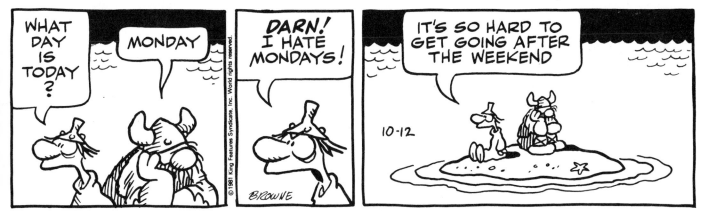

BRENDA STARR®

by Dale Messick

The rhythm and pace of a strip can be established by the size of the panels. A reader's eye will dart through a small panel, linger longer through a larger, more complicated one. A small panel is effective for highlights and sharp dramatic moments; a large panel for "establishing" shots. Alternating large and small panels gives the eye nonverbal clues to the dramatic flow of the sequence while adding visual interest. As with camera angle, the degree to which panel sizes should vary depends on the type of material and how much action is involved. "Peanuts" panels, again, are the same size. So are those in "Doonesbury." Panel sizes in "Hagar" and "Shoe" vary.

Generally, you need less detail in a newspaper comic strip than in a magazine cartoon. As I mentioned earlier, since newspaper comics are printed small, they must be drawn boldly and simply in order to be read easily. Also, because comics appear daily, there's a certain visual carryover that reduces the need for repetitive "establishing" material. One panel with a full background is often sufficient for the entire sequence. Your expertise as a gag cartoonist in setting scenes with minimal visual clichés will help here.

Lettering can add important flavor to a comic strip, but its prime function is to present dialogue that reads easily. The trick to legible lettering is to keep the size of the letters uniform and to leave a lot of breathing room between and around the words. Obviously, the fewer words in a balloon, the more inviting it looks, so apply the same writing discipline to your dialogue as your magazine gag lines.

Most strip lettering is done in capital letters, but lower case letters are acceptable, even preferable, if you want a different mood. The important consideration is to letter in a manner which feels natural to you; lettering is your handwriting, which can give your strip an individuality it might not have with the standard block lettering seen in other strips. Jules Feiffer's lettering, for example, has become an inherent part of his strip's design and even suggests, through its nervous look, the mood of his work. The same holds true for Garry Trudeau's "Doonesbury" and Jeff MacNelly's "Shoe." The awkward-looking lettering in "Cathy" is similarly in character with the theme of that strip; it's actually preferable there to perfectly balanced and ordered lettering.

Since lettering represents speech, you might, where it is called for, add visual accents to indicate an emphasis on a word or speech pattern. Heavier letters, for instance, will indicate shouting, as in the "Koky" and "Momma" examples. Walt Kelly, in "Pogo," even used special styles of calligraphy to help establish the individual voices of several characters, such as P.T. Barnum for the speeches of the fast-talking bear. However, don't get so fancy in your lettering that it's distracting to the words themselves, or the drawings.

PRODUCING THE STRIPS

As in gag cartooning, there is no one right procedure to complete a strip. Whatever works best for you is correct.

My own system for drawing a week's worth of

SHOE
by Jeff MacNelly

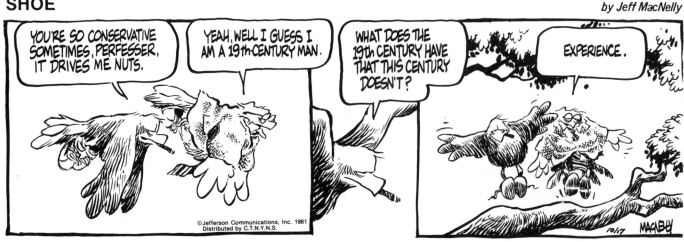

©Jefferson Communications, Inc. 1981
Distributed by C.T.N.Y.N.S.

"Koky," as well as my "Hang In There" panel, followed a mass-production approach. First I did quick, rough thumbnail sketches of all six sequences plus the Sunday to establish a visual flow for each episode, highlighting the center of interest, deciding on backgrounds, props and the camera angles to use. These are the first of several I did for one week. By visualizing all six dailies at once, I could also make sure they'd look good together on the reproduction sheets that the newspaper editor receives from the syndicate.

Hang In There!

"WHAT'S WRONG, WARREN? YOU LOOK CONTENT."

The second step was to sketch each sequence in blue pencil (on a plate finish two-ply bristol). I used blue pencil since the lines would not show when the drawing was photographed by the engraver, and

NEWSPAPER SYNDICATION: COMIC STRIPS AND PANELS

A Sunday "Koky" page. There are many different ways to divide the overall space into panels as long as they break at several basic, pre-designated points. All Sundays, though, are written so that the top line—with the title and opening panel—may be dropped without affecting the main action, by a newspaper in need of more space. These "drop" panels are often tacked on (in front) after the gag is created. I drew the interior panels of the Sunday the same size as I did the dailies, to insure conformity of appearance. Color on a Sunday is added by the printer, who follows the artist's guide on an overlay.

that eliminated the chore of erasing. I lettered the dialogue in each panel first; words had to be a certain size to be readable, but drawings could be larger or smaller to fit in the remaining space. I never used a ruler, instead "measuring" everything by eye and lettering freehand. I doodled proper expressions and gestures, then loosely sketched the final drawing.

Next, I lettered all the dialogue in ink, and then, with the same pen, drew all the panels. I aimed to get into a steady rhythm and draw spontaneously, without concern for mistakes. With the drawings completed, I drew the borders freehand on all six panels, using a thick felt marker, inked all the balloons, then went back to add blacks and shade in all the panels. The last step was to brush out, with opaque white paint, the extra "mistake" lines. Once in a while, I would completely redo a panel or area I disliked and patch it.

Ordinarily, I did the Sunday page separately, since that was the equivalent of two and a half dailies. The process was the same, except for adding the color. This was a mechanical process of taping a piece of tracing paper over the drawing and writing numbers in areas to be colored. Each number corresponds to one of sixty-four colors on a code sheet distributed by the engraver, who uses the tissue as a color guide and lays in the color mechanically.

This mass production approach worked well for me; it maintained uniformity in the week's art and enabled me to complete all the work in about three days. Every cartoonist works differently, of course. Some prefer to complete each strip before doing the next. Many cartoonists make tight pencil drawings, using a light box to develop them through stages. The drawings are then inked in pen or brush precisely over the pencil line.

Instead of transferring roughs to heavier bristol, a number of cartoonists make their final drawings on light, see-through visualization paper. They find this saves drawing time and postage costs. Still others make photostats of the pencil version (which darkens them and makes them camera-ready without ink) and mail those to the syndicate for reproduction. Cartoonist Profiles, the quarterly journal of cartooning, has published many interviews with well-known comic strip artists who explain in great detail exactly how they work. Included are articles on Dik Browne, Jerry Dumas, Bill Hoest, Jim Unger, Bill Keane and Mort Walker.

SUBMITTING A STRIP

Newspaper syndicates usually like to see about twelve finished strips (representing two weeks of dailies) and another twelve "good" roughs. It's preferable to submit photostatic copies rather than the original art, for several reasons.

For one, it's difficult for a syndicate to handle original art, which is usually large and cumbersome. You want to make it easy and inviting for an editor to view it, so a small-size presentation is favored. Reducing the original art also shows you and the editor what it would look like in actual newspaper size. (Make sure you work in the proper proportions. Rule the borders of a strip from your local newspaper, then rule a diagonal line through and beyond the corners. New horizontal and vertical lines meeting anywhere along the diagonal form a different size rectangle in the same proportions as the original.) My personal preference was about "two up," 4-by-13¼ inches. The smaller the drawing, the less area to cover, making for savings of time, energy and money (in materials). Also, in a smaller space there's less temptation to cram in details and too-thin lines that will get lost or muddy in

reduction. Mailing photostats also saves postage, although the stats themselves are costly. Be sure to make extra copies of the strip so you can submit it to several syndicates at the same time.

Along with the samples you might include a letter which summarizes the strip's concept and characters and suggests directions for its future development. The point of the letter is to show an editor that you have thought carefully about the strip's intention and are prepared to make a long-term commitment to it. Remember, dailies are done about six weeks in advance of publication; Sundays about ten weeks. Mail your submission according to the same rules of gag cartooning, with the proper cardboard and the self-addressed stamped return envelope.

THE SYNDICATE BUSINESS

In effect, a newspaper syndicate is a sales agent. It distributes material produced by the artists and writers it represents to as many newspapers and magazines as it can sell. The weekly price paid for a feature varies according to the circulation of the subscribing publication (the New York *Daily News*

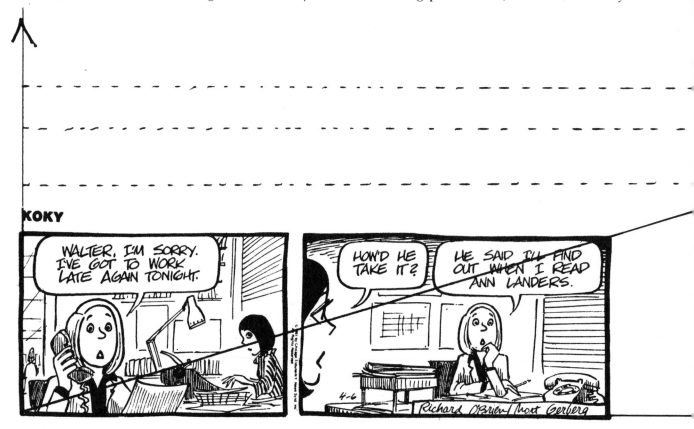

pays more than the Hagerstown *Herald*) and the popularity of the feature. ("Peanuts" commands a higher fee than many others.)

The syndicate employs editors to search out and develop new features, production and promotion people to package them and salespeople who travel continually around the country, in direct competition with representatives from other syndicates.

The amount of money a feature earns is determined by the number of papers carrying it and their circulations. A strip carried in fifty large newspapers might earn as much or more than a strip appearing in one hundred fifty small ones.

The standard contract between a cartoonist and the syndicate calls for a fifty-fifty split of the profits from newspaper sales and merchandising, but there are many variations in these agreements. In some cases, syndicates pay the creator a weekly guarantee, a minimum amount of money which will come out of his fifty percent share. Sometimes a cartoonist is hired on a straight salary basis, with no percentage participation. Contracts between syndicates and artists are complex legal documents and a cartoonist should never try to negotiate one without expert advice.

While the material they offer differs, all syndicates aim to sell features that help build a news-paper's circulation. That was the reason for the first strip—"The Yellow Kid," in 1896—and for all those that run today. And why newspapers want strips with a wide general appeal.

The selling of a strip, though, depends on a lot of things besides the quality of the work. Limited space is a major problem. The number and sizes of newspapers in the country seems to shrink every day. An editor is rarely able to add a new strip without dropping one that he's already running. This means that the syndicate salesperson must first convince an editor that one of his current strips is weak; that readers don't care about it—and then sell him on the potential popularity of the new strip.

Timing is an unpredictable factor, too. The syndicate, or a competing one, may have just contracted for a strip like yours. (Or, they may be *looking* for one like yours.) Like gag cartoons, proposals for comic strips often make the rounds of a number of syndicates before they sell, if they ever do. Bill Yates says that he sees about one hundred fifty to two hundred a month, many of them from established professionals. Of these two thousand proposals a year, a syndicate may launch only one or two, owing to the amount of time, effort and money involved in developing and promoting a

The procedure of scaling a drawing up and down in size.

new feature. (It was almost a year from the time O'Brien and I first met with the Tribune Syndicate about "Koky" to the day of its first appearance in the papers.) So the odds against having a strip accepted run high.

Moreover, just because your strip is taken on doesn't assure you of fulfilling your dreams of fame and fortune. Most comic strips don't earn as much as you imagine. Many fold, despite their quality, because they don't make money; others linger, looking to catch on. There are about four hundred dailies, Sundays and panels now appearing in newspaper syndication, and according to a rough consensus of several editors perhaps only sixty have two hundred or more papers. At an average price of $14 per paper per week, this means about $1,300 per week for the creator, net, after production and promotion costs. More comics are probably in the one hundred-paper range, averaging $15 per paper per week, or about $600 a week to the creator, after costs. Although they don't talk about it, many syndicates carry strips that net them, and the creators, each less than $100 per week.

The ones that do make it big, though, make it *big*. With merchandising possibilities added to a large potential income from a big list, you *could* become a multimillionaire. Several years ago, Charles Schulz reportedly earned over $1,000 a day just from newspaper income, and he also participates in "Peanuts" merchandising that might gross $100 million a year. Such is the stuff of which dreams of rainbows and pots of gold are made.

The reality, though, is that the chances are tiny that you'll create a blockbuster strip. If you're talented—and lucky—you could be fortunate enough to have a strip that assures you of a respectable check every month. In exchange for the regular income you must, of course, commit yourself to regular work on the same cartoon all the time.

Financial considerations aside, to some gag cartoonists the comic strip form is too limiting and not worth trading what they feel is complete freedom of choice and expression. To others, it offers still another opportunity to expand their talents out of one box into many.

11
Political
Cartooning

The field of political cartooning is confined to a few, has limited opportunities and requires special personalities of those who practice it.

Ideally, political cartoonists work for one "base" newspaper, and are also syndicated (like comic strips) throughout the world, like Herblock in the Washington *Post*, for example. Others, without a paper, like Pat Oliphant, work directly for a syndicate; self-syndicate their work, like Jerry Robinson; or freelance, like Ed Sorel. But all told, the American Association of Editorial Cartoonists claims only one hundred fifty active members, of whom about sixty are syndicated. And of those, perhaps two dozen get most of the attention.

Given the limited number of newspapers and political periodicals, there are few jobs available, other than filling spots vacated by incumbents. Many papers actually prefer to subscribe to several well-known syndicated cartoonists, picking what and when they wish, rather than hiring some "force" whom they have to deal with regularly and who would cost them more money every week.

Political cartoons, also called editorial cartoons since they are usually found on the editorial pages of the newspaper, are vehicles of strong opinion. Like the editorial columnist, the cartoonist constantly challenges the establishment, often with a power that a writer cannot achieve. "Part of a cartoonist's job," says Tony Auth of the Philadelphia *Inquirer*, is to confront people with things they really don't want to see."

Political cartoonists are a special breed who seem motivated by anger; by a smoldering sense of moral outrage at the world and a compulsive need to express it.

"Cartoons are ridicule and satire by definition," says Paul Conrad of the Los Angeles *Times*. Mike Peters of the Dayton *Daily News* says that "cartooning is not a fair art. . . . Cartoonists are like loaded guns, looking through the newspaper for a target to blast." Jeff MacNelly, now with the Chicago *Tribune*, who has been syndicated in over four hundred newspapers, agrees; he knows "many cartoonists who, if they couldn't draw, would be hired assassins." Pat Oliphant, of Universal Syndicate, who is credited with sparking the recent contemporary-look innovations in political cartooning, supposes his "position is negative. . . . If you're going to be in favor of something, you might as well not be a cartoonist."

In addition to a negative attitude, a political cartoonist should have several other strong traits, among them a genuine interest in politics, a good sense of history and sharp journalistic instincts. (Many, like Oliphant, Don Wright of the Miami *News* and Ben Sargent of the Austin *American-Statesman*, were originally newspapermen.) He must also be a good draughtsman, with a special talent for caricature, and as a humorist have sharp points of view which he is eager to express. In addition, he must work fast, thriving under the pressure of constant deadlines, and have the courage to hold to his opinion.

These are combinations of attributes and talents which few cartoonists have, which may be why the field is small. Moreover, as Jules Feiffer says, "It's not so much how good you are as how obsessed you are."

Anyone interested in becoming a political cartoonist should be at least minimally acquainted with the history and traditions of the form. (I've suggested several books and articles in the bibliography.) What's particularly important to a magazine gag cartoonist is the shift over the past fifteen years to the kind of light humor in ideas and techniques that had not been used before.

William Hogarth, in eighteenty-century England; Honoré Daumier, in nineteenth-century France, and Thomas Nast in the late 1800s, regarded as the father of American political cartooning, were among the original strong influences.

The early American political cartoons, following the style of the times, were wrought with a heavy touch: ornate and complicated drawings embellished with details and explained with labels, captions and dialogue in balloons. The cartoons were heavy-handed satire that made use of classical allusions and a serious atmosphere that was created first through elaborate pen and inks, then, after Boardman Robinson introduced it in the early 1900s, litho crayon on pebbly paper, which became the standard technique for newspaper editorial cartoons for the next fifty years.

The political cartoons of the thirties, forties, and fifties, continuing the old tradition, were generally solemn and static; dark, one-panel drawings that utilized allegorical figures, boldly labeled, in heroic, tableau poses. For example, a World War II cartoon by Rollin Kirby, in litho crayon, pictured a huge gorilla with "Axis Powers" lettered on it, holding a blood-dripping knife in one hand and in the other a paper with the words, "Peace Terms. Made in Germany." The caption reads, "Beware Gargantua." Another, by Daniel Fitzpatrick, also in crayon, shows a towering, white-bearded old man labeled "History" writing with a quill on a tablet while standing on a hill enveloped in flame and smoke labeled "Greece," over a caption reading, "An Old Reporter On An Ancient Battlefield."

War was invariably represented by a glowering, bearded Roman gladiator in armor, and Peace by a beautiful young woman with wings. A "political" comment might have shown a flailing swimmer labeled "Taxpayer" in an ocean labeled "Financial Trouble," being thrown a life preserver labeled "Tax Relief" by a grinning Uncle Sam standing on shore.

In contrast, today's approaches are more sophisticated in style, content and form. There are cartoons in the familiar single panel, like the Mike Peters example; multi-panel talk like Feiffer and Sorel; and other variations, like the Oliphant and Robinson examples here, all making use of lively humor and wit.

The editorial cartoonist may work with or without outside direction. If he's employed by a local newspaper, he may sit in on editorial conferences, noting which topics will be covered in the next edition, and choosing or being assigned one for his subject. A newspaper may expect its cartoonist to accept its own political philosophy and do cartoons along that line. However, if the cartoonist doesn't

Edward Sorel

Mike Peters

THERE'S ANOTHER GROUP HERE COMPLAINING ABOUT OUR NEUTRON BOMB TESTING...

subscribe to the paper's policy, he could indeed have problems.

The most successful political cartoonist is fiercely independent, working with no outside direction, choosing his own subjects and expressing his own opinions, guarding a strong sense of integrity. Unlike a writer, a cartoonist, says the veteran Bill Mauldin, deals with the total creative effort. You must do it alone, he says, or "you're not a cartoonist, you're a pants presser." There should be no sacred cows for the cartoonist and he should always expect to offend somebody. "When you sign your work," says Oliphant, "you really have to believe what you've said." Sometimes, he adds, just deciding what you believe is "the exhausting part."

Most syndicated cartoonists produce a daily "belief" five times a week. Because of deadline pressures, they may begin their day at dawn. Some

must turn in one finished drawing by the end of the day; others may mail in five at a time, once a week. Some do three, others only one.

Like magazine cartooning, coming up with the ideas is the most challenging part of the work. But where a magazine gag cartoon is instant communication of a *funny* idea, on *any* subject, a political cartoon is instant communication of a *provocative* idea on a *topical* subject—done funny. The prime purpose of a gag cartoon is to be funny; on a second level, it may also comment on some current social condition. The political cartoon works in reverse; its prime purpose is to make the comment and, in the process, it may also be funny.

Jules Feiffer has been doing it all in his weekly cartoon in the *Village Voice* for over twenty-six years now, carrying on his now-familiar sequential dialogues in matters heavy and light. Feiffer basically

believes that *everything* is politics, so his work not only deals with contemporary issues and events, but with personal emotions and philosophies; the politics of private as well as public life. Of his own body of work Feiffer prefers "the long-lasting things like the 'Wheel of Life,' rather than the angry political stuff. I like the things that have to do with the way people see themselves in their lives, in relation to the world; cartoons that maintain their resonance over a decade or more, that deal with constants in society, like corporate greed, racism, pollution; things that never lose their timeliness.

"A cartoon," for Feiffer, "is a response to the confusion in national affairs, international affairs and my private life . . . a therapeutic response to my own sense of confusion, my own anger. Coming up with an idea, putting it into a pithy statement of what I want to say, takes it away from the personal into a more general area for a reader. This gives me a feeling of control of my life . . . I've nailed it, I understand that. That illusion may not last, but for the moment it's gratifying, and if I didn't have it, it would be troubling."

A New Yorker profile, written by Jim Stevenson, published in 1979, detailed the daily schedule of Pat Oliphant, then with the Washington *Star*.

Oliphant produced a daily cartoon five times a week that appeared in nearly five hundred newspapers throughout the world, and his deadline was to turn in a finished drawing to the paper by the end of every day. "Ideas are the toughest part," he said, "ideas that suit you and your manner of expression." Oliphant feels that you can't work ahead or stockpile ideas; he has made notes or carried ideas in his head but they went stale. There is no "shelf life" to an idea, he says.

Jerry Robinson, who created his own syndicate (Cartoonists and Writers) in 1978, *does* work ahead. He produces six "Life with Robinson" panels a week, and estimates that seventy-five percent of his time is spent on ideas and writing. During the week he reads newspapers and periodicals of public opinion and listens to news reports on radio and television, clipping articles and making notes on subjects that he thinks will make a good cartoon.

"But almost everything I read for the cartoons I would read anyway," Robinson points out. While Robinson draws a whole week of cartoons in advance, he says it's "not as good as doing one a day. It's hard to anticipate what will still be current seven days later." He begins production on Monday morning, writing in one sitting about fifteen car-

Pat Oliphant

toons from the notes and ideas he has collected. Some of the ideas will have been fully formed in his mind already; he develops the others mostly by doodling pictures first. He then selects the best six and lays them out (in light pencil on a plate finish bristol). All of the final drawings are done "under pressure" on Tuesday, in pen, brush and ink.

To maintain accuracy in his cartoons (like the right chairs and desks in the Senate) Robinson relies on research from an extensive personal morgue, composed largely of sketches he's made of places and faces.

Robinson maintains that "sketching people from life or from television [like "Face the Nation" or "Meet the Press"] is preferable to all other techniques for doing caricatures, since it's the one way you can get a full sense of people . . . beyond the physical look, and that includes their characteristic gestures and attitudes." News photos are helpful, says Robinson, but "after you've done someone for a little while, don't use the original."

The political cartoonist faces all the creative challenges of the magazine gag cartoonist plus a few special ones. For one thing, he mines his ideas from the same small group of subjects as his colleagues, unlike the magazine gag cartoonist, who is un-

limited in his choice of subjects. With perhaps two dozen top syndicated political cartoonists working the same themes every day, graphic images representing concepts like war, the economy, taxes—can become overused. The political cartoonist therefore must not only come up with something truly original to *say* about a given subject, he must also say it in a unique manner. This may be why humor—a most personal ingredient of expression—has become so important in political cartooning. While *what* someone says about a subject—his point of view—may be similar to the next cartoonist's opinion, the *way* he says it, through humor—his jokes—is likely to be different.

If you are seriously interested in trying to crack this field, start by following a rigid work schedule to produce one topical cartoon every day. Study the news regularly and work on subjects which excite you most. This may be the same way you'd begin getting ideas for magazine gag cartoons, except here you can refer to real events and real people. To dramatize the idea, you might use a cliché symbol or allegorical reference. Animate the idea in whichever form it works best; single-panel, multi-panel, caption or dialogue.

The only important test for the cartoon is to make sure it really says what you *feel*—boldly and

clearly. Don't try to say too much. Keep it simple and make only one point at a time. An editorial cartoonist who appears several times a week can take more than one crack at a subject. Assume that your reader has read the same news you have, and don't be too obvious. A subtle approach is more compatible with sophisticated humor. What's funny, as we've said before, is a matter of personal taste. *How* funny an editorial comment should be is a matter of opinion. One thing is certain; humor in political cartoons does make the cartoon memorable. A good cartoon evokes a visceral reaction which is deep and long lasting. Jeff MacNelly believes that "you can get the reader's attention and hold it better through humor than with a hatchet." Paul Szep of the Boston *Globe* says that the cartoon "has to be entertaining in itself because you're competing against the old tube." People see pretty grim things on the six o'clock news and it doesn't work, he says, to "go for the jugular" every day. "You need humor and ridicule." However, the humor should always be used as the means; the end is making the comment.

Accuracy in drawing is particularly important in the political cartoon, since the selection and rendering of details is part of the comment.

The outstanding element of political drawing, of course, is the caricature, which is itself a distinct and elusive art form. Some cartoonists can do caricature naturally and easily; others cannot. One of the difficulties which beginners encounter is that they attempt realistic portraits instead of exaggerated caricature. They also tend to repeat the already-accepted images of public figures done by other caricaturists, rather than creating their own personal versions.

You'll learn to caricature better by sketching from life rather than from photographs or other drawings, which carry their own interpretation. Sketches, though, should be selective and minimal. Try this exercise: *Look* at a face first *without* drawing it, studying the shape of the head, the hairline, the nose, etc. *Then* draw the face from memory. This automatically prevents it from being a realistic drawing and forces you to be interpretive.

Al Hirschfeld, the theatrical caricaturist, makes little sketch notes with a pencil during performances. The jottings don't look like anything to anyone else, but they're helpful reminders to Hirschfeld when he does his drawings later.

Gestures add distinctiveness. Think of impressionists like Rich Little, imitating the hunched shoulders of Richard Nixon or the strut of Jimmy Cagney. You often recognize a close friend or relative from a distance by the way he walks. You can learn these mannerisms only by direct observation. Good caricatures do not depend on always exag-

Paul Szep

"Awkward, yes ... but a small price to pay to avoid unnecessary gun controls."

gerating the same features of the subject, but shift their focus over the course of time. Nixon's dark beard was an early target, giving way to his nose and eyes. Cartoonists initially emphasized Ronald Reagan's neck wrinkles, then switched to his pompadour.

Caricature, though, is more than cleverly distorting a pretty face and reducing it to essentials. The true art is to maintain the essence of personality. The great caricaturists, like David Levine, are able to capture their subjects in all their subtle moods

and emotions in different situations, even as they change through the years. That is exceptional art. Your studies of the art of caricature must include the drawings of Levine and Ed Sorel.

As I pointed out before, the standard technique for the editorial cartoon used to be a litho crayon, and while a few cartoonists today, notably Herblock and Mauldin, still use it, most others are returning to the pen and brush and ink, perhaps because they impart a lighter and looser feeling, more in keeping with the more humorous content. The one

David Levine

consideration that must be remembered is that your drawings are meant for newspaper reproduction, so line and halftone must be bold and clearly defined. To get a uniform gray, many cartoonists draw on a chemically treated paper (such as Grafix board) which, when brushed with another chemical, produces one or two gray tones. The process replaces the use of Ben Day sheets, patterned acetate which is cut and pressed on areas to be shaded.

If you maintain the discipline of doing an original political cartoon five times a week for a few months, you will have accomplished two things. First, you'll have discovered for yourself whether or not you're cut out to be a political cartoonist.

Secondly, if you *are*, you'll have a portfolio of work ready to show to prospective employers.

There is no standard procedure for seeking a job as an editorial cartoonist on a newspaper. If you investigate the histories of the successful cartoonists you'll find many were lucky to be at the editor's office when he was looking for a cartoonist. Others knew somebody with clout. Many who have broken in over recent years—Jim Borgman, Tony Auth, Paul Szep, Mike Peters, Doug Marlette, among others—began their political cartooning careers right out of college. Others kept banging on doors, going to great lengths and distances. Oliphant moved from his hometown, Adelaide, Australia, to

Herblock

Tony Auth

his job at the Denver *Post*. Gene Bassett left New York and went to Honolulu because "you have to go where the paper is." One young cartoonist, according to Jerry Robinson, took a bus ride out west and got off at some city whose local newspaper didn't have an editorial cartoon. He spent a few days walking around, becoming familiar with the local issues, went back to his hotel, drew a dozen cartoons about them, called on the newspaper's editor, showed him the drawings and, yes, he got the job.

The acceptance of humor in political cartooning has led some of its artists to the comic strip. Mac-Nelly, after establishing himself as a political cartoonist, created the comic strip "Shoe," and Doug Marlette, of the Charlotte *Observer*, followed suit with his own "Kudzu." Garry Trudeau's "Doonesbury" fits both categories. Auth and Szep are collaborating on a humor panel, and several other political cartoonists are also venturing into the humor field.

The flow could just as easily go the other way, too. If you're a mild-mannered magazine cartoonist who gets angry enough, you might turn into a full-fledged editorial cartoonist. And have yet another box to play in.

12
Television

Cartoons on television once meant little more than animated Saturday morning specials for children, but today they are an important part of the graphics for adult programming as well.

Television cartoons fall into two categories: animated and still. Animated cartoons are seen in advertising commercials, titles and lead-ins for programs or segments, as pieces that stand on their own and as visuals "illustrating" stories on news and entertainment shows.

Still, or single-panel cartoons are used individually and in series with others. There are one-panel magazine gag cartoons, cartoon illustrations, titles and lead-in drawings for programs or program segments, single-frames in a story sequence that stands on its own and cartoon sketch reportage. There is also on-camera cartoon drawing, in various applications.

All television drawings should create some illusion of movement, in one way or another, since viewers expect television to move. Animation is obviously the best "motion technique," but it is an expensive and slow process and not used as often as the single frame on daily programming. It appears more frequently on shows where there is more production time. Several years ago, NBC aired a "magazine format" series called "Weekend," which regularly included a one-minute "sophisticated" animated cartoon centered on a character in contemporary, gently humorous, social situations. For Public Broadcasting Service's "51st State" magazine

series, I created a four-and-a-half minute, limited-animation fable entitled, "Opportunity Buzzes." (It was an expanded version of a one-panel cartoon I had done a few years earlier. Using the original cartoon as the central frame, I wrote a script with a narrator and cast of additional characters, portraying action which led up to "that one moment in time," then went beyond it to another ending. The animation was simple; I did all the drawings and designed very few "moves," relying mostly on narration and camera movement to carry the action.)

Animated gag cartoons comprised the "Cartoon-A-Torial," a nationally syndicated weekly series of five fifteen-to-twenty-second editorial cartoons. The cartoons were selected from the regular newspaper output of about fifteen of the nation's leading cartoon journalists, including people like Szep, Wright, Marlette, Borgman and Bassett. The animations appeared on local TV news programs as lead-ins to the national news block, special features in a regular time slot, or as lead-ins to commercials.

The original newspaper cartoon was animated minimally, through multiple photostats and re-drawings, by a studio in New York without the aid of the cartoonist. Bernie Shusman, who created the series for Newsweek Video, said that what he looked for in a cartoon were elements which "made it animate-able." This might be the facial expressions of people talking, violent action or just the composition of a drawing; some cartoons naturally *look* more animated than others.

Shusman, who had worked in television news for many years, had "always been intrigued by how cleverly issues were captured in one frame" by a cartoonist. "Cartoon journalism sums up a story in a few seconds," he says. Shusman had seen drawings done on camera during news telecasts in Atlanta, New Orleans and Chicago, but felt they had been flat. "I wanted to give a drawing full production value . . . and that meant semianimation." "Cartoon-A-Torial" ran for several years, continuing to experiment, and produced several solutions to the problem of transforming a static print cartoon into an animated one for television.

Cartoonists have also created animated "specials," running from fifteen minutes to two hours, based on comic strips like "Peanuts" and "Miss Peach" and tied into holidays or events, like Thanksgiving, back-to-school, and so forth. Mell Lazarus, for example, in collaboration with other writers, has written five "Miss Peach" television

shows that aired and several "Mommas" that are still in the works. In the "Miss Peach" series, specially designed puppets were used instead of Lazarus's drawings, an idea of the production company's to save money. The results were highly successful. "For the first time in television history," says Lazarus, "an economic consideration really paid off artistically."

Non-comic strip cartoon specials are also often based on a holiday or theme. Programs have been put together with several gag cartoonists doing their versions of Halloween, Valentine's Day or love. Arnie Levin animated "The American Wit Parade," a collection of printed material of American literary humor and comic art, for the Public Broadcasting Service; Bob Blechman produced a one-hour animated Christmas special, also for PBS, called "Simple Gifts," which included, besides a piece of his own, original segments done by four other cartoonists/illustrators: Seymour Chwast, chas b slackman, James McMullan and Maurice Sendak. In these situations, Levin and Blechman were also performing as writer-producer-director-designer-animator.

Beyond Saturday morning specials, children's educational television programming has provided a variety of opportunities for gag cartoonists to write, design and animate. Series like "Sesame Street," "Electric Company" and "Feeling Good" have carried contributions from many print cartoonists, including Arnie Levin, Sam Gross, Bob Blechman, Bill Woodman, Frank Modell and Mike Thaler. Thaler also created a superhero called Letterman for "Sesame Street."

Drawing single-frame cartoons for television is more accessible to the magazine cartoonist. Traditional gag cartoons have been used as regular parts of news or magazine programs and as part of special-events coverage. I drew gag cartoons for NBC's local New York news program; they were introduced twice daily by the anchorperson and shown full-screen for about seven seconds. I also drew gag cartoons that were incorporated into special live election coverage; the drawing was shown on a screen behind the anchorperson as he spoke, in what is called a "two-shot."

While gag cartoons have been used occasionally on television news programs, cartoon illustrations are used frequently. Most are drawn by the station's graphics department on daily "deadline" assign-

ments, and are usually restricted to "soft" feature stories that have an inherent lightness to them, like street fairs, the common cold, an eclipse, etc. A single drawing, however is generally too static to accompany a story which plays for two to three minutes (a *long* time on a television screen; time it yourself). More effective is a sequence of about six different single-image concepts timed to be shown at appropriate points in the script, each for five or six seconds, which produces an illusion of movement and passing time.

A single frame may play during an entire story, if it is rich in detail and is composed well enough to accept a camera panning over it, pulling back for long shots and moving in for tight closeups for ten seconds per "look." This technique is used often in courtroom and other special on-the-spot sketches.

A series of single-frame drawings can form a "storyboard" feature that stands alone. My first television assignment was to create a three-minute humorous skit for a show called "Woman!" that had no budget at all for animation, sets or even actors. I wrote a script involving two characters, then cartooned about fifteen frames, representing the action's highlights. My eleven-by-fourteen-inch drawings were blown up and mounted on twenty-two-by-twenty-eight-inch boards. In some cases, one drawing was photographed in long, medium and closeup shots to make several frames. The boards were then set up in order on easels, and "looked at" by the camera in sequence with the narration to create a dramatic, "animated" effect. These are my storyboard sketches for the first of twenty-four frames and a few finished drawings. You can see how they were designed for multiple use.

Drawing on camera is another nonanimation approach to cartoons on television. Several reporters who do the weather on news shows (Tex Antoine was the most famous) have drawn little cartoons, or at least added a finishing touch as they speak. On some news/magazine shows a cartoonist is introduced and starts to draw. We watch the picture begin to form, then, after a few seconds, the program

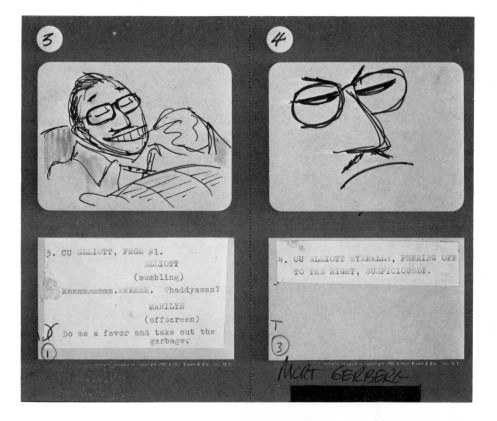

3. CU ELLIOTT, FROM #1.
 ELLIOTT
 (mumbling)
Mmmmm.mmmm.mmmmm. Whaddyawan?

 MARILYN
 (offscreen)
Do me a favor and take out the
 garbage.

4. CU ELLIOTT EYEBALLS, PEERING OFF
 TO THE RIGHT, SUSPICIOUSLY.

MORT GERBERG

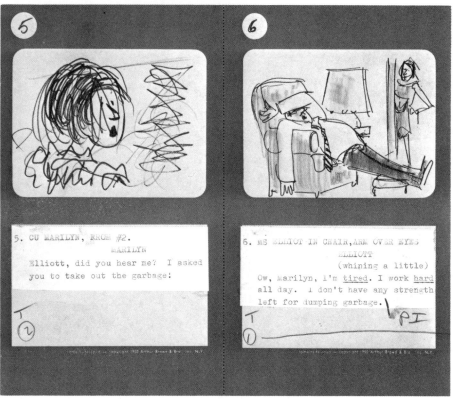

5. CU MARILYN, FROM #2.
 MARILYN
Elliott, did you hear me? I asked
you to take out the garbage!

6. MS ELLIOT IN CHAIR, ARM OVER EYES
 ELLIOTT
 (whining a little)
Ow, Marilyn, I'm tired. I work hard
all day. I don't have any strength
left for dumping garbage.

The action in this three-minute television skit was visualized through fifteen drawings that were looked at by the camera twenty-four times. Each drawing was designed so that it could be "framed" several ways. Look at the finished art on pages 194 and 195 that corresponds to the storyboard sketches.

The same art for frame one is used in closeup to make frame three. The same art for frame two is used in closeup to make frame five. The process was repeated throughout the storyboard.

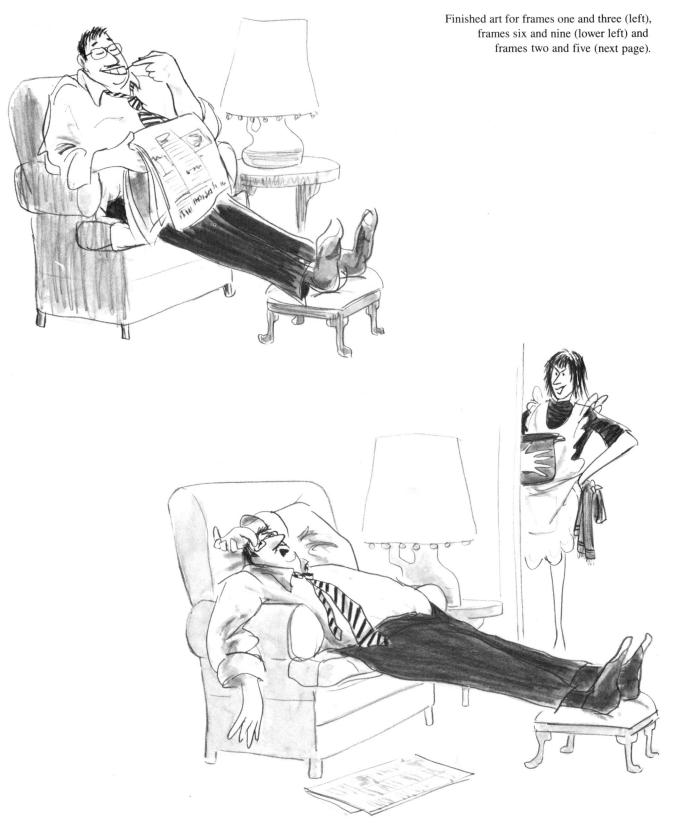

Finished art for frames one and three (left),
frames six and nine (lower left) and
frames two and five (next page).

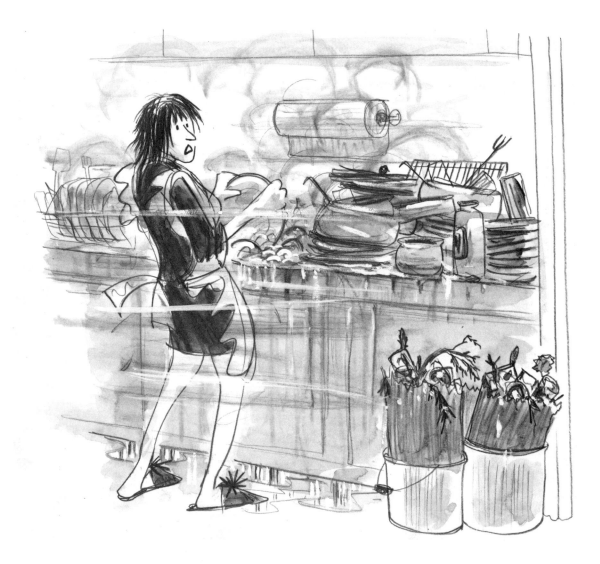

goes on to another subject. The camera returns to "peek" at the drawing-in-progress several times during the course of the show, winding up with a last look when the caption is added.

The more ambitious on-camera drawing is done all at once, in a preset, limited time. In some cases, the cartoonist is interviewed while he draws. This demands intense concentration, not only to create a "readable" drawing in four to five minutes but, simultaneously, to make intelligent responses to questions.

In other cases, cartoonists appear alone. Several years ago I did a regular spot on WNBC-TV's Channel 4 News called "Cartoon Views of the News." Within a minute and twenty seconds, I would introduce and deliver some light patter about a topical subject like inflation while I sketched a gag cartoon about it, winding up my "monologue" with the caption/punch line. The spot was taped and usually was completed in one or two takes. It required a great deal of preparation and rehearsal on my own, though, perhaps thirty-five to forty practice runs, until the performance was automatic; until the timing was so right that I would always arrive at the same places in my patter when I completed certain portions of the drawing, and always finished within the same time frame, give or take three seconds.

For drawing quickly and boldly, I found it best to use a thick black felt marker, and loosely followed a light blue pencil sketch, prepared beforehand, which the camera did not pick up well, on a light

blue paper. On air the performance looked totally spontaneous. This kind of cartooning, of course, like most television, was actually more "show business" than anything else. The drawing itself was certainly not finished; at best it was the equivalent of a "rough." But it didn't have to be more. The visual interest was to see a picture materialize, suggesting "animation," from a blank piece of paper, while a viewer watched and listened. The completed drawing would be seen for only three or four seconds. It was merely necessary to make a strong visual impression on a viewer; his own mind would add the details and create the illusion and memory of a fuller drawing.

Single-frame cartoon drawings designed for television must be "read" by a viewer in even less time than a cartoon on a printed page. A print cartoon exists in time and space. You can physically look at it again and again. On television there is no second chance to see a picture; it flashes on for a few seconds and then disappears. You either get it or you don't. (Watch a TV news program with a stopwatch and check the on-screen time for graphics. You'll see that four seconds is a *long* time to look at art.) All the techniques we previously discussed for creating "instant communication" in a gag cartoon apply here to an even greater degree. The *idea* of the television frame must be absolutely simple and broad. The most obvious, recognizable visual clichés are used to dramatize concepts. There is no room for subtlety that would cause hesitation in a viewer's perception. And a frame should try to convey only one idea at a time.

The drawing itself should contain *only* the essential elements, arranged in an eye-pulling composition, and be rendered in techniques especially suited for the medium. Television images pass through several "generations," or stages of reproduction (like film, videotape or cameras) before you see them on your screen, and each generation further weakens the original. In preparing art, therefore, the bolder the better is the general rule. Television art styles and techniques do not rely on lines but solid areas of tone and color (everything is done in color) to give weight to a drawing, so it can be identified more easily. Television artists use a variety of paints, acetate overlays, colored papers, chalk, airbrush, crayons, Magic Markers, in all combinations to effect this. Their choice of media may be affected by how quickly a medium can be used, the deadline and how many drawings are needed.

Beverly Littlewood, manager of the graphics department of News 4 New York on NBC-TV, says that the most important talent a television artist can have "is a four-letter word: F-A-S-T. An artist receiving an assignment to create visuals for a story may have only three hours from conception to completion," so he must be able to think and draw quickly and under pressure. He may meet with the reporter and together they'll work out the look and flow of the story, exchanging ideas on which words and pictures will be used. The reporter may even rewrite his script at the last minute to fit the artist's visuals.

Littlewood says that the use of graphics on television news has increased greatly in the past four years and so, proportionately, has the use of cartoons, particularly since the style of "happy news" became popular. Cartoon graphics "are used only when they are appropriate for the piece," she says, "for stories that are light; human interest features, or categories like sports, food and health, rather than hard news." Cartoon drawings of real people and places, in more serious events, particularly politics, could be interpreted as editorializing. "We're a news program," says Littlewood, "so we're sup-

posed to be unbiased. If we do use political art we must label it as 'commentary'."

An artist may be chosen for an assignment because he is particularly adept at a certain technique or a unique style or "specialty which defines itself," such as a background in animation, reportage sketching, caricature, comic strips or gags.

Dave Ubinas, a veteran of Littlewood's staff, has been its principal cartoon specialist. He works fast, is skilled in all media and techniques and is able also to work in several styles. These samples of his drawings should be glanced at only for a few seconds, to get a sense of how they worked on the television screen. Imagine them all in flat, bright colors. The drawings of the policeman, the goat lady and the giraffe are all examples of "spots" that were used in two-shots during lead-ins to three different feature stories. The mouse illustrated a special weather report. The lady in the fur coat was "animated" by being pulled slowly by hand across a background, on a "track" which Ubinas designed, while the reporter narrated the story. For a four-

Drawings by Dave Ubinas.

Multi-media
cels by
Dave Ubinas

minute story by Betty Furness about breakfast cereal, Ubinas designed this series of drawings, which appeared full-screen, during the narration.

While most of the television work is done by the station's art staff, there are opportunities for freelancers who have a specialty, as Littlewood refers to it. I had assignments for several stories which needed a kind of visual humor that stood on its own, rather than on the script. Bill Woodman has also done this work. The process is much like drawing spots for daily newspapers. These, for example on the following page. I remember receiving a

phone call, discussing ideas with the reporter (the piece was about landlords and apartments) and showing up at the studio three hours later with seven or eight finished sketches.

The drawings were done with a black Wolff pencil over an orange chalk background on smooth ledger paper. It was one of many media combinations I experimented with, looking for one which felt comfortable and which would also work on television. My first attempts, done in pen-and-ink-and-wash print technique, were unsuccessful; the lines were too light and did not hold up through

Mort Gerberg illustrations for a television news story on WNBC-TV. Renderings were in black Wolff pencil over an orange chalk background, which added a touch of quick, simple color to the screen; or, for black and white viewing, a gray background that was more eye-pleasing than stark white.

several generations of electronic transmission. In drawing gag cartoons I had the additional problem of how to add a caption underneath that was legible on a small screen.

The solution was to use media proven to be effective for film and television. These cartoons, which were aired on NewsCenter 4, were drawn with a thick black felt tip marker on acetate sheets, colored on the backs with an opaque paint called Cel-Vinyl, and taped on a colored paper background. The technique is exactly like the one used for animation cels. The drawing doesn't have the subtleties of one done for print, but it transmits an idea quickly. Look at it for six seconds, then turn away. You should have seen all you needed to "get" the idea.

The captions were also best handled in the techniques of television. While hand-lettering kept the flavor of a gag cartoon, the caption looked better when it was in a form like a crawl or "super" that the television viewer was accustomed to. I would therefore use the photographic equipment at the studio to set the captions in type and print them on clear acetates superimposed over the drawings. Even so, I learned that it is hard to read off a television screen, particularly if the caption is longer than eight words. Captions are better spoken in a "voice-over," as well as read, the way they were done on "Cartoon-A-Torial." Captionless gags worked best of all.

In drawing for television, then, the form is often as important as the content; the *manner* in which drawings are produced is a special field all its own. Computer graphics and other video electronic technology continues to increase the methods of creating and presenting visuals on television, and artists contemplating work in the medium should study them. Ultimately, technology will probably make it possible to animate all art inexpensively and quickly enough to satisfy any time demands of television.

The financial rewards of cartooning on television depend on a variety of factors. If you join the staff

"O.K.? I'll vote your conscience if you'll vote mine."

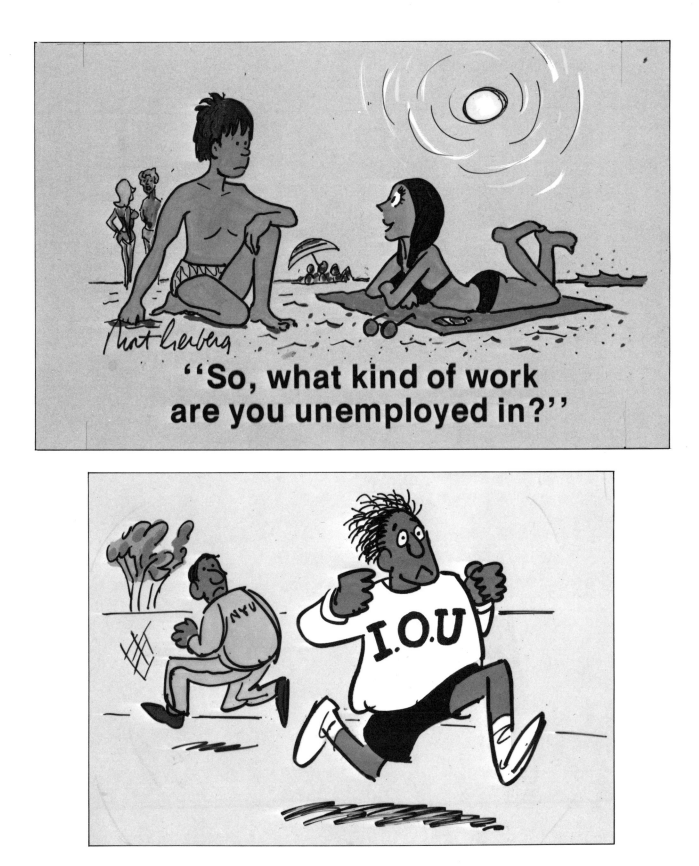

of a station's graphics department, your earnings may be determined by a union, like the Motion Picture Screen Cartoonists or the National Association of Broadcasters, Engineers and Technicians. If you freelance a specialty, your price will be affected by your reputation, the kind of work you do, your market, whether or not you appear on camera and how well you negotiate. Clearly, a bigger "name" will command a higher fee. If you're writing and designing a storyboard segment instead of only drawing it, you'll be paid more. If your drawings appear on a network program they'll usually bring a higher fee than if they are shown only on a local show. Public broadcasting pays less than commercial stations, but probably more than cable. If the drawings are shown more than once, and if you appear on camera showing or working on them, that should bring in more. Much of television talent is paid for according to some existing union scale (the *Graphic Artists Guild Handbook* should be helpful).

Beyond the money, I regard working on television as a valuable opportunity to create in different dimensions of time and movement. This can be not only enjoyable, but the experience can expand your thinking when you return to your work "inside the box" on the printed page.

13
Animation

Animation offers the cartoonist the opportunity to work in more dimensions simultaneously than in any other graphic form.

Instead of squeezing and freezing dramatic action into a single quintessential frame, he expands it to produce a continuing narrative in a thousand frames. Where the comic strip creates an illusion of lapsed time, animation exists in *real* time, anywhere from a few seconds to an hour or more. In addition to *time*, animation offers the added dimensions of *sound*—for dialogue and music—*color*, and the most magical of all, *movement*. Drawings become larger, smaller, fade in and out, change shape and color, figures enter and exit, in limitless arrangements and sequences.

The relationship between the single-panel cartoon and the animated film is close; both are concerned with instant communication through individual frames which either stand alone or work together. Cartoonists who have worked in both animation and print agree that their experiences in one mode influences the other.

Bob Blechman, well-known in many cartoon forms, admits that he loves film the most, probably because it offers so many more challenges. He quickly adds that his "print experiences feed the film work, because print experiences enable you to tell which of the frames are the really important ones." The only real problem is that you "need to work through other hands." When he is doing an

Frames from a storyboard for "Opportunity Buzzes," written, designed and animated by Mort Gerberg, for PBS's The 51st State. Gordon Hyatt was the executive producer.

animation, Blechman may have fifteen people in his studio drawing and painting.

Arnie Levin attributes much of his success as a print cartoonist to his previous work as an animator. He says he developed the ability "to look at film and actually see on a Moviola frames moving at one twenty-fourth of a second and see what's out of place . . . see what's wrong . . . like an ear or eyeball missing." The ability to notice what's "recognizable but different about that instant" is to be able to re-create it and make it interesting, which is, says Levin, the basis of a gag cartoon. Levin also thinks animation helped him learn to think in terms of physical, visual clichés.

Animated art—producing an illusion of movement—is created through a series of drawings which depict an action through individual stages, each drawing advancing the movement slightly. The drawings are photographed, frame by frame, onto a piece of movie film, which is projected at the rate of twenty-four frames every second (meaning that each frame is seen for only one twenty-fourth of a second). In order to produce a one-minute animated film, therefore, it's necessary to create 1,440 individual frames. The entire process is elaborate, expensive and highly structured.

Since animation is so costly, the bulk of its application is in television commercials, which are carefully planned, budgeted and paid for by an advertiser. The commercial usually runs twenty, thirty or sixty seconds, and is created by the client's advertising agency in conjunction with an animation production studio. The basic decision to use animation often arises from the wish to treat the subject in a nonrealistic approach, lightly and with humor (as long as it's appropriate for the product or service). The commercial will cost more than simple live action but the client anticipates it will be better remembered and bring better results, just as print advertising has been found to be more effective if it contains cartoons.

Advertising agency personnel usually begin the process by writing a script and roughing out a storyboard, a sort of comic strip summary depicting key action frames. Storyboards are the basic blueprints of any animation; they are the models upon which the actual drawings are based. On the preceding page are some frames from a storyboard I did for my four-minute animated feature called "Opportunity Buzzes." Notice that the storyboard

indicates the art in a "TV frame," and underneath, the dialogue, sound effects and camera directions.

Once the storyboard is approved by the client, an animation production studio is chosen, generally after competitive presentations and bidding including, perhaps, considerations about which cartoon styles may be available. Animation studios have working relationships with a number of freelance cartoonists and often suggest one of them to the agency (see next page). The studio's animation director asks the cartoonist to create the characters and style for the commercial from the script and other client information. The samples are then approved by the studio, the agency and the client to make sure that everybody's on the same track. Sometimes the initial samples are rejected and another artist with a different style and approach is called in. It is often a matter of taste and is all part of the animation business.

The first step in production is recording the sound track, which includes dialogue, sound effects and music mixed together. A film editor locates and times the duration of each sound precisely, so that drawings can be created to match. The longer the action lasts, the more drawings that will be needed.

The animation director, knowing that he has to create 1,440 frames for each sixty seconds of film, and knowing how many seconds each bit of dialogue and action will take, prepares an exposure sheet, a frame-by-frame breakdown of the entire film which notes and synchronizes each bit of action to sound. Through this process the animation director allocates the appropriate number of frames for each scene, according to their importance.

With this information, the animator-cartoonist makes the key drawing, in pencil, of each scene, perhaps every tenth or twelfth frame, based on the original approved storyboard. These key drawings are like single-panel cartoons in that they represent the quintessential or extreme instants of the action. Drawings are made on white bond paper thin enough to be nearly transparent, about ten-by-twelve inches, with three holes at the top, which allow the drawing to be registered precisely on a set of metal pegs on a bar. Other artists, called assistant animators and in-betweeners, then draw the stages of the action in between the extreme shots on paper registered over the animator's drawings, which

designers/**Arnold Roth**/**Harvey Kurtzman**/
Skip Andrews/**Rowland B. Wilson.**

designers/**Nick Gaetano**/**Bill Peckman**/
Gahan Wilson/**Jack Davis.**

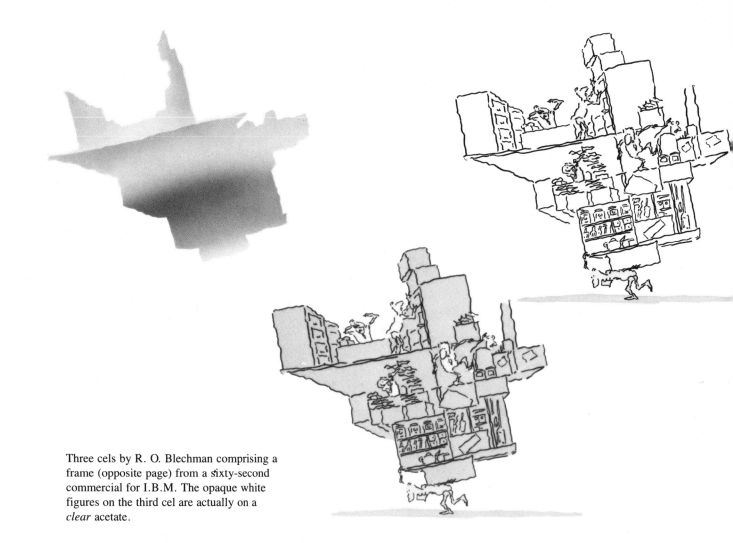

Three cels by R. O. Blechman comprising a frame (opposite page) from a sixty-second commercial for I.B.M. The opaque white figures on the third cel are actually on a *clear* acetate.

serve as guides. The more individual drawings allocated for an action (like opening a door, for example) the smoother the move will appear; the fewer the drawings, the rougher or more limited the animation.

When all the pencil drawings have been completed, time and money permitting, they are photographed, frame by frame, onto a strip of movie film (usually 35-mm) according to directions on the exposure sheet by an animation camera, a sophisticated device which moves itself and the art it photographs in any combination of precisely measured positions. The film is combined with the magnetic sound track to produce a pencil test, which shows how well the pictures and drawings are synchronized with one another, and provides an opportunity for changes and corrections.

The final stages of the film are completed by inkers, who trace the pencil drawings in ink onto cels (sheets of clear acetate, the same size as the bond paper, and also punched with three holes to ensure registration) and opaquers, who paint the reverse side of the cels according to the animator's original color design. There are usually a number of cels—counted by levels—necessary for each frame, for background and middleground, which may be stationary, and for characters and other "moving" elements that play in front.

The creative variations possible within an animated film are bounded only by time, money and imagination. As with print cartoons, strongly defined characters and visual clichés are particularly important, as well as broad gestures, which can be utilized to great advantage when animated. The same general principles of writing and drawing print cartoons apply, but the "rule" about keeping cartoons simple is of special importance in animation. Since all the elements of the "move" must be redrawn hundreds, perhaps thousands of times,

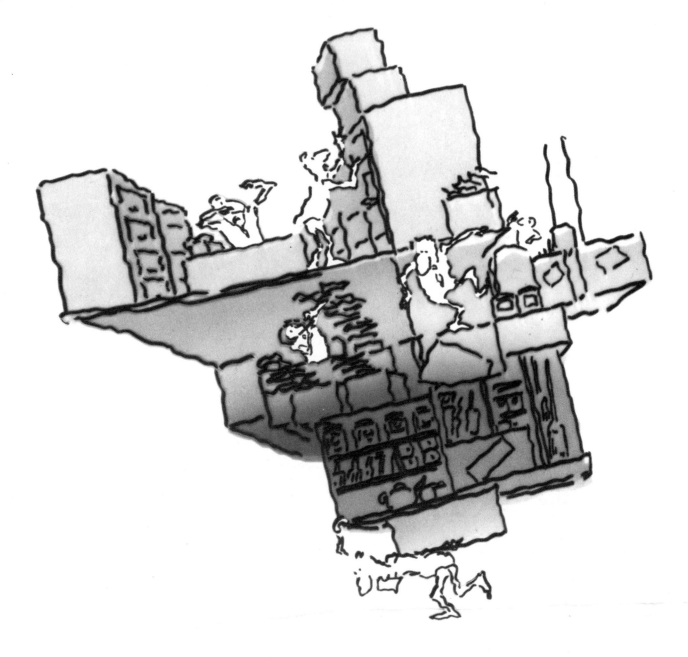

they cannot be designed in a complicated style; otherwise the whole film will take too long to complete and become prohibitively expensive. Study animated commercials on television and you'll get a good idea of what styles are currently favored.

Magazine cartoonists who get animation assignments are usually hired for their individual style and their ability to come up with imaginative visual solutions; they do not merely illustrate a script, they inject a personality and special life into it. Cartoonists like Blechman, Levin, Rowland B. Wilson, Arnold Roth, Harvey Kurtzman, Gahan Wilson,

Mischa Richter and Ed Koren are among the many stylists who have been hired to design animations.

These are three cels by Blechman that made up one frame from a sixty-second commercial for IBM. The first level is the entire drawing on paper, in black line with two colored Zipatone sheets stripped into the large areas. The next cel is a multi-toned airbrush wash in color on acetate; the third level is a duplicate of the first, on acetate, with the figures opaqued in cel-white to make them stand out in front of the background.

These are frames from two different films by

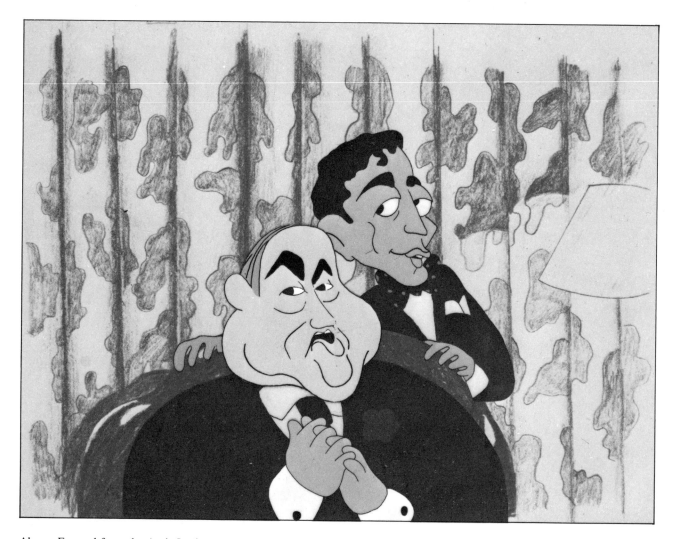

Above: Four-cel frame by Arnie Levin from a two-minute film, "The Chocolate Bunny," for The Children's Television Workshop's The Electric Company. Levin wrote, designed, produced and directed it, creating characters and backgrounds based on the film, "The Maltese Falcon." The backgrounds were drawn in soft pencil on paper. The cels were produced by Xeroxing animators' pencil drawings on clear acetates to get "ink" lines, then painting them with Cel-Vinyl Cartoon Colors. Right: A series of frames animating the Sidney Greenstreet character. The eyes and mouth are drawn on one cel level. The nonmoving part of the face is drawn on another cel level, which is "held" or repeated as the frames are photographed through the stages of the action.

Arnie Levin, demonstrating how sequential drawings create the illusion of movement—a man speaking and a horse galloping. Notice, too, the wide differences in style between the two.

While TV commercials make up the principal market for animation, advertising sales promotion and public relations films also make use of them, although the animation is usually more limited. Among the other markets are productions for television, described earlier, and movie theaters, which these days seem to be confined to public service announcements.

The problem in doing "editorial" animation is that it rarely earns enough money to cover the huge expense. Unless there is a generous sponsor or underwriter, an animation project has only a slight chance of getting done. Animated films can be made much less expensively in foreign countries like Yugoslavia, and many productions are completed there. There is also the occasional full-length feature, like the classic Disney version of *Snow White*. Some are still made by the Disney Studio, others by people like Ralph Bakshi, who produced *Fritz the Cat* (based on cartoon characters created by R. Crumb, the underground comic artist), and a version of Tolkien's *The Lord of the Rings*. These were commercial ventures, as any other film is; the difference is that in animation, the costs are much greater, and so is the risk.

Any discussion of animation today would be incomplete without mentioning computer graphics, one of the most exciting film innovations of recent times, now becoming a mammoth special field of its own. Many of the recent science-fiction films like *Star Wars, Star Trek, Poltergeist, E.T.* and particularly *Tron* have made heavy use of computer graphics in animation, as has television. Merely becoming acquainted with the technique involved requires a good deal of study.

Print cartoonists who wish to explore or break into the animation field should first learn the process. There are many technical details which you should know about first-hand. Obtain some actual work experience on any level on a film, even if it's only to help out a colleague. Pick up some of the special tools and materials of animation and experiment, trying out a few of the many techniques for producing a cel. These experiments can become part of your portfolio when you call upon agency and animation studio people for assignments. Animation work can be tedious if you are doing in-between work, like inking or painting, but the experience is valuable if you want to design animations (or even aim ultimately to open your own production studio). If your drawing style is naturally suited for film, your work may have just the right appeal for an art director and could get a tryout. It's a long shot, though, since the field is

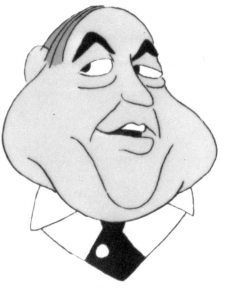
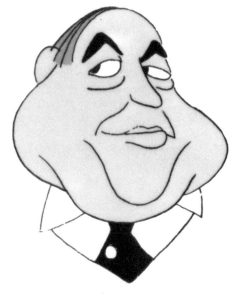

A multi-level frame from a one-minute film "I'll Break the Bronco," which Arnie Levin wrote, designed, produced and directed for The Electric Company. The film was an exercise in using the letters "br" together. The cowboy whistles and the bronco gallops in.

relatively small, the competition keen and the assignments not as numerous as in print. For more specific information and direction about entering the field, call on a local animation studio or advertising agency and offer your services. They will also be better able to give you an estimate of how much you could earn as a salaried employee or freelancer.

Three frames from the animated action of the bouncing bronco. Only the key drawings were drawn by Levin; animators and in-betweeners did all the others. The lines were drawn directly on acetate with a Radiograph pen and black Castell acetate ink, then colored with Cel-Vinyl.

Ultimately, while the technical aspects of animation attract and intrigue the eye, concepts and original ideas are still necessary to hold an audience's attention. And this is why there will always be the need for a cartoonist—to come up with yet another new perception, another untried solution, especially in a field like this, which is constantly growing and outdoing itself.

14
Comic
Books

The comic book allows the greatest freedom of expression on the printed page. It tells stories of any length through pictures in varying sizes, combinations, shapes, sequences and colors; and dialogue in boxes, balloons or free-floating. In its most traditional format, the comic book most closely resembles a multi-paged comic strip; in the extreme, in the underground "comix," it has a dimension of its own.

The comic book, for all intents and purposes, was born with the introductory episode of Superman in Action Comics, in 1938. Superman was the first true superhero, a descendent of heroic characters in science fiction, Western and detective pulp fiction magazines, which were popular in the United States in the 1920s and '30s. His appearance, in turn, immediately spawned a whole genre of superheros, like Captain America, Captain Marvel and Batman who, through adventures in the comic books which showcased them, "helped" this country win World War II. With the dictators and the forces of fascism destroyed in real life, comic books returned to the proven-popular Western, crime and monster themes from the pulp days, and gave rise to new superheros like The Submariner, Green Lantern, The Atom, The Human Torch and Wonder Woman.

The comic book became, for many writers and cartoonists, an arena for wide experimentation. Story lines were more detailed and realistic, graphically visualized in action and violence; drawings

and design were rendered in unusual techniques, shapes and perspectives; for example, in Will Eisner's The Spirit.

The appearance of Mad magazine in 1952 introduced political and social satire into comic books for the first time, shifting the focus from superheros to familiar subjects in our everyday world. The original comic book Mad, as conceived by Harvey Kurtzman, filled a vacuum with satire and parody; before it, all comic books were fantasy. It was a natural direction for Kurtzman, who says of himself, "I am rooted in reality; I'm not so good at fantasy." It was the beginning of a trend that would have wide influence. Under the editorial guidance of Kurtzman and with the artistic talents of people like Jack Davis, Will Elder and Wallace Wood, Mad produced wild, contemporary humor, and became a model for other satiric comic books which followed: Kurtzman's Help and Trump and later, the National Lampoon.

Another innovation in comic books occurred in the 1960s when Stan Lee introduced in Marvel Comics a new breed of superhero. These Marvel superheros, led by Spiderman, The Hulk and the Fantastic Four, differed from the traditional superheroes in that they struggled with real human problems and weaknesses, all too familiar to their (mostly teenage) readers, who were thus able to identify strongly with them, making Marvel Comics immensely successful. Characters, both good and bad, are not created in strictly black-and-white terms. Villains are not necessarily all evil and heroes definitely have feet of clay. In fact, Marvel heroes agonize over moral questions, have difficulty making decisions and often behave like a bunch of neurotics. Says Lee, "Our characters soliloquize enough to make Hamlet seem like a raging extrovert." In Marvel stories, Lee adds, it was the first time that comic book stories were written "with the same concern for human speech and characterization as movies, novels and plays."

The pendulum swing towards realism went even farther in the late 1960s with the emergence of the underground comic books, or "comix," led by artists such as Robert Crumb, S. Clay Wilson, Gilbert Shelton, Art Spiegelman and Bill Griffith. The comix, in both style and content, can be seen as a rebellion against all of the restraints which had previously governed the comic book form. They deal primarily with "taboo" and "bad taste" subjects like sexual freedom, radical politics, violence and drugs, depicted in explicit language and in drawings which are often grotesque and bizarre. Much of the material is sexual and graphic, giving the comix a pornographic flavor, but the overall intention is satire (aimed at all targets from the traditional community to the new-left politics), rather than prurience for the sake of titillation.

The underground comics make up a clearly special, limited area of cartooning, and those who work in it do so primarily as a labor of love, since problems of publishing and distribution are great and the financial rewards small. Anyone interested in learning more about the field, including the names of publishers and distributors, should write to the Cartoonists Guild and ask for a copy of its booklet, "Digging the Underground."

"Overground," traditional comic books do represent a possible out-of-the-box market for the gag cartoonist, several of whom have switched to the field as their main work, notably Peter Paul Porges, a regular contributor to Mad magazine, and Lenny Herman, who freelances and edits for Harvey Publications. The "overground" comic book field today may be divided into two broad categories: humor and adventure.

The humor group is represented by Harvey Publications, which publishes "Richie Rich" and "Casper, The Friendly Ghost," among others; Archie Comics; Western Publications, which does the Walt Disney characters' comics; Mad magazine and other satire-parody comics; and portions of the National Lampoon. The adventure comics include the Marvel Group and D. C. Comics, which produces the original superheroes like Superman and Batman.

The process of creating comic book material varies from publisher to publisher; at one extreme, a story is done entirely by one cartoonist-writer; at the other it is a joint effort by a writer, illustrator, inker and letterer. Stories for comic books may be done by people on a magazine's staff, by regular freelancers and by occasional freelancers.

Sid Jacobsen, managing editor at Harvey Publications, believes that the humor comics group is the more accessible to the gag cartoonist, since the adventure comics require highly developed illustrative skills and familiarity with technical material, as in the science-fiction fantasy stories. While the rate of pay at Marvel and the other adventure comics usually runs considerably higher than in

Storyboard by Harvey Kurtzman for a "Little Annie Fanny" page from Playboy magazine. Kurtzman works with Sarah Downs, Will Elder and Phil Felix in producing the multi-paged feature. Downs usually makes color sketches from the storyboard while Kurtzman does drawings to size. These are then traced onto illustration boards and painted by Elder. Felix does lettering and borders. There is a lot of "back and forth" work in the process, says Kurtzman.

the general humor group, the illustrations require much more labor, as you can see by browsing through a few stories. Most of the artists who illustrate adventure comics are able to work rapidly, turning out four or five pages a day; at a page rate of roughly $60 a page, he can earn a good income. If this genre of drawing does not come naturally to you, then you'll have a tough time competing with the fifty or sixty artists who regularly ply this area.

In the humor comics group, says Jacobsen, it's more likely that a cartoonist will write as well as illustrate stories. At Harvey Publications he has employed only writer-cartoonists, since so much of the humor is visual. Also, because the material, like the Richie Rich stories, is so special, he has found that only a few can do it well and consistently. The idea for a story is generally submitted first in typewritten form, outlining the action in a half page. The cartoonist then prepares what is in effect a storyboard, like the Richie Rich examples here, done by Len Herman. Another artist may then do final pencil drawings and still others will do inkings, lettering and coloring—"piecework," as Jacobsen calls it. Pay rates, of course, vary among publishers, but run about $25 per page for a humor story, $45 per page for pencils, $20 for inking, $6 for lettering and $7.50 for coloring.

At Mad magazine, though, the financial structure and rates are the highest in the field, going up to several hundred dollars per page, and include many benefits like sharing in royalties from the publication of the Mad books. Most of the Mad work, though, is created by about twenty-five regular artists and writers, and has a flavor and personality special to the magazine. Study it thoroughly before attempting a submission. Usually a Mad story is the product of an artist and a writer; in a few cases, notably Sergio Aragones and Al Jaffee, it is done by one cartoonist. Mad magazine has a number of imitators, like Cracked, which offer cartoonist-illustrators work at much lower rates.

Children's comic books, like Sesame Street, Cricket and 3-2-1 Contact, comprise another group of humor comic books where a cartoonist might work, if his style and tone is appropriate. While these pay rates are modest, you might be able to work regularly here, and that's valuable.

The comic book field as a whole seems to go through cycles of growth and shrinkage, in popularity and size. Kurtzman, who feels that it is currently suffering, mostly as a result of the computer games takeover, nevertheless believes that there is new energy coming up from the underground comix and from European influences, particularly in quality reproduction, such as Heavy Metal. His own "Little Annie Fanny," which appears in Playboy, is the best example of American process color cartooning, as well as top-quality comic art. Currently, superheroes are still strong as themes, and Marvel and D. C. Comics may be most open to new ideas and characters. While the field is small, special and demanding, it does offer the cartoonist the chance to work regularly, as well as the opportunity to experiment with the combined disciplines of animation and illustration, which you also may use as stepping stones for the continuity work in syndicated comic strips.

Rough pencil layout by Len Herman for a Richie Rich comics page.

15
Greeting Cards

The greeting card field, once characterized by conservative, flowery expressions of traditional sentiments, has changed and expanded rapidly over recent years and become an important market for magazine cartoonists.

The main reason for the transformation has been a widespread swing to humor, ranging from the "studio" card, usually quiet and cute, to those cards that are outrageous, almost pornographic. The field, once dominated by a few large companies, notably Hallmark and Norcross, now boasts about two hundred, offering not only varied lines of cards but allied products and promotion items, like T-shirts, books, calendars, posters, diaries, pads, comic strips, appointment memos, dolls and the like.

The greeting card form is another which bears close relationship to magazine cartoons. Both communicate messages quickly, succinctly, graphically, memorably and with humor.

In most cases, the greeting card is like a two-panel gag cartoon: the situation being "set up" on the outside cover, and the unexpected switch, or punch line, on the inside—as with these examples by Bruce Cochran, Charles Barsotti, Russell Myers and Dean Vietor.

Like the magazine cartoon, greeting cards are most successful when they combine simple, stylized art and quickly recognized visual and verbal clichés. There are also some special characteristics

of greeting cards, according to Bill Brewer, senior stylist of Hallmark.

"Sentiments and characters, whimsical or hysterical, must, with the exception of some non sequitur humor, communicate intimate, personalized me-to-you feelings," says Brewer. "Card senders and receivers must be able to identify with the characters. Personality and expressions with which people wish to identify must be present, even while they are rendered humorously."

A card, states Brewer, should be "something not

Happy Birthday to someone
who's sophisticated, cultured,
intelligent, good-humored,
charming...

...in fact, a lot like me!

just looked at, but something that can be shared."
And, he notes, "the idea in a cartoon is paramount.
I am always looking for *ideas* for cards and related
social expressions products. It's a relatively simple
matter to have the ideas illustrated. I look for car-
toonists who can write card ideas and create funny
visual situations and sight gags."

It's not surprising, then, that many established
magazine gag cartoonists do work professionally in
this field. (It's natural for most cartoonists I know
to make their own cards rather than buy them.

GREETING CARDS

We all
got together
to decide
what to do about
your leaving!

Giving you
this card was our
<u>second</u> choice!

Our <u>first</u> choice
was to try
to talk you into
staying!

Anyway,
good-bye from
all of us!

Illustration for card
by Bruce Cochran.

Cynthia, Danny and Lilia—my niece, nephew and daughter—have large collections of birthday greetings I did for them. Steve Heller edited and published a book of cartoonists' personal Christmas cards.) Some, like Bill Hoest, launched their careers in greeting cards. Hoest says, "I made the transition to magazine cartoonist fairly easily from humorous greeting cards, having started at Norcross, and freelanced greeting cards for several years." Barsotti and Cochran are still active with Hallmark, as are Russell Myers (who draws the comic strip "Broom-Hilda") and Dean Vietor. Paul

Keep smiling!

COCHRAN

It makes people wonder
what we've been up to!

Coker worked in the field for years. George Booth and Arnie Levin are among others who have created a special line of cards for a company. Still another company has sold a package of Christmas cards by several New Yorker cartoonists, including Ed Fisher, Dana Fradon, Mischa Richter, Frank Modell, Lee Lorenz and Bob Weber. (Greeting card companies also purchase licensing rights to popular comic strips or television series and build a

You mean the WORLD to me!

R.MYERS

Can I put my arms around
your EQUATOR?

line of cards around these characters, like Schulz's ubiquitous "Peanuts" characters and Tom Wilson's "Ziggy".)

Greeting cards are created in several ways: by a company's staff artists and writers, by regular contributors under contract and by freelancers. Freelance submissions may come in unsolicited, not only from professional writers and cartoonists, but from people in all other professions. It's an art form accessible to everyone. Different companies handle unsolicited material in different ways, but

Illustration for card
by Dean Vietor.

all procedures seek to establish ownership and originality of the material, to avoid problems which might arise if an idea comes in from two different sources. At Hallmark, for example, freelancers are first asked to fill out and sign a submission agreement before their material is reviewed.

Ideas may be submitted in any number of forms, some more finished than others, like submitting cartoon roughs. Cartoonists generally submit actual replicas of folded greeting cards, complete with a lettered sentiment and fairly finished

You take my breath away!

Happy Valentine's Day!

Illustration for card
by Bill Brewer.

sketches, but that's not necessary. Writers who are not artists might include a rough stick figure drawing to illustrate their ideas. Still other writers just type their ideas on cards, labelling the outside and inside portions of the sentiment and describing what the visual should look like. Established gag cartoonists might include with their submission some samples of their published work, to show their style.

According to Brewer, "It has been my experience that our most successful contributors are those who both write and draw. Frequently the il-

lustrator will contribute something academic while the idea-creator/cartoonist will contribute something magic."

With regard to marketing, Brewer points out that "ninety-five percent of our products are purchased by females and our cartoonists must concern themselves with appealing to them."

This concept of creating an idea or situation with which a reader/buyer can strongly identify, emo-tionally and personally, is, of course, exactly what makes a gag cartoon successful, which is why cartoonists are well-suited to this field. However, like gag cartoons, greeting cards are not as simple to do as they look. Before you sit down to prepare a portfolio of card ideas, spend some time browsing through card shops to see what's being marketed, and try to get a feel of your own natural inclinations. If you've ever hand-made any personal

Sketch for card
by George Booth.

greeting cards, study them and see if there are any universal ideas, themes or approaches there, which could appeal to a general public. This market is also unique in that consumers buy your (cartoon) product alone, on a one-to-one basis, instead of its being part of a package, like a newspaper or a magazine. It's a direct test of your creative appeal.

The financial rewards of greeting cards vary greatly, depending on your commitment to the field. A staff or contract cartoonist with a company usually receives assignments, is guaranteed a certain number of drawings per month, may work in his own studio and usually receives higher rates than the occasional freelancer. Probably the bulk of all greeting cards are created and produced by people in these categories. Individual ideas for cards may be paid for at rates of about $80 each, and cartoon illustrations at about $200, varying from company to company and the individual's previous experience. Freelancers who can sell a line or series of cards centering around a theme or characters will be able to earn more, as will "name" artists who might be able to negotiate better rates because of their proven "box-office appeal" from previously published work.

The continuing growth and diversification by the established card companies and the emergence of new ones suggest that this market may become even more important to the freelance cartoonist seeking new challenges and opportunities.

16
Advertising

In the field of advertising the cartoonist may explore many possibilities for assignment work which pays well—better, in fact, than comparable work in the editorial area.

The purpose of advertising is to promote the sale of products, ideas and services. It does so by using words and pictures to arrest a reader's attention, make a memorable impression and motivate action. Research has proven that ads containing cartoons or humorous illustrations are particularly successful. The reason, of course, is that cartoons effect instant and powerful communication. In an ad, cartoons make ideas easier to understand, present facts and figures more warmly, persuasively. Advertisers, recognizing the importance of cartoon art, have created a market for it worth hundreds of millions of dollars a year.

THE WORK

Advertising employs all forms of cartoon art—magazine cartoons, spot illustrations, comic strips, animation—in numbers of ways in film and print. The most noticeable are in television commercials and in large ads in national magazines aimed at general audiences, such as Rowland B. Wilson's series for New England Life, for example. Or R. O. Blechman's for the New York *Times*; chas b slackman's drawings for the Marine Midland Bank, Chuck Saxon's for Chivas Regal. However, probably the greatest volume of cartoon art is used in media

Rowland B. Wilson

"My insurance company? New England Life, of course. Why?"

If you need 90 day money fast and your bank makes you see 90 people,
TELL IT TO THE MARINE

At Marine Midland, we realize that a slow bank is a bank that's not working hard enough for you. That's why our system is built for speed.

For instance, most of our loan officers have the power to give approvals on their own signatures. So we won't slow you down with a lot of conferences and calls and committees.

Another step we take is making sure our local people have a grasp of the community as well as the country. Over the last 125 years, we've learned how to anticipate local needs, whether they're seasonal or long term.

Besides that, a Marine Midland loan officer makes it his business to know your business. In fact, chances are that he already has experience in your industry. There's a good reason for this. Having the most branches in New York State gets us involved in practically every business in New York State.

So no matter how fast or how long you need money, just tell it to the Marine.

MARINE MIDLAND BANK

Chivas Regal • 12 Years Old Worldwide • Blended Scotch Whisky • 86 Proof
General Wine & Spirits Co · N Y

which are *not* widely seen by the public; in local newspaper and trade magazine ads (like my Bulova series), house organs, sales brochures, direct mail, logos, film strips, slide films, client movies, audio-visual presentations, employee newsletters, annual reports, sales promotion booklets, posters, packages, letterheads, billboards, matchbooks—all directed to special audiences for specific purposes.

Drawing by Chuck Saxon for a Chivas Regal advertisement. Ideas and layouts for ads like this are generally created by an advertising agency and assigned to a freelance artist for finish.

Two examples from a series of cartoon ads for Bulova Watch Company, which ran in a home furnishings trade newspaper. The ads consisted of a cartoon on the subject of time, picturing a clock from the Bulova line, plus a Bulova logo and slogan. I wrote and roughed out ides for approval by the sales promotion agency in charge of the account.

Boris Drucker's sales promotion mailer for Sylvania, or his drawings for a DeSoto Benefits Report seen at the end of this section), as well as my calendar for Arrow, are examples.

A mailing piece for Sylvania by Boris Drucker, designed like a "gag" greeting card to gain high reader attention.

There are three principal markets which produce this material: advertising agencies, companies and small businesses and art studios.

Advertising agencies generally handle the big national and regional campaigns. Some agencies are also responsible for their clients' smaller, collateral material. All agencies function through "team efforts," involving contact people like salespersons and account executives, who act as liaisons between the agency and the client company; and "talent," like copywriters, art directors, layout artists, illustrators and freelance specialists. Advertising is produced by many minds, hands and conferences, a "group think" process distinctly different from the "isolationist" one the cartoonist is familiar with, but one he must adapt to, one way or another, if he is to be successful here. Ordinarily the freelance cartoonist deals only with the art director, who communicates the wishes of the client and agency.

Companies and small businesses themselves produce a large volume of "internal" material like newsletters, bulletins, memos, house organs, window displays, order forms, show cards. Here freelance cartoonists work with the company's advertising or public relations departments. This is an excellent area to explore since all companies, regardless of size, buy freelance art. Besides, they may be easier for the beginner to approach, particularly in smaller cities. Good prospects are department stores, banks, hardware stores, newspapers and travel agencies. These drawings are from an opinion folder accompanying a corporation's dividend check mailing. I first submitted rough ideas to its public relations company.

Art studios solicit and receive work from both advertising agencies and private companies; because of the amount and diversity of their assignments, they are also a fine market for the free-

This calendar was sent to prospective clients as a reminder of the company's year-round services.

Drawings by Mort Gerberg for a corporate "editorial" mailing piece accompanying a dividend check.

THE GREAT PUBLIC ISSUE ISSUE

YOUR QUARTERLY DIVIDEND IS ENCLOSED
It is paid on September 1 at the rate of
$.41 per share of common stock
registered in your name on August 8, 1977.

lancer. An art studio necessarily utilizes many specialists, like letterers, pasteup and mechanical people, photo retouchers, airbrush artists, animators and cartoonists.

You certainly need not live in a large city to get advertising work. Your hometown businesses can provide you with any number of assignment opportunities. The initial time and energy spent going out and hustling can pay off well. One good contact leads to another.

In most advertising work, a cartoonist is required to illustrate an idea or concept that the client and agency has come up with, providing a special style and approach for a drawing. The creative process of coming up with a visual solution and rendering it appropriately is pretty much the same as in spot illustrations and any other kind of cartooning we've already discussed. The difference here is that you'll probably get a lot more direction from *other* people. Here is a rough sketch done by an advertising agency, Doyle Dane Bernbach, for a cartoon in a Chivas Regal ad. It was assigned to Jim Stevenson

to finish. The idea and layout for this Betty Furness ad came from NBC's advertising department; I did the drawing to fit. Occasionally, a cartoonist is asked to write his own ideas, because his particular humor is seen as additionally valuable in selling the product.

Some cartoonists go further and offer their clients complete advertising art services. They not only draw cartoons; they can also design, lay out, spec type and paper, size art and produce complete mechanicals, ready-for-camera. Some even write copy. Boris Drucker is one who has established a solid freelance career in the field for himself, balancing it with one in in magazine cartooning. Roland Michaud and Bernard Schoenbaum worked as artists in New York advertising agencies. Ken Alvine operates his own advertising art studio in South Dakota.

Cartoonists have different attitudes about advertising work. Bob Weber, one of the most sought-after cartoonists, says, "Most of the time, you're given a layout; it's already determined what you're going to be drawing, but I feel it's a challenge; it's solving a problem, and it's harder to draw that stuff than do a regular cartoon, because it may not be what I'm into at all." Lee Lorenz feels that of the many out-of-the-box areas, advertising is the "furthest away from cartoons because there's the least amount of yourself in it. Usually you're illustrating their situation." For the same reason, Chuck Saxon thinks that advertising is "the opposite of New Yorker cartoons."

Bud Handelsman prefers it "when the idea comes from the advertiser and I can simply illustrate it. I find it very difficult to think of original cartoon ideas whose purpose is to sell a product."

"Hello, Betty Furness? I'm stuck with a monstrous problem."

INSTANT GLUE

All about new glues, cool ways to save money, and how to read between those funny lines on food packages.
BUYLINE: BETTY FURNESS

4 N 7:30PM TONIGHT

Opposite page: Four-color cartoon, rendered in felt tip pen and colored markers, by Boris Drucker, for an A.T.&T. employee relations slide film. Cartoon drawings for films are usually developed from a script provided by the company.

Compared with regular cartoons, advertising cartoons demand "less emphasis on farce and satire," says Joe Mirachi.

Bob Blechman, one of the foremost editorial and advertising artists, is a perfectionist; he strives to maintain control over everything he does, both in the art and the idea. "I hate to render," he says. "I dislike artists who do only what is expected of them." With this attitude, naturally, he anticipates resistance. "When you are creating ideas, there is the potential for disagreement," he says. "They have a different approach and you never know where there is going to be a problem." In Blechman's New York *Times* campaign, "These Times Demand the *Times*," he took only the headline from the agency/client; he insisted on creating the individual ideas in the part of the series he did.

Most cartoonists agree that dealing with agencies and other clients can be the most difficult part of advertising work. However, one cartoonist, who runs his own advertising design business in a small city, says that when you're working for someone else you *must* be willing to change your drawing for your client, no matter how great *you* think it is. Learn your client's preferences and how he wants to sell his product. The professional must balance the need to satisfy his customer with maintaining his artistic integrity and satisfaction. This is a fundamental tradeoff of hiring yourself out; someone *other* than you tells you what to draw, and in return you are paid (or should be paid) a premium price for your time and efforts. Every artist comes to find his own balance point naturally enough—inside. That changes, too, depending upon the assignment. Obviously, the fewer people you have to satisfy besides yourself, the easier the work will be. For this reason alone, the beginner in advertising art is better off starting with simple assignments like doing spots, for example, for one person at a company who has *total* responsibility for buying.

GETTING STARTED

The advertising art field is extremely competitive; cartoonists are not only vying with other cartoonists for work, there are also full-time advertising

THESE TIMES DEMAND THE TIMES.

The New York Times

Home delivery call 1-800-631-2500. N.J.800-932-0300.
Boston 617-787-3010. Washington area 301-654-2771

Advertisement by
R. O. Blechman for The
New York *Times*,
which appeared in
large space campaigns,
such as newspapers,
magazines and posters.

illustrators looking for it. Getting assignments results from making contacts and following them up diligently, being in the right place at the right time, and having a style or talent that is "commercial." This last ingredient is not definable. There are some fine cartoonists who, despite their reputations in national magazines, never "sell" the advertising agencies. Other cartoonists, less successful in magazines, do a huge volume of work in advertising. The only way to determine your own suitability for advertising is to go out into the field and test it.

You can do this on your own, or through an agent or "rep," who, in exchange for about twenty-five percent of what you earn, assumes the responsibility of taking your samples around, promoting you, finding assignments, dealing with clients and negotiating agreements. It sounds attractive, but there are few artist reps who handle cartoonists at all. Those that do carry only one or two in their portfolio, usually the bigger "names." It's the familiar chicken-and-egg situation; an agent is not interested in handling you because you're not established, but you may find it difficult to get established without an agent. If you feel you *must* have a rep, you might try looking for one who is just getting started himself and is willing to gamble on you.

To actively sell yourself you should prepare presentations of your work—portfolios to show to prospective clients and promotional folders to mail to them. Portfolios may be elaborate books with acetate pages and many colors, or simply an envelope filled with tearsheets. The degree of showiness depends on your personal style, what you're selling and your reputation. Exactly what samples and how many you should put into a portfolio is also a matter of feel. Art buyers usually look for a distinctive style. For this reason, many cartoonists feel they should show only the work which has best established their identity—their cartoons—and not try to compete with general illustrators by including an array of styles and techniques. Others believe it's valuable to demonstrate versatility to underline creativity, and that more is better. The cartoonist's greatest strength is his ability to create unusual visual solutions to problems—saying something differently from the way it's already been said. Your portfolio, then, should emphasize your magazine cartoons, including any variations you've tried.

You might tailor a portfolio to an art director. If you know what the assignment may be, you can show work similar to it and indicate your suitability to and interest in the director's creative problem. Many art directors like to feel that they're dealing with already-proven talent, so you should also include samples of your commercial assignments. What you have done for others often gives an art director confidence and makes it easier and safer for him to make a choice; it's making decisions by "agreement," by indirect recommendation. (At first you may not even get to see the art director, and may have to leave your portfolio. Follow-ups with phone calls and notes will eventually earn specific reaction to your work.)

You should consider preparing a promotion folder or card about yourself and mail it to a list of selected art buyers, as photographers and illustrators do to drum up new business. Actually very few cartoonists try this, but those that do consider it an excellent investment. Obviously, the more elaborate your mailer, the more costly it will be. Expense considerations for producing one include its size (three-by-five inches is convenient since it fits into standard card files), quality of paper, number of colors used, number of illustrations in line and halftone, number of folds, typography, printing and handling, addressing and mailing, and postage. Discuss it with your local printer. A mailer is meant to represent you to an art director in your absence. It is a selling piece, a sample of what you can do for him, so create it carefully, enlisting other specialists' expertise if necessary.

Build your mailing list carefully, too; choose names of art directors, other buyers of art and people in allied areas who influence the selection of art. Names can come from personal contacts and recommendations and can be culled from various publications. Among them are Art Direction magazine, which identifies art directors at agencies in its articles; *The Standard Directory of Advertising Agencies*, which lists not only the key people at all the ad agencies in the country but their clients, as well; *Art Directors Annual* and *Society of Illustrators Annual*, which reproduce ads and credit the agency, ad director and artist. These books are probably available at your local library. Go through them and pick the art directors who are credited with producing ads with cartoons or ads which you like personally.

Follow up your mailings with personal visits,

wherever possible. For these you might want to prepare something special, like a rough idea for an ad, a series of mailers—a redesign of a printed layout—to show the art director how cartoon techniques can help him for specific accounts and to demonstrate your interest in working with him. These self-assigned efforts are valuable in stretching yourself; they also make good extra samples in your portfolio. It's also worthwhile for you to study and learn about some technical areas, if you aren't familiar with them, like typography, paper and production.

Many cartoonists make little effort to get advertising work, but simply wait for requests to come in from people who have noticed their work in print or who have been recommended to them. Once you get started, you may continue this way. Luck is always a major factor in getting work, but the more you put yourself "out there," the better chances are that someone will ask you to do something.

WHAT TO CHARGE

Deciding how much to charge is difficult for all freelancers, whether big-name veterans or first-timers. The problem in pricing arises from the enormous variations in the work, its use, who is ordering it and the economic times. *The Graphic Artists Guild Handbook Pricing and Ethical Guidelines*: is excellent for general information and "ballpark" figures. I've found that my best source of pricing suggestions came from colleagues with greater experience who had done similar work. Ultimately, though, every cartoonist must establish his own minimum rates. These will vary, depending upon the difficulty of the work, how much time it will take (don't forget travel and meeting time with the principals) and what the nonmonetary benefits may be, like making good contacts for the future or receiving beneficial "exposure." These "minimums" also vary greatly among artists.

The most basic suggestion on pricing is that you must think well above a magazine editorial rate, which is payment for one-time use. In advertising, your cartoon may be used more than once, sometimes in several ways, and is part of a budget. It is common for cartoonists to undervalue their drawings, simply because they're used to the lower numbers. It is not easy to ask an agency for $750 for a black-and-white drawing that would bring in a third that amount from a magazine. Knowing how your drawing will be used, where, and how often, is essential to pricing. It is worth much more, for example, in a full-page ad running six times in a magazine which charges $80,000 for the space than in a sales promotion brochure mailing which costs $8,000 to produce.

Usually, the larger the buyer-organizations, the clearer and more experienced they are about budgets and the amount of money allocated for cartoon talent. Naturally, prices are negotiable. The top advertising cartoonists like Chuck Saxon, Bob Weber, Jack Davis and Rowland B. Wilson, can command a higher fee than middle-range names, and so on down the line. What is important is to feel comfortable about how much you'll receive for the job. Make sure that all payment questions are settled beforehand.

Part of negotiating price is understanding exactly what you are selling and the procedures by which you'll be paid. You may be required to submit a bill before you get any money; sometimes you first receive a purchase order. Payment is often arranged in stages: a percentage immediately upon receipt of sketches, another portion when the finishes are submitted and the final payment upon acceptance. You should also have some "kill fee" arrangements, under which you are paid a cutoff amount if, for various reasons, the client decides not to use your final drawings or go to the final stages after you've done preliminary sketches.

This arrangement is common when you are writing as well as drawing. If a client also wants you to provide concepts and ideas, you must be guaranteed payment for the time you turn your head on for him and sketch out roughs—even if they are all rejected and the job is killed at that point. The guarantee becomes part of the total fee if the job goes on to completion. For example, if you agree to do a series of eight drawings at, say, $400 apiece, you might agree to submit ten roughs for about $1,500 if they "quit" the job at that point. The complete job is worth $3,200 to you. My feeling is that coming up with concepts and ideas is the most important part of an assignment, and so should be paid for accordingly. In any case, make sure you get paid for everything and *never*, ever work on "spec." Spec time should be reserved for your own cartoons or children's books, or strips or whatever; but if someone is hiring you, he should pay for your thinking. Some cartoonists even charge an initial consultation fee, if a meeting is requested to

explore the possible avenues of your participation. You might also specify a reasonable number of "fixes" and consultation in your price, and request extra compensation if the client makes changes after you receive his okay to finish the work.

Once you complete several assignments, you'll begin to get a sense of your role in advertising, and the variations that are possible beyond those examples given here. The work can be challenging, both on the artistic and personal levels, and is the most dependably rewarding of all out-of-the-box activities, if you're willing to invest the time, energy and proper attitude to gain it. It may even become, as it has for many, your full-time career in cartooning.

Design and drawings by Boris Drucker for a multi-page employee benefits report for DeSoto. Drucker produced the complete, ready-for-camera mechanical.

17
Humor Books
and Other Things

In the section on spot drawings, I mentioned humor books as an area where the cartoonist can seek assignments as an illustrator. In these, for the most part, he receives a flat fee for doing a dozen or so drawings; sometimes he also gets a small royalty. However, cartoonists may also write their own humor books, since they are highly qualified to do so and because publishers tend to look favorably on humor ideas from cartoonists.

Humor books, excluding gag cartoon collections, are done in many different formats, and recently it has been the case that when one book becomes successful, there immediately appear a spate of "spinoffs."

The popular form is a ninety-six-page paperback, about five-by-eight inches, either horizontal or vertical, in black-and-white, combining words and pictures on one theme. The book may be a series of cartoon situations based on some sentiment like hating cats or sex or diets; or nostalgia, as in *What Ever Happened To . . . ?* which I wrote in collaboration with Marcia Seligson and Avery Corman. These books are mostly visual, with only captions or titles as text.

Another format is the handbook or the "how-to" book, which satirizes some popular trend or contemporary lifestyle through a step-by-step explanation of "appropriate" behavior. The first successful example of these was Dan Greenburg's *How to Be a Jewish Mother*. More recent examples include *The Official Preppy Handbook*, which gave rise to its own

shelfload of spinoffs, covering MBA degrees, "real men," "Jewish princesses" and "Valley girls." Familiar formats like coloring books or dictionaries are also often used for satire, as are guidebooks, an approach I used in my recent political satire, *Your* *Official Guide to Reaganworld, the Amusement Park for All the Right People*. The subjects and methods of presentation are limitless, but seem to be tied to current trends and fads.

A look at the paperback best seller list and half

an hour browsing in the humor section of your local bookstore will give you an idea of what is currently being published, if not selling.

If there is any guideline for producing a book a publisher may be interested in, it is the broad-based, mass appeal concept again, like television sitcoms and syndicated comic strips. The large bookstore chains, like B. Dalton and Waldenbooks, control about sixty percent of the entire retail book business, so they *must* buy a book in large quantities and promote it in order for it to sell well. While there are always freakish, inexplicable exceptions to the rule, this generally means that a humor book should not be too serious, relevant or controversial.

Ideas for books are generally presented to publishers in some outline form; perhaps half a dozen pages and some sample drawings, with a summary stating its intention and scope. If your previous work is known to an editor you may have to put less down on paper; if you are unknown you'll have to do more. The aim of the outline is only to sell the book, so do only what's necessary. Since publishers often take a long time to make decisions, it has become an acceptable practice to make simultaneous submissions to several. It is a good idea, too, for your protection, to establish for the record exactly when and to whom you make your submission. Unfortunately, book ideas which have been rejected by a publisher occasionally appear from them later, in somewhat different form. If you submit your work through an agent you shouldn't be concerned about your work being "adapted"; but if you're taking it around on your own and you are unknown, protect it, if only by the rudimentary means of sending a copy of it to yourself via registered mail and filing it away unopened.

If a publisher does accept a book idea, you'll be offered a contract, which includes stipulations for an advance payment against future royalties, a delivery date and scores of other conditions. Contract terms are negotiable, and it's always advisable to have either an agent or a lawyer handle this part of it for you. Again, there are many variables, including how important the publisher thinks the book will be and how big your name is. Advances on humor books are usually in the $5,000 to $10,000 range. The chances are generally small of making more money than your advance. However, besides the possibilities of earning money, people are attracted to the humor book form for other reasons. A book, for one, has a certain permanence which few other published forms have, so what you say in it endures. It also provides you with an opportunity to engage and hold a reader's attention over a long stretch; it is working on a larger canvas.

If you are so disposed, you might stretch farther and work in even bigger forms. Novels, nonfiction, movies and plays have been written by cartoonists such as Jules Feiffer, Mell Lazarus, Herb Gardner, Ed Fisher, Jim Stevenson, Mort Walker, William Hamilton, Jerry Robinson and Rube Goldberg. William F. Brown wrote the book for the musical, *The Wiz*. Shel Silverstein also writes songs. All examples of cartoonists *really* working out of the box.

There really is no limit to the areas which a cartoonist can play in. There is also sports cartooning, a specialty which combines characteristics of several other areas. Or chalk-talk lectures. Or caricatures and on-site drawings at conventions. Or . . .

As I said at the outset, the out-of-the-box activities enumerated in this book are probably the best known, but there are surely others which the magazine gag cartoonist may try in order to add dimension and income to his career. Through these summaries and examples I've sought to familiarize you as much as possible with the way it really is out there. But to really know, you must do it yourself (in the typical way of the freelancer), whatever it is which chooses you most strongly. In the next section you'll find specific data about selected markets as well as other information to ease your entry into the field. So come in—and break a leg!

Appendix
THE
MARKETPLACE
AND RESOURCES

SELECTED MARKETS*

MAGAZINES
General Magazines

Name of Publication	Publishing Frequency	Address	Cartoon Editor	Single-Panel B&W Rate	Needs
American Legion	Monthly	P.O. Box 1055 Indianapolis, IN 46206	Kay Whitehead	$125	General
Audubon	Bi-monthly	950 Third Ave. New York, NY 10022	Roxanna Sayre	$150	Ecology
Changing Times	Monthly	1729 "H" St., N.W. Washington, D.C. 20006	Ellen Roberts	$250	Shopping and money
Cosmopolitan	Monthly	224 West 57th St. New York, NY 10019	Stephen Whitty	$225	Relationships, women, sex
Diversion	Monthly	60 East 42nd St. New York, NY 10017	Carole Martin	$100	Travel, leisure, general
Good Housekeeping	Monthly	959 Eighth Ave. New York, NY 10019	Pat McBride	$200	Family, general
Ladies' Home Journal	Monthly	641 Lexington Ave. New York, NY 10022	Joanne Arbett	$250	Family, general
National Enquirer	Weekly	Lantana, FL 33462	Michele Cook	$210 for originals and reprints	General

*All information subject to change

GENERAL MAGAZINES (*cont.*)

Name of Publication	Publishing Frequency	Address	Cartoon Editor	Single-Panel B&W Rate	Needs
National Lampoon	Monthly	635 Madison Ave. New York, NY 10022	Ted Mann	$200	Outlandish, irreverent
The New Yorker	Weekly	25 West 43rd St. New York, NY 10036	Lee Lorenz	$400	General
Playboy	Monthly	747 Third Ave. New York, NY 10017	Michelle Urry	$350	Men's humor
TV Guide	Weekly	Radnor, PA 19088	Lorene Cary	$125	Television

Trade Magazines

Name of Publication	Publishing Frequency	Address	Cartoon Editor	Single-Panel B&W Rate	Needs
American Machinist	Monthly	1221 Ave. of the Americas New York, NY 10020	Anderson Ashburn	$ 20	Gags about the office, plant, shop
Automotive News	Monthly	965 E. Jefferson Ave. Detroit, MI 48207	Robert Lienert	$ 15	Auto-related
Campus Life	10 times yearly	Box 419 Wheaton, IL 60187	Tim Stafford	$ 40	General
Creative Computing	Monthly	39 E. Hanover Ave. Morris Plains, NJ 07950	Andrew Brill	$ 15	Computer
Datamation	Monthly	666 Fifth Ave. New York, NY 10019	John Kirkley	$ 50	General with accent on computing, research, science
Farm Journal	14 times yearly	230 W. Washington Sq. Philadelphia, PA 19105	Dick Braun	$ 35	Agricultural
The Farmer	Bi-monthly	The Webb Co. 1999 Shepard Rd. St. Paul, MN 55116	Donna Chermak	$ 10	Agricultural
Insurance Salesman	Monthly	1200 N. Meridian St. Indianapolis, IN 46204	————	$ 12.50	Agents, general
Medical Economics	Monthly	Oradell, NJ 07649	————	$ 80	Medical, general
Modern Medicine	Bi-weekly except July, Aug., Dec.	747 Third Ave. New York, NY 10017	Debra Pysno	$ 35	Medical, general
Nebraska Farmer	Twice monthly	P.O. Box 81208 Lincoln, NE	Robert Bishop	$ 5	General
Phi Delta Kappan	10 times yearly	Box 789 Bloomington, IN 47401	————	$ 15	Education oriented

Name of Publication	Publishing Frequency	Address	Cartoon Editor	Single-Panel B&W Rate	Needs
Western Horseman	Monthly	3850 N. Nevada Ave. Colorado Springs, CO 80933	————	$ 10	Western
Writer's Digest	Monthly	9933 Alliance Rd. Cincinnati, OH 45242	John Brady	$ 25	Writers' gags

NEWSPAPER SYNDICATES

Field Newspaper Syndicate
1704 Kaiser Avenue
Irvine, California 92714
Telephone: 714-549-8700
Editor: Leighton McLaughlin

King Features Syndicate
235 East 45th Street
New York, New York 10017
Telephone: 212-682-5600
Editor: Bill Yates

Los Angeles Times Syndicate
Times Mirror Square
Los Angeles, California 90053
Telephone: 213-972-7937
Editor: Jane Amari

McNaught Syndicate Inc.
60 East 42nd Street
New York, New York 10017
Telephone: 212-682-8787
Editor: Anne Rickey

Newspaper Enterprise Association
200 Park Avenue
New York, New York 10016
Telephone: 212-557-2333
Executive Editor: Sid Goldberg

Register and Tribune Syndicate
715 Locust Street
Des Moines, Iowa 50304
Telephone: 515-284-8244
Editor: James B. Cooney

The Tribune Syndicate
220 East 42nd Street
New York, New York 10017
Telephone: 212-949-3400
Editor: Don Michel

United Feature Syndicate Inc.
200 Park Avenue
New York, New York 10016
Telephone: 212-557-2333
Executive Editor: Sid Goldberg

Universal Press Syndicate
4400 Johnson Drive
Fairway, Kansas 66205
Telephone: 913-362-1523
Editor: Lee Salem

CHILDREN'S BOOK PUBLISHERS

Avon Books
959 Eighth Avenue
New York, New York 10019
Telephone: 212-262-5700
Senior Editor: Jean Feiwel

Crowell Junior Books
(Harper Junior Books Group)
10 East 53rd Street
New York, New York 10022
Telephone: 212-593-7011
Editorial Director: Patricia Allen

Dell Publishing Co., Inc.
1 Dag Hammarskjold Plaza
New York, New York 10017
Telephone: 212-832-7300
Editor: Beverly Horowitz

Doubleday and Co., Inc.
245 Park Avenue
New York, New York 10017
Telephone: 212-953-4872
Editorial Director: Marci McGill

CHILDRENS BOOK PUBLISHERS (*cont.*)

E.P. Dutton
2 Park Avenue
New York, New York 10016
Telephone: 212-725-1818
Editorial Director: Ann Durell

Farrar, Straus & Giroux, Inc.
19 Union Square West
New York, New York 10003
Telephone: 212-741-6900
Editor-in-Chief: Stephen Roxburgh

Four Winds Press
730 Broadway
New York, New York 10003
Telephone: 212-505-3000
Publisher: Judith R. Whipple

Greenwillow Books
105 Madison Avenue
New York, New York 10016
Telephone: 212-889-3050
Editor-in-Chief: Marcie Imberman

Harper & Row
10 East 53rd Street
New York, New York 10022
Telephone: 212-593-7000
Associate Publisher, Harper
Junior Books: Charlotte Zolotow

Lippincott Junior Books
10 East 53rd Street
New York, New York 10022
Telephone: 212-593-7011
Editorial Director: Patricia Allen

Parents Magazine Press
685 Third Avenue
New York, New York 10017
Telephone: 212-878-8700
Editor: Stephanie Calmenson

Prentice-Hall, Inc.
Englewood Cliffs, New Jersey 07632
Telephone: 201-592-2618
Editor-in-Chief, Children's Books: Barbara Francis

Scholastic Books
730 Broadway
New York, New York 10003
Telephone: 212-505-3000
Editor: Bernice Chardiet

Frederick Warne & Co., Inc.
2 Park Avenue
New York, New York 10016
Telephone: 212-686-9630
Editor: Meredith Charpentier

Franklin Watts, Inc.
730 Fifth Avenue
New York, New York 10019
Telephone: 212-757-4050
Editorial Director: Jeanne Vestal

HUMOR BOOK PUBLISHERS

Andrews and McMeel Inc.
4400 Johnson Drive
Fairway, Kansas 66205
Telephone: 913-362-1523

Ballantine Books Inc.
201 East 50th Street
New York, New York 10022
Telephone: 212-751-2600

Clarkson N. Potter Inc.
1 Park Avenue
New York, New York 10016
Telephone: 212-531-9200

Crown Publishers Inc.
1 Park Avenue
New York, New York 10016
Telephone: 212-532-9200

Dodd, Mead & Co.
79 Madison Avenue
New York, New York 10016
Telephone: 212-685-6464

Doubleday Publishing Co.
245 Park Avenue
New York, New York 10017
Telephone: 212-953-4561

Harper & Row
10 East 53rd Street
New York, New York 10022
Telephone: 212-593-7000

Holt, Rinehart and Winston
383 Madison Avenue
New York, New York 10017
Telephone: 212-872-2000

Price/Stern/Sloan Publishers Inc.
410 N. La Cienega Boulevard
Los Angeles, California 90048
Telephone: 213-657-6100

The Putnam Publishing Group
200 Madison Avenue
New York, New York 10016
Telephone: 212-576-8900

St. Martin's Press Inc.
175 Fifth Avenue
New York, New York 10010
Telephone: 212-674-5151

Wallaby Books Division of Simon & Schuster
1230 Avenue of the Americas
New York, New York 10020
Telephone: 212-245-6400

Workman Publishing Co. Inc.
One West 39th Street
New York, New York 10018
Telephone: 212-398-9160

COMIC BOOK PUBLISHERS

Archie Comic Publications, Inc.
1116 First Avenue
New York, New York 10021
Telephone: 212-421-9377
Editor: Richard Goldwater

Charlton Publications
Division Street
Derby, Connecticut 06418
Telephone: 203-735-3381
Editor: George Wildman

Comics Magazine Association of America
60 East 42nd Street
New York, New York 10017
Telephone: 212-682-8144
Editor: J. Dudley Waldner

D. C. Comics
75 Rockefeller Plaza
New York, New York 10010
Telephone: 212-484-8500
Editor: Dick Giordano

Harvey Publications
888 Seventh Avenue
New York, New York 10019
Telephone: 212-582-2244
Editor: Sidney Jacobsen

Mad Magazine
E. C. Publications Inc.
485 Madison Avenue
New York, New York 10022
Telephone: 212-752-7685
Editor: John Ficarra

Marvel Comics Group
575 Madison Avenue
New York, New York 10022
Telephone: 212-754-0340 or 838-7900
Editor: James Shooter

Western Publications
1220 Mound Avenue
Racine, Wisconsin 53404
Telephone: 414-633-2431
Editor: Wally Green

GREETING CARD PUBLISHERS

Alfred Mainzer, Inc.
27–08 40th Avenue
Long Island City, New York 11101
Telephone: 212-392-4200

Drawing Board, Inc.
256 Regal
Dallas, Texas 75221
Telephone: 214-637-0390

Fran Mar Greeting Cards, Ltd.
630 South Columbus
Mount Vernon, New York 10550
Telephone: 914-664-5060

Gibson Greeting Cards, Inc.
2100 Section Road
Cincinnati, Ohio 45237
Telephone: 513-841-6600

Hallmark Cards, Inc.
25th & McGee Trafficway
Kansas City, Missouri 64108
Telephone: 816-274-5111

Norcross, Inc.
950 Airport Road
West Chester, Pennsylvania 19380
Telephone: 215-436-8000

Paper Moon Graphics, Inc.
P.O. Box 34672
Los Angeles, California 90034
Telephone: 213-559-9053

Recycled Paper Products
3325 N. Lincoln Avenue
Chicago, Illinois 60657
Telephone: 312-549-0428

ANIMATION STUDIOS

Howard Beckerman
19 West 44th Street
New York, New York 10036
Telephone: 212-869-0595

R. O. Blechman, Inc.
2 West 46th Street
New York, New York 10036
Telephone: 212-869-1630

Phil Kimmelman & Associates
65 East 55th Street
New York, New York 10018
Telephone: 212-944-7766

Perpetual Motion Pictures
11 East 44th Street
New York, New York 10036
Telephone: 212-953-9110

Hal Seeger
45 West 45th Street
New York, New York 10036
Telephone: 212-586-4311

Sel Animation, Inc.
240 Madison Avenue
New York, New York 10016
Telephone: 212-686-3666

RESOURCES

PROFESSIONAL JOURNALS AND PUBLICATIONS

Gag Re-Cap
Box 86
East Meadow, New York 11554
Editor: Al Gottlieb
 Monthly. Describes cartoons published in about sixty leading general magazines. Credits cartoonists, provides addresses of magazines, prices paid for cartoons and editors' names.

Trade Journal Re-Caps
Box 86
East Meadow, New York 11554
Editor: Al Gottlieb

Monthly. Same format as Gag Re-Cap but covers about forty trade journals and house organs.

Cartoonist Profiles
P.O. Box 325
Fairfield, Connecticut 06430
Editor: Jud Hurd
 Quarterly. Professional-interest magazine dedicated to art of cartooning, covering all aspects of professional cartooning. Features "how-to" interviews with cartoonists in the fields of comic strips, political cartooning, magazine cartooning, advertising, greeting cards and others.

Funny Papers
1594 Marion Street, Apt. 102
St. Paul, Minnesota 55117
Contributing editors: Al Batt, Loanne Engen
 Published monthly. Market information, marketing tips, writing/cartooning tips, humor writing techniques.

Trade Journal Recaps
1594 Marion Street, Apt. 102
St. Paul, Minnesota 55117
 Published monthly. Covers about sixty-five trade journals and house organs.

Writer's Market
9933 Alliance Road
Cincinnati, Ohio 45242
 Annual directory aid to freelancers. Addresses and names of editors provided together with type of work accepted.

Artist's Market
9933 Alliance Road
Cincinnati, Ohio 45242
 Similar to Writer's Market but a more varied selection of market sources.

Writer's Digest
993 Alliance Road
Cincinnati, Ohio 45242
 Monthly. Supplies information about writing, literature and markets.

Literary Market Place
R. R. Bowker Co.
1180 Avenue of the Americas
New York, New York 10036
 Annual. A library reference book providing addresses and names of book publishers, agents and agencies, book trade events, etc.

The Occasional
30 East 20th Street
New York, New York 10003
"A National Voice for Graphic Artists." Published by the Graphic Artists Guild. Information on techniques, artists, markets, legal matters, new publications and books.

The Cartoonist
National Cartoonists Society
9 Ebony Court
Brooklyn, New York 11229
Annual publication of the society.

Editor & Publisher
575 Lexington Avenue
New York, New York 10021
Weekly. Covers every aspect of the newspaper industry, featuring articles on trends in the industry, newspaper executives, interviews and controversies.

Editor & Publisher
Syndicate Directory
575 Lexington Avenue
New York, New York 10021
Annual guide to all syndicated features and services.

Publishers Weekly
1180 Avenue of the Americas
New York, New York 10036
Weekly. Journal of the book industry. Provides information for publishers, booksellers, writers, editors. Contains articles, pre-publication book reviews and news covering every aspect of book publishing and book selling.

PROFESSIONAL ORGANIZATIONS

Cartoonists Association
Box 423
Grand Central Station
New York, New York 10017
Telephone: 212-677-3317
Dues: $175 yearly.
Scope: Organization of professional freelance cartoonists primarily from magazines; provides a forum for the exchange and dissemination of pertinent information for its members.

Graphic Artists Guild
30 East 20th Street
New York, New York 10003
Telephone: 212-777-7353

Dues: Annual membership $110, Provisional membership $75 (earning under $9,500 per year)
Scope: Organization for visual artists. Full-service guild servicing artists (illustrators, designers, photographers, artists' representatives, etc.); meetings and lectures on contracts and copyrights; negotiations.

National Cartoonists Society
9 Ebony Court
Brooklyn, New York 11229
Telephone: 212-743-6510
Dues: Within 100 miles of New York, $75 yearly, $35 initiation fee. Out of New York area: $50 yearly, $25 initiation fee. Associate member: same dues, $100 initiation fee
Scope: A cartoonist must be a professional earning the major portion of his or her income from cartooning. Membership is primarily from the syndication field.

Association of American Editorial Cartoonists
22 Mimosa Drive
Wilmington, Delaware 72641
Telephone: 501-741-8747
Dues: $50 yearly—active member, $10 yearly—retired member, $15 yearly—organizations
Scope: To promote and stimulate public interest in the editorial cartoon; to raise the standards of the profession and to create close association among cartoonists through mutual interest.

Society of Illustrators
128 East 63rd Street
New York, New York 10021
Telephone: 212-838-2560
Dues: $100 initiation fee, $200 yearly Artist member, $250 yearly Associate member
Scope: Non-profit organization for professional illustrators. Provides scholarships to students. Annual exhibition for professional non-members.

Cartoonists Guild
156 West 72nd Street
New York, New York 10023
Telephone: 212-873-4023
Dues: $135 yearly for full member, $85 yearly for apprentice member
Scope: Organization for the freelance cartoonist; not necessary to be professional for membership.

SELECTED BIBLIOGRAPHY

Abel, Bob, ed. *The American Cartoon Album.* New York: Dodd, Mead Co., 1974.

Becker, Stephen D. *Comic Art in America.* New York: Simon & Schuster, 1959.

Blackbeard, Bill, and Williams, Martin, eds. *The Smithsonian Collection of Newspaper Comics.* New York: Harry N. Abrams, Inc., 1978.

Blackbeard, Bill, and Williams, Martin, eds. *The Smithsonian Collection of Classic Comic Strips,* Washington, D.C.: Smithsonian Institution, 1976.

Blechman, R.O. *R.O. Blechman: Behind the Lines.* New York: Hudson Hills Press, 1980.

Crawford, Tad. *A Legal Guide for the Visual Artist.* The Graphic Artists Guild,

Donahue, Don, and Goodrick, Susan, eds. *The Apex Treasury of Underground Comics: R. Crumb and Friends.* New York: Quick Fox, 1974.

Esquire Cartoon Album, 25th Anniversary Volume. New York: Doubleday & Co., 1957.

Feiffer, Jules. *The Great Comic Book Heroes.* New York: Dial Press, 1965.

Feiffer, Jules. *Jules Feiffer's America: From Eisenhower to Reagan.* New York: Alfred A. Knopf, 1982.

Fisher, Ed; Gerberg, Mort; Wolin, Ron, eds. *Art in Cartooning.* New York: Scribner, 1975.

The Graphic Artists Guild Handbook: Pricing and Ethical Guidelines. 4th ed. The Graphic Artists Guild.

Halas, John, and Manvell, Roger. *The Technique of Film Animation. 2nd ed.* New York: Hastings House, 1968.

Hefner, Hugh M. *The Twentieth Anniversary Playboy Cartoon Album.* Chicago: Playboy Press, 1974.

Hoff, Syd. *Editorial and Political Cartoons.* New York: Stravon Educational Press, 1956.

Horn, Maurice, ed. *World Encyclopedia of Comic Art.* New York: Chelsea House, 1975.

The Drawings of Heinrich Kley. New York: Dover Publications, 1961.

More Drawings by Heinrich Kley. New York: Dover Publications, 1962.

Lariar, Lawrence, ed. *Best Cartoons of the Year.* New York: Crown Publishers, yearly edition.

Lariar, Lawrence, ed. *The Best of Best Cartoons, 20th Anniversary Edition: A Treasury of the 500 Best Cartoons of the Past 20 Years.* New York: Crown Publishers, 1961.

Lee, Stan. *The Origins of Marvel Comics.* New York: Simon & Schuster, 1974.

Levine, David. *The Arts of David Levine.* New York: Alfred A. Knopf, 1982.

Maltin, Leonard. *Of Mice and Magic.* New York: New American Library, 1980.

McCary, Winsor. *Little Nemo.* New York: Nostalgia Press, 1972.

Meglin, Nick. *The Art of Humorous Illustration.* New York: Watson-Guptill, 1973.

The New Yorker 1950–55 Album. New York: Harper & Brothers, 1955.

The New Yorker Album of Drawings, 1925–1975. New York: Viking Press, 1975.

The New Yorker Twenty-Fifth Anniversary Album, 1925–1950. New York: Harper & Brothers, 1951.

Nickles, Marione R., ed. *After Hours: Cartoons from the Saturday Evening Post.* New York: E.P. Dutton & Co., 1960.

Nickles, Marione R., ed. *The Nine To Fivers: Cartoons from the Saturday Evening Post.* New York: E.P. Dutton and Company, 1962.

Robinson, Jerry. *The Comics.* New York: G.P. Putnam's Sons, 1974.

Sorel, Edward. *Superpen: The Cartoons and Caricatures of Edward Sorel.* New York: Vintage Books, 1979.

Strunk Jr., William, and White, E. B. *The Elements of Style.* With Revisions, an Introduction and a New Chapter on Writing. New York: The Macmillan Company, 1959.

Suares, Jean-Claude. *Art of the Times,* Avon Books, 1973.

Thomas, Bob. *Walt Disney, The Art of Animation: The Story of the Disney Studio Contribution to a New Art.* New York: Golden Press, 1958.

Walker, Mort. *Backstage at the Strips.* New York: Mason-Charter, 1976.

Waugh, Coulton. *The Comics.* New York: The Macmillan Company, 1947.

Westin, Alan F., ed. *Getting Angry Six Times a Week: A Portfolio of Political Cartoons by Fourteen Major Cartoonists.* Boston: Beacon Press, 1979.

White, David Manning, and Abel, Robert H. *The Funnies: An American Idiom.* London: The Free Press of Glencoe, 1963.

Writer's Digest *Guide to Greeting Card Writing.*

Writer's Digest *Cartoonist's and Gag Writer's Handbook.*

SUGGESTED ARTICLES

Newsweek. "Cartoon Time," December 23, 1968.

The Washington Post. "Cartoonists Elite: Clubby Lunches and Just One Stop," by Judith Martin; Style/People/Fashion, Leisure section, January 23, 1972.

The Wall Street Journal. "A Dying Art: Cartoonists Dwindle As Big Magazines Fold," by Frederick Klein; July 19, 1972.

The New Yorker, "Endless Possibilities"; Profile on Pat Oliphant; December, 31, 1979.

Newsweek. "The Finer Art of Politics," October 13, 1980.

Index